INGE MORATH

GRENZ.RÄUME LAST JOURNEY

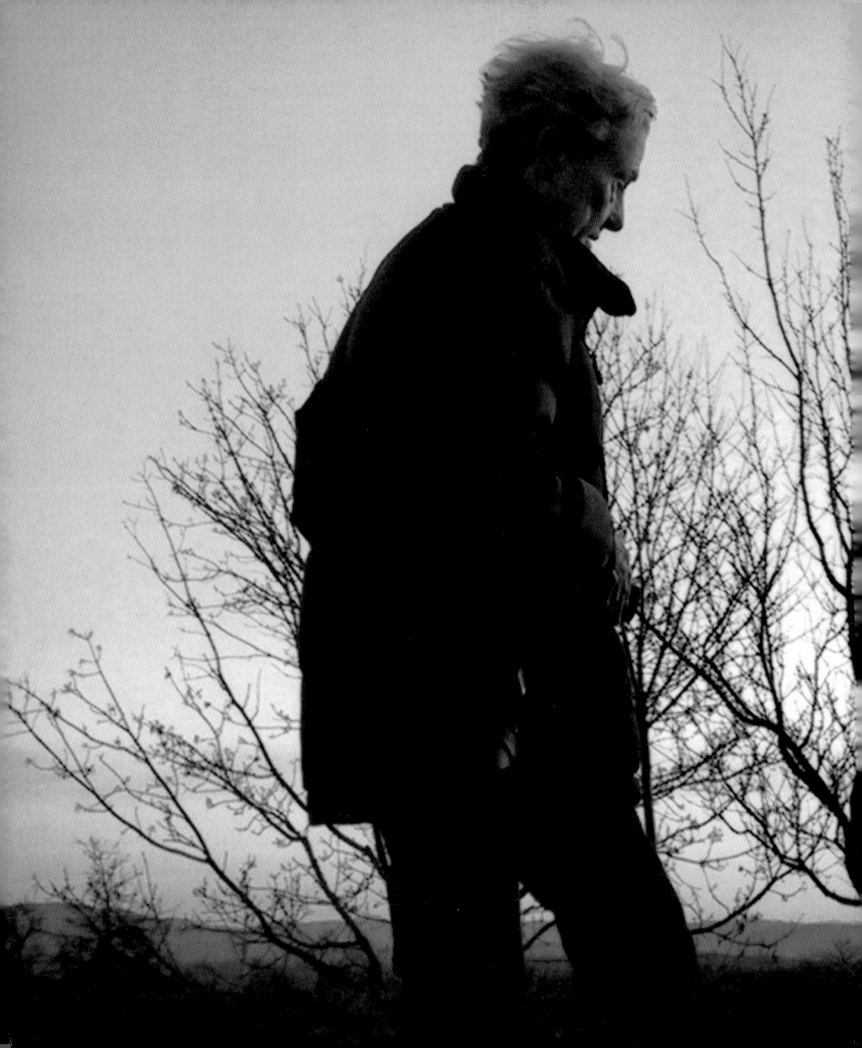

REGINA STRASSEGGER

INGE MORATH

GRENZ.RÄUME LAST JOURNEY

VORWORT FOREWORD BY
ARTHUR MILLER

PHOTOGRAPHIEN PHOTOGRAPHS BY
INGE MORATH
AND STOJAN KERBLER, BRANKO LENART,
REGINA STRASSEGGER

TEXTE TEXTS BY
INGE MORATH, RENATE & IMO MOSZKOWICZ,
DRAGO JANČAR, WERNER MÖRATH,
GERHARD ROTH, KAREL PEČKO,
GERALD BRETTSCHUH, REGINA STRASSEGGER

GRAZ ZWEITAUSENDDREI
KULTURHAUPTSTADT EUROPAS

PRESTEL
MUNICH · BERLIN · LONDON · NEW YORK

INGE MORATH (1923–2002) gehört zu den großen Photographinnen des 20. Jahrhunderts. Studium der Romanistik in Berlin und Bukarest. Durch die Zusammenarbeit mit Ernst Haas Kontakt zu den Magnum-Begründern Robert Capa und Henri Cartier-Bresson in Paris. 1953 Mitglied von ›Magnum‹. 1955–61 ausgedehnte Reisen in Europa, Afrika, Asien und den USA. Nach ihrer Heirat mit Arthur Miller 1962 Reisen in die UdSSR und China. ›Grenz.Räume‹ ist Inge Moraths photographisches Vermächtnis.

INGE MORATH (1923–2002) is one of the major photographers of the 20th century. Studied Romance languages in Berlin and Bucharest. Collaboration with Ernst Haas linked her up with Magnum-founders Robert Capa and Henri Cartier-Bresson in Paris. In 1953 she became a member of "Magnum." Traveled extensively in Europe, Africa, Asia and the USA 1955–1961. After her marriage with Arthur Miller in 1962, she traveled in the USSR and in China. *Border.Spaces* is Inge Morath's photographic legacy.

REGINA STRASSEGGER, geb. 1955 in Graz/Österreich. Studium der Zeitgeschichte und Philosophie in Graz, Windhuk, Joensuu, Edinburgh. 1980 Entwicklungsprojekt in Namibia. Seit 1989 beim ORF. Preisgekrönte Dokumentarfilmerin. Die ›Grenz.Räume‹ sind auch ein Filmprojekt von Regina Strasseger, das im Januar 2003 Premiere hat. Lebt in Wien.

REGINA STRASSEGGER, born 1955 in Graz/Austria. Studied contemporary history and philosophy in Graz, Windhuk, Joensuu, Edinburgh. Initiated a development project in Namibia 1980. Since 1989 she has been working for Austrian television as a documentary film maker. *Border.Spaces* is also a film project by Regina Strassegger, due to be premiered in January 2003. Lives in Vienna.

STOJAN KERBLER, geb. 1938 in Ptuj/Slowenien. Elektrotechnikstudium in Ljubljana. Seit 1960 freischaffender Photograph. Zahlreiche Ausstellungen und Auszeichnungen in Europa, der UdSSR, in Lateinamerika. Lebt in Ptuj.

STOJAN KERBLER, born 1938 in Ptuj/Slovenia. Studied technology in Ljubljana. Since 1960 freelance photographer. Numerous exhibitions and awards in Europe, USSR, Latin America. Lives in Ptuj.

BRANKO LENART, geb. 1948 in Ptuj/Slowenien. 1954 Emigration nach Graz. Seit 1970 freischaffender Photograph. Zahlreiche Austellungen und Auszeichnungen in Europa und USA. Lebt in Graz und Piran.

BRANKO LENART born 1948 in Ptuj/Slovenia. In 1954 emigrated to Graz. Since 1970 freelance photographer. Numerous exhibitions and awards in Europe and USA. Lives in Graz and Piran.

Österreich
Austria

Wien
Vienna

Steiermark
Styria

Graz
Gradec

Mur Mura

Klagenfurt
Celovec

Staatsgrenze border

Drava Drau

Maribor
Marburg

Ptuj
Pettau

Slovenj Gradec
Windischgraz

Štajerska

Ljubljana
Laibach

Slovenija
Slowenien

INGE MORATH GRENZ.RÄUME – Ein Projekt von ›Graz 2003 – Kulturhauptstadt Europas‹ / A project for "Graz 2003—Cultural Capital of Europe"

INHALT CONTENTS

1888 Inge Moraths Großvater Hans Tomschegg wird Bürgermeister der k.u.k. Stadt Windischgraz, heute Slovenj Gradec; der Nachbar Hugo Wolf kommt öfters zum Klavierspiel. **1895** Heirat der Großeltern; Gründung des Städtischen Krankenhauses. **1897** Geburt von Mathilde und Else Wiesler, Mutter und Tante von Inge Morath. **1904** Erstes Automobil in der Stadt. **1914** Ausbruch des Ersten Weltkriegs; Windischgraz/Slovenj Gradec erhält Telefon. **1915** Mathilde Wiesler besucht als erstes Mädchen die Realschule in Marburg/Maribor. **1918** Zusammenbruch der k.u.k Monarchie; Ausweisung deutschsprachiger Beamter aus der damaligen Untersteiermark (Štajerska). Auch die Tomscheggs und Wieslers müssen gehen. General Rudolf Maister aus Marburg besetzt mit seinen Einheiten Grenzgebiete; Kämpfe. **1919** Frieden von St Germain; Grenzziehung. Die damalige Untersteiermark kommt zum neu gegründeten Königreich der Serben, Kroaten und Slowenen. **1921** Lokale Grenzverschiebungen. Heirat von Mathilde Wiesler und Edgar Mörath. **1923** Geburt von Inge Mörath (später Morath) in Graz. **1927** Familie Dadieu kauft anläßlich der Geburt ihrer Tochter Renate das ›Haus an der Grenze‹. **1932–41** Gemeinsame Sommer der Familien Dadieu/Mörath im ›Haus an der Grenze‹. **1933** Machtergreifung Hitlers in Deutschland. Die Familie Mörath lebt in Darmstadt. **1938** Einmarsch der Nazis in Österreich. Armin Dadieu wird Gauhauptmann der Steiermark. **1940–44** Inge Morath studiert in Berlin und Bukarest. **1941** Überfall der Nazis auf Jugoslawien; Annexion der Untersteiermark. **1941–44** Josip Broz Tito koordiniert Widerstand der Partisanen. **1942** Sechs Millionen Juden sterben in den Gaskammern der Nazis. Imo Moszkowicz verliert seine Mutter und sechs seiner Geschwister; er selbst überlebt Auschwitz. **1945** Niederlage von Nazi-Deutschland; Wiederherstellung der Grenzen von 1919. Marschall Josip Broz Tito führt die Volksrepublik Jugoslawien. Inge Morath auf der Flucht von Berlin nach Salzburg. **1946–49** Inge Morath und Renate Dadieu leben in einer Künstler-Kommune im besetzten Wien. **1948** Bruch zwischen Tito und Stalin. **1949** Uraufführung von Arthur Millers ›Tod eines Handlungsreisenden‹ in New York. **1950** Inge Morath geht mit ihrem Kollegen Ernst Haas zur Photoagentur Magnum nach Paris. Zunächst Texterin für Robert Capa, Henri Cartier-Bresson u.a. **1952** Inge Morath beginnt zu photographieren. **1953** Arthur Miller reagiert in New York mit seinem Stück ›Hexenjagd‹ auf die Repressionen der McCarthy- Ära. **1955** Inge Morath beginnt internationale Reisetätigkeit. **1956** Aufstand der Ungarn, Niederschlagung durch sowjetische Truppen; Heirat von Renate Dadieu und Imo Moszkowicz. **1962** Heirat von Inge Morath und Arthur Miller. **1966** Inge Morath wird Staatsbürgerin der USA. **1965–78** Viele Reisen Inge Moraths, u.a. in die Sowjetunion und nach China; zahlreiche Publikationen. **1979** Die Ehepaare Morath/Miller und Dadieu /Moszkowicz treffen sich nach langen Jahren wieder im ›Haus an der Grenze‹. **1980** Tod von Josip Broz Tito; der Zerfall Jugoslawiens beginnt. **1981–90** Zahlreiche Reisen, Bücher, Ausstellungen, Preise. **1989** Fall des Eisernen Vorhangs. **1991** Ausbruch des Krieges in Jugoslawien; Unabhängigkeit von Slowenien und Kroatien. Ende der Sowjetunion. Großer Staatspreis für Inge Morath in Wien. **1993** Tod von Inge Moraths Mutter. **1999** Austellung Inge Moraths in Wien. **2001** Film, Buch, Austellungs-Projekt ›INGE MORATH – GRENZ.RÄUME‹. **2002** Inge Morath stirbt im Januar in New York.

1888 Inge Morath's grandfather Hans Tomschegg becomes mayor of the Habsburg city of Windischgraz, now Slovenj Gradec. Hugo Wolf, composer, pianist, and neighbor, is a frequent visitor. **1896** Grandparents marry; founding of city hospital. **1904** First automobile in the town. **1914** Outbreak of World War I; first telephone in Windischgraz/Slovenj Gradec. **1915** Mathilde Wiesler is the first girl to attend the Classical Gymnasium, Marburg/Maribor. **1918** Collapse of the Habsburg Monarchy; expulsion of German-speaking state officials from what was then Lower Styria (Štajerska), including the Tomscheggs and Wieslers. General Rudolf Maister of Marburg/Maribor occupies the border areas with troops; fighting. **1919** Treaty of St. Germain; redrawing of borders. Štajerska becomes part of the newly established Kingdom of the Serbs, Croats, and Slovenes. **1921** Regional border-adjustments. Mathilde Wiesler and Edgar Mörath marry. **1923** Inge Mörath (later Morath) born in Graz. **1927** On the birth of their daughter Renate, the Dadieu family purchases the "house at the border." **1932–41** The Dadieu and Mörath families spend their summers together in the "house at the border." **1933** Hitler comes to power in Germany. The Mörath family now lives in Darmstadt. **1938** Nazis annex Austria. Armin Dadieu becomes district captain of Styria. **1940–44** Inge Morath studies in Berlin and Bucharest. **1941** Nazis invade Yugoslavia; annexation of Štajerska. **1941–44** Josip Broz Tito coordinates Partisan resistance. **1942** Six million Jews perish in the Nazi gas chambers. Imo Moszkowicz loses his mother and his six brothers and sisters; he himself survives Auschwitz. **1945** Defeat of Nazi Germany; reestablishment of the 1919 borders. Federal People's Republic of Yugoslavia promulgated by Marshal Tito. Inge Morath flees from Berlin to Salzburg. **1946–49** Inge Morath and Renate Dadieu live together with other artists in occupied Vienna. **1948** Rupture between Tito and Stalin. **1949** Premiere of Arthur Miller's *Death of a Salesman* in New York. **1950** Together with photographer Ernst Haas, Inge Morath moves to Paris and joins the Magnum photographers' agency, working to begin with as copy-writer for Robert Capa, Henri Cartier-Bresson, and others. **1952** Inge Morath starts taking photographs. **1953** Arthur Miller responds to McCarthyism in the United States with his play *The Crucible*. **1955** Inge Morath begins traveling internationally. Austria regains its sovereignty. **1956** Hungarian Uprising put down by Soviet forces; Renate Dadieu and Imo Moszkowicz marry. **1962** Inge Morath and Arthur Miller marry. **1966** Inge Morath becomes an American national. **1965–78** Inge Morath travels widely; destinations include the Soviet Union and China; numerous publications. **1979** Morath/Miller and Dadieu/Moszkowicz meet again for the first time in many years in the "house at the border." **1980** Tito's death; Yugoslavia begins to break up. **1981–90** Numerous journeys, publications, exhibitions, prizes. **1989** The iron curtain falls. **1991** Outbreak of war in Yugoslavia; Slovenia and Croatia declare independence. End of the Soviet Union. Inge Morath receives Austrian National Award in Vienna. **1993** Death of Inge Morath's 95-year-old mother, Mathilde Mörath. **1999** Inge Morath exhibition in Vienna. **2001** Film, book, and exhibition project: INGE MORATH —BORDER.SPACES. Jan. **2002** Inge Morath dies in New York.

VORBEMERKUNG

Wie das Leben so spielt: Im Juni 1999 macht ein großes Transparent beim Wiener Messepalast, dem heutigen Museumsquartier, auf die Eröffnung der Inge-Morath-Ausstellung sowie auf die Anwesenheit der berühmten Photographin aufmerksam. Was für ein wunderbarer Zufall: die in Österreich politisch heißen Zeiten haben mich als Filmemacherin im ORF in Turbulenzen gebracht – Distanz und Hinwenden zu Neuem könnten nicht schaden...

Wenig später steht mir Inge Morath gegenüber. Die Frau von Welt ohne Allüren zeigt Interesse an der Frage, ob es denkbar wäre, mit ihr eine Fernsehproduktion in der Südsteiermark zu machen. Und dann ihr Satz: »Diese Gegend ist eine heimliche Sehnsucht von mir. Machen wir was!« Das Gespräch dauert keine fünfzehn Minuten. Wir tauschen unsere Telefonnummern aus und freuen uns über die schöne Idee. Eine photo-filmische Spurensuche in den steirisch-slowenischen Grenzraum, ins Land ihrer Vorfahren, ihrer Kindheitssommer, in eine Region der neu wachsenden Nachbarschaft – nach all den Jahrzehnten der Trennung.

In den folgenden Monaten nimmt die Idee Gestalt an. Sie wird ein Projekt für Graz 2003, der Kulturhauptstadt Europas, Geburtsstadt Inge Moraths. Film, Buch und Ausstellung sollen Orte, Stimmungen, Begegnungen dieser den Jahreszeiten folgenden Zeitreise widerspiegeln; Skurriles und Nostalgisches, Ländliches und Städtisches von hüben und drüben der Grenze. Im Februar 2001 beginnt die photo-filmische Reise, im Juni geht sie weiter, am 11. September erhält das Kapitel Grenzsituation eine neue Dimension, und im Oktober 2001 geht diese ungewöhnliche Zeitreise verfrüht zu Ende: Inge Morath – die energievolle, unermüdliche, spontane, charmante – erkrankt schwer. Daß es eine Krankeit zum Tode ist, weiß niemand von uns. Inwieweit es Inge Morath selbst bewußt ist, bleibt mir bis zum Schluß verborgen. Das Fest zum 80. Geburtstag Inge Moraths im Mai 2003 findet ›in memoriam‹ statt. Sie wird uns besonders nahe sein in Graz, Slovenj Gradec, New York, Budapest, Ljubljana, München, wenn ihre Bilder ausgestellt werden – begleitet von Buch und Film –, wenn ihr visueller Strom, ihre Liebe zum Leben, zu diesem Landstrich an uns vorbeizieht.

Mein Dank gilt Arthur Miller, Renate und Imo Moszkowicz, Werner Mörath, Karel Pečko, Drago Jančar, Gerhard Roth, Gerald Brettschuh; außerdem Viktor Laszlo, Eva Gressel, Stojan Kerbler, Branko Lenart, Milena Zlatar, Christian Draxler, Margarete & Sepp Loibner, Thomas Meczner-Barthos, Kurt Kaindl, Petra Lüer, Brigitte Blüml sowie Wolfgang Lorenz.

REGINA STRASSEGGER – WIEN, JUNI 2002

PREFACE

Life's surprises: June 1999, a big banner advertizes the opening of the Inge Morath exhibition at the fair center and museum quarter in Vienna, to be attended by the famous photographer herself. What a stroke of good luck! As film maker for Austrian television, Austria's heated political life has churned me up—a little distance and pastures new can do no harm.

Not long afterwards, Inge Morath and I are standing face to face. The unaffected woman of the world shows interest when asked if making a television film with her about southern Styria might be a possibility. And then the words: "That stretch of borderland has always been a secret longing of mine. Let's do something!" Our conversation scarcely lasts fifteen minutes. We exchange telephone numbers, both of us enthusiastic at the idea—after decades of separation, Inge Morath is to embark on a photographic voyage of rediscovery to the Styrian-Slovenian border, the land of her ancestors and childhood summers, a region where neighborly ties are growing again.

In subsequent months the idea takes shape for "Graz '03," a project to be held in the European Cultural Capital for 2003 and Inge Morath's birthplace. The film, book, and exhibition are to reflect locations, moods, encounters on this time-journey following the seasons; moments of hilarity and nostalgia, rural and urban life on both sides of the border. The photographic-filmic journey began in February 2001, continuing in June; on September 11 the chapter "Border Situation" acquired a new dimension; and in October 2001 this unusual time-journey came to a premature close: Inge Morath—so full of energy, untiring, spontaneous, and charming—becomes seriously ill. Just how critical her situation was, none of us knew. Whether Inge Morath herself knew I never found out.

Inge Morath's eightieth birthday celebration will now have to take place in May 2003 in memoriam. She will be especially close to us when her photographs are exhibited in Graz, Slovenj Gradec, New York, Budapest, Ljubljana, Munich, accompanied by the book and the film—when her flux of images, her love of life and of this region flow past us.

My thanks go to Arthur Miller, Renate and Imo Moszkowicz, Werner Mörath, Karel Pečko, Drago Jančar, Gerhard Roth, Gerald Brettschuh; also to Viktor Laszlo, Eva Gressel, Stojan Kerbler, Branko Lenart, Milena Zlatar, Christian Draxler, Margarete & Sepp Loibner, Thomas Meczner-Barthos, Kurt Kaindl, Petra Lüer, Brigitte Blüml, and Wolfgang Lorenz.

REGINA STRASSEGGER—VIENNA, JUNE 2002

LETZTER TANZ LAST DANCE

Im Schloß Gradišče ist alles bereit – die Schloßfrau in Mantelschürze erwartet
ihre steirischen Gäste von beiden Seiten der österreichisch-slowenischen Grenze.
Alle sind sie gekommen, um an diesem Herbsttag 2001 ihren Ehrengast zu feiern:
Inge Morath. Niemand ahnt, daß die weltberühmte Photographin todkrank ist.

Everything is ready at Château Gradišče—the pinafored chatelaine awaits
her Styrian guests from both sides of the Austro-Slovenian border. All are
here on this day in fall 2001 to celebrate their guest of honor: Inge Morath.
No one suspects that the world-renowned photographer is critically ill.

Schloßfrau erwartet Festgäste.
Chatelaine awaiting party guests.

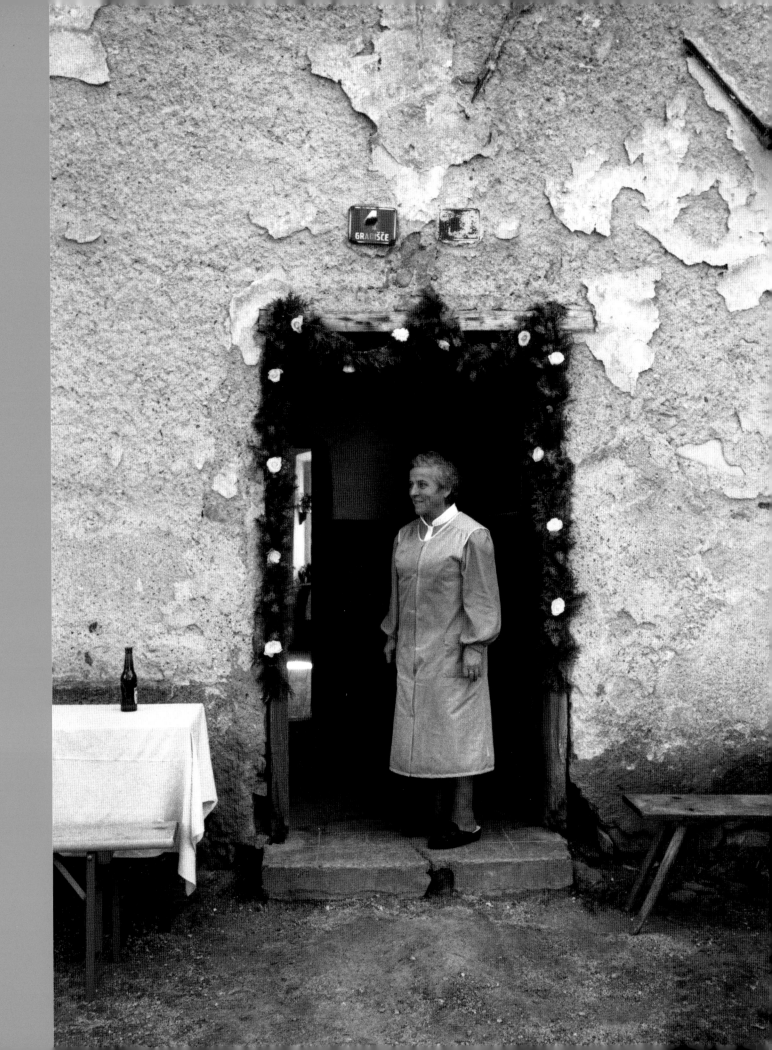

Auftakt. Prelude.

Kreistanz. Round dance.

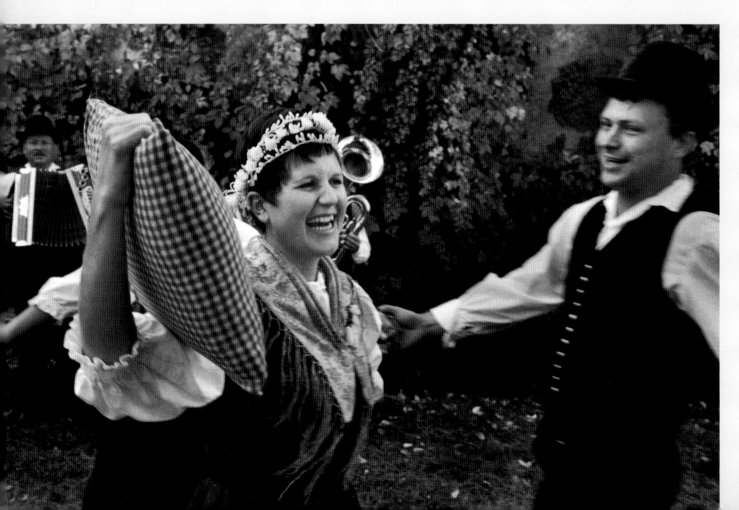

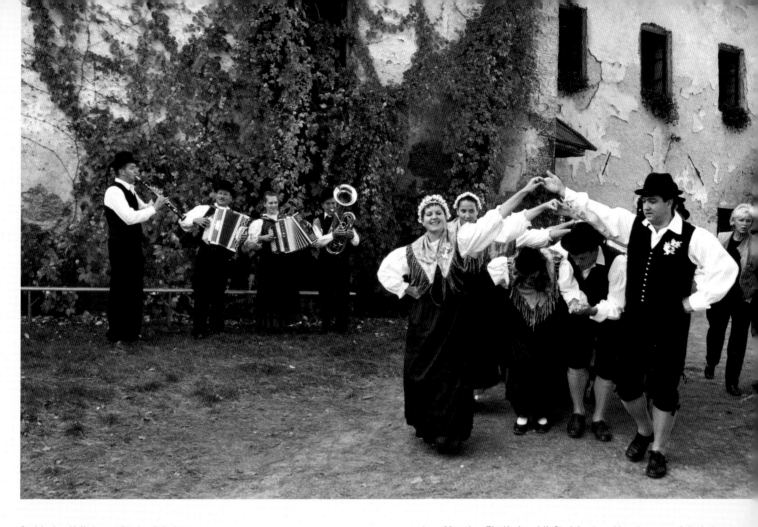

Steirischer Volkstanz. Styrian folk dance.

Inge Morath – Ein Kreis schließt sich. Inge Morath—come full circle.

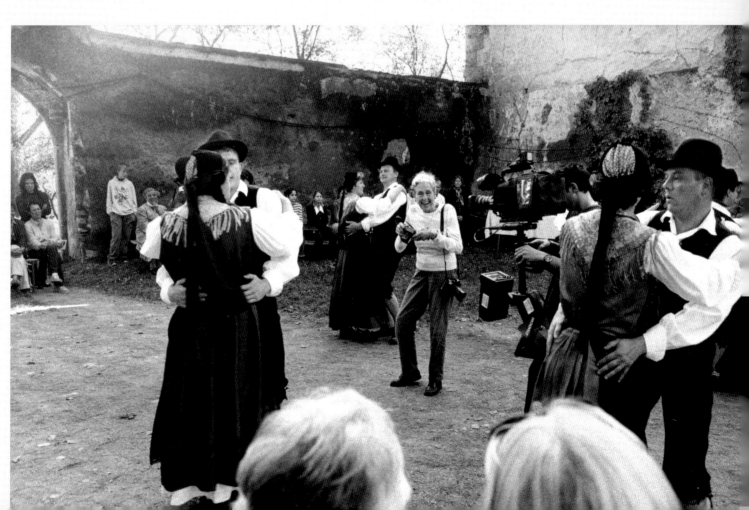

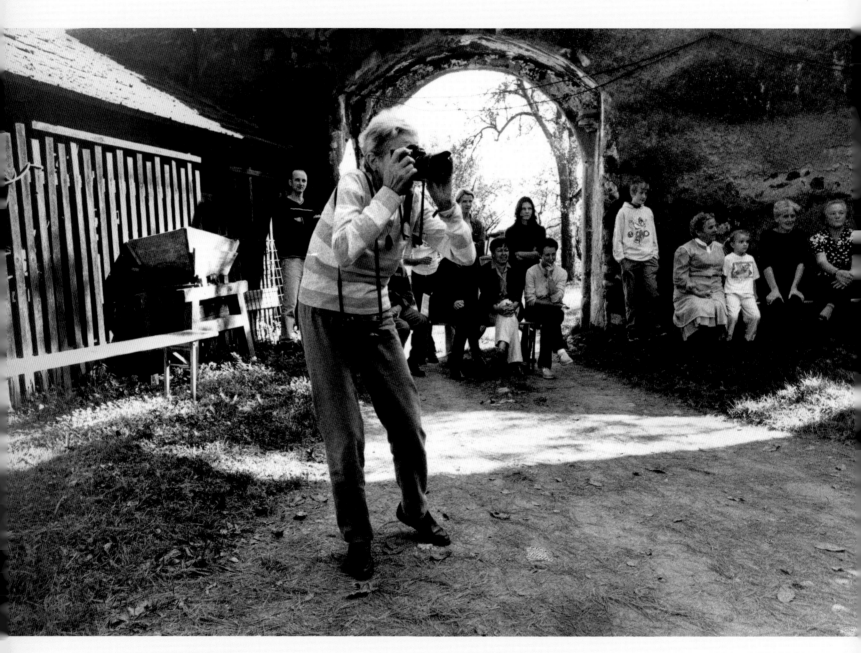

Inge Morath schießt eines ihrer letzten Bilder.

Inge Morath taking one of her last pictures.

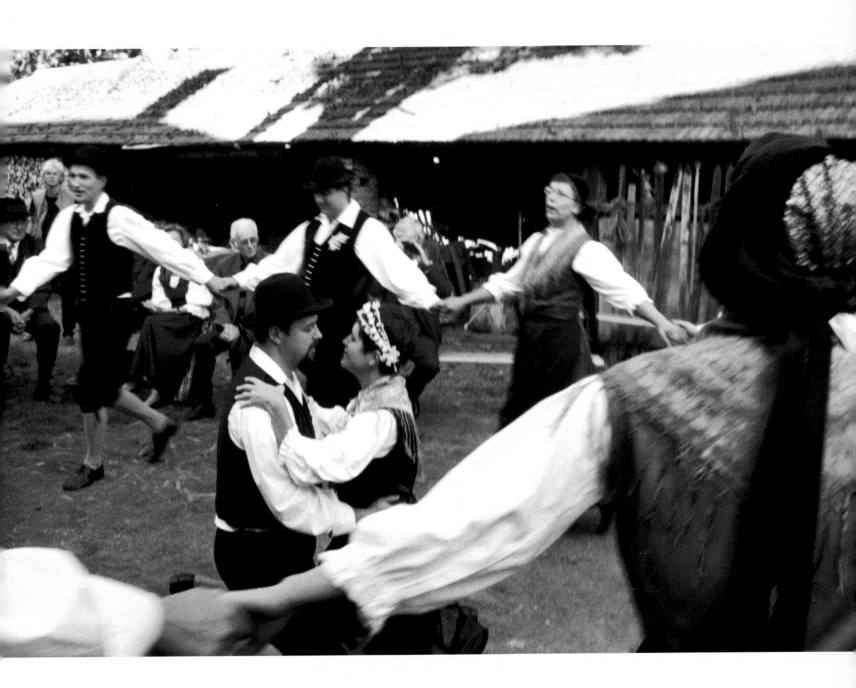

INGE MORATH UND GRENZEN

VON ARTHUR MILLER

Die Faszination durch die Grenze war für Inge Morath, die in Graz geboren wurde, der im Süden Österreich gelegenen, nach Südosten weisenden Grenzstadt, etwas ganz Natürliches. Die Familie ihrer Mutter besaß in der Untersteiermark, die heute zu Slowenien gehört, Häuser und Grundstücke. Als von der deutschen Kultur geprägtes Kind verlief, so könnte man sagen, eine Art Grenze durch Inges Mutter Mathilda, die für die an der Grenze zu Österreich lebenden Slawen besonderes Verständnis hatte.

Für Inge war der Begriff der Grenze zwischen Kulturen und Rassen im Hinblick auf die Völkerverständigung sehr wesentlich. Großgeworden in der Zeit des Nationalsozialismus unter dem Eindruck einer extremen, ja manisch nationalistischen Weltanschauung, widersetzte sie sich der verbreiteten Tendenz, Individuen nach ihrer Herkunft zu charakterisieren und nicht als menschliche Wesen. Dabei war sie keineswegs blind für die Tatsache, daß der Einzelne durch die Kultur geprägt wird. Darüber hinaus kam sie im Zuge ihrer Reisen, ihres Studiums und ihrer Fremdsprachenkenntnisse gar nicht umhin, bei ihrer Beschäftigung mit unterschiedlichen Menschen auch deren Kultur und Geschichte wahrzunehmen. Ihre historische Betrachtungsweise ließ sie ebenso tiefen Respekt vor Unterschieden wie vor Individuen und ihren Kulturen empfinden.

Natürlich vermochte auch Inge sich der Einsicht nicht zu verschließen, dass der jeweilige Nationalcharakter kulturell sowohl positive als auch rückschrittliche Züge aufweist. Nach dem Ende des Zweiten Weltkriegs konnte sie es gar nicht abwarten, Deutschland und Österreich zu verlassen und eine Möglichkeit zu finden, in Frankreich zu leben, das ihr zur zweiten Heimat wurde. Überhaupt war ihr die französische Kultur die liebste, doch noch während ich dies sage, erinnere ich mich, dass sie auch einen gewissen spirituellen Zug der russischen Mentalität bewunderte, die familiäre Wärme des Italienischen, die ehrwürdige Selbstsicherheit der Chinesen, die Dichtung, Literatur und Malerei der Deutschen, die spanische Strenge und die große literarische Bandbreite der Engländer. Kurzum, sie war tatsächlich eine Weltbürgerin, die mit vielen Aspekten der Weltkultur vertrauter war als irgendwer sonst, der mir je begegnet ist.

Die Idee der Grenze entbehrt daher nicht einer gewissen Ironie. Vor einigen Jahren verbrachten wir einige Zeit mit Imo und Renate Moszkowicz in ihrem Haus am gebirgigen Rand der Steiermark – Slowenien nur wenige Meter vor der Haustür. Wir gingen die stille Straße entlang, die slowenischen Häuser zur Rechten, die österreichischen zur Linken – beide von ähnlicher Gestalt –, doch während jene von einer gewissen Armut zeugten, waren die anderen schön hergerichtet, gestrichen und damit Ausdruck des Wohlstands. Tatsächlich wanderte die Grenze an manchen Stellen über die Straße, so daß man mitunter nach Slowenien hinüberwechselte und dann wieder zurück nach Österreich,

obwohl man einfach nur geradeaus marschierte: Der Grenzverlauf war von irgendwelchen weit entfernten Bürokraten festgelegt worden, die keinen blassen Schimmer von der Situation vor Ort hatten. Die Absurdität des Ganzen erinnerte an das Pflügen des Meeres oder das Durchschneiden des Windes. Hier sah man, wie eine unterschiedliche politische Geschichte gletschergleich völlig verschiedene Sedimente und Steine zurückgelassen hatte. Unübersehbar war die Tatsache, daß die Geschichte zählt und daß sie viel länger dauert als die Vergangenheit, denn hier ist die Vergangenheit Gegenwart.

Inge liebte diese Gegend, die sie bewegend fand und die sie in ihre Arme nahm. Sie sprach von dem großen Haus, das die Mutter ihrer Mutter verloren hatte, von einem ihrer Vorfahren, der Bürgermeister einer nahe gelegenen Stadt gewesen war, doch niemals zeigte sie bei alledem auch nur die geringste Rührseligkeit. Sie schien die Urteile der Geschichte zu akzeptieren und wollte einfach nur weitermachen. Dieser Charakterzug war übrigens einer der Gründe, warum sie Amerika zu lieben gelernt hatte, dessen Bewohner ständig die Zukunft entwerfen und wenig Geduld mit der Vergangenheit haben. Sie konnte die amerikanische Neigung beklagen, sich der Vergangenheit wie etwas Verbrauchtem, einer alten Maschine zu entledigen, aber die Freiheit, selbst über ihr Leben zu bestimmen, war ihr, die dem eisernen Zugriff des Faschismus entronnen war, teurer als alles andere.

In der Idee der Grenze schien sie die Komplexität ihrer eigenen Existenz gefunden zu haben. Die Grenze ist das Ende von etwas, aber auch der Beginn, der Ausweg und der Eingang, der Wunsch zu vergessen und das Bedürfnis nach Erinnerung. Inge war zwischen diesen widerstreitenden Kräften hin- und hergerissen. Sie konnte sich abgestoßen fühlen von dem rückgratlosen Gehorsam, wie er der militaristischen Seite der deutschen Kultur innewohnt, und im nächsten Moment Deutschlands Kunst und Poesie in Schutz nehmen. Was sie aber unabhängig von allen nationalen Gesichtspunkten immer verteidigte, waren menschliche Würde und Freiheit. Als Photographin arbeitete sie viel mit Juden zusammen und hatte zahlreiche Freunde unter ihnen, ja sie heiratete sogar einen solchen, übersah dabei aber nicht, was sie an der arabischen und moslemischen Kultur fasziniert hatte. Entsprechend weigerte sie sich, diese Menschen zu dämonisieren. Inge war eine Frau ohne Dämonen.

Kurzum, Inge Morath lebte ihr Innenleben auf einer Grenze, der Trennlinie nicht zwischen Dunkelheit und Licht, sondern jener, die quer über einem ungewissen Pfad durch wechselnde Grauschattierungen verläuft. Es war eher ein geistiges als ein physisches Territorium, und seine Feinheit, seine Anklänge an das Ewige lassen sich in vielen ihrer Photographien erkennen, deren Sujets häufig im Raum zu schweben scheinen, unbewegt, wartend...

ÜBERSETZUNG AUS DEM ENGLISCHEN: NIKOLAUS G. SCHNEIDER

INGE MORATH AND BORDERS

BY ARTHUR MILLER

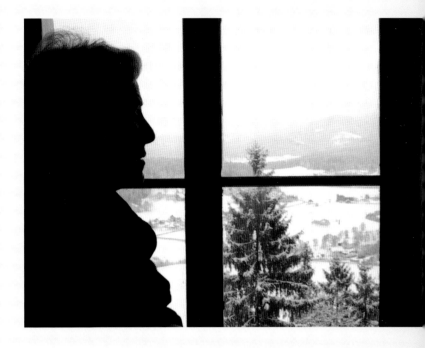

A fascination with the border came naturally to Inge Morath who was born in Graz, the frontier city of southern Austria facing the Southeast. Her mother's family had homes and property in Lower Styria, what is Slovenia today. A child of Germanic culture it might be said that a kind of border ran through Mathilda, Inge's mother, who had a particular understanding of the Slavic people who bordered Austria.

For Inge the concept of the border between cultures and races was essential to the understanding of peoples. Raised under Nazism with its manic super nationalistic credo, resistence to the current tendency to characterize individuals according to their origins rather than as human persons was something to be resisted. It was not that she was blind to the impress of culture on individuals, however, quite the opposite—through travel and study and her mastery of languages she could not help but take culture and history into account in all her approaches to different people. What her historical perspective gave her was a profound respect for differences and for individuals and their cultures.

Inge of course could not help but understand that there are indeed good and retrograde cultural traits imbedded in national characteristics. With the end of World War II she could not wait to escape Germany and Austria and to find a way to live in France, which became her second birthplace. French culture, I think, was her favorite of all, but saying this I am instantly reminded of how she adored a certain spiritual stretch in the Russian mentality, the familial warmth of the Italian, the venerable self-security of the Chinese, the poetry and literature and painting of the Germans, the Spanish austerity and the breadth of the English literary embrace. In short, she was in actuality a citizen of the world, with a closer affinity to more aspects of world culture than anyone I have ever encountered.

The idea of the border, therefore, had an ironical side. A few years ago we spent some time together with Imo and Renate Moszkowicz in their house on the hilly edge of Styria, with Slovenia a few yards from their front door. We walked along the silent road with Slovenian houses on our left and Austrian on our right; both were of similar design, the one showing signs of relative poverty and the other nicely kept and painted and clearly prosperous. The border actually wandered across the road in places so that one sometimes crossed over it into Slovenia and back into Austria while walking straight ahead, for it had been drawn by far away bureaucrats who hadn´t the slightest idea of the situation on the ground. The absurdity of it all was like plowing the sea or slicing the wind. Here one saw how two different political histories, like glaciers, had left behind very different deposits, different stones; here one could not avoid the fact that history counted and that it endured far longer than the past, for here the past is now.

Inge loved this territory which moved and embraced her; she spoke of the great house her mother´s mother had lost, of her ancestor-mayor of a nearby city, but she never showed the least sentimentality of these things. She seemed to accept history´s verdicts and only wanted to move on. This trait, incidentally, was one of the reasons she had come to love America whose people were constantly constructing a future and had little patience with the past; she could lament the American tendency to dispose of the past as something used up, like an old machine, but the freedom to choose one´s life was for her more precious than anything else, coming as she had from the iron controls of Fascism.

In the idea of the border she seemed to have found the complexity of her own existence. The border is the end of something and also the beginning, the escape and the entry, the desire to forget and the need to remember. Inge was torn by these contradictory forces. She could bridle at the spineless obedience inherent in the militaristic side of Germany´s culture, and a moment later defend Germany's art and poetry; in the end what she could not help rising to defend was human dignity and freedom, regardless of national context. As a photographer she worked alongside and had many close friends who were Jews, and indeed married one, but she could not forget what had moved her in Arab and Muslim culture and refused to demonize those people. Inge was a woman without demons.

In short, she lived her interior life on a border, that dividing line not between darkness and light but astride an uncertain path through shifting shades of grey. It was a spiritual territory more than a physical one, and its delicacy, its touches of the eternal can be glimpsed in many of her photographs whose subjects often seemed suspended inspace, motionless, waiting....

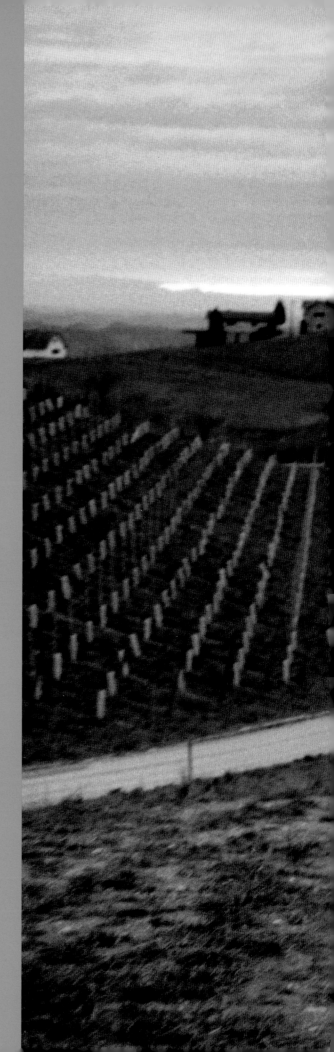

SEHNSUCHT GRENZRAUM
LONGINGS, BORDER SPACE

»Dieser Landstrich an der Grenze ist eine heimliche
Sehnsucht von mir… Wenn mich jemand fragt
"Wo bist Du her, wo fühlst Du Dich eigentlich zu
Hause?", dann ist das – abgesehen von dort, wo ich
jetzt in Amerika schon so lange wohne – hier in den
Weingärten, dem Paradies meiner Kindheit. Aber auch
die Gegend über der Grenze, von der mir meine Mutter,
die Titti, so viel erzählt hat, die gehört dazu. Seltsam,
daß ich das jetzt alles wiederentdecke.«

INGE MORATH

"I secretly long for that stretch of land along the order…
When someone asks me "Where are you from? Where
do you feel at home?", then—apart from where I've
lived so long in America—here in these vineyards, my
childhood paradise. But the land across the border, about
which my mother Titti told me so much, is also a part
of it. Strange that I'm rediscovering these things now."

INGE MORATH

Weinstraße bei Eckberg.
Wine route near Eckberg.

Folgende Doppelseite: Zaun an der Grenze und Marterl.
Overleaf: Fence at the border and wayside chapel.

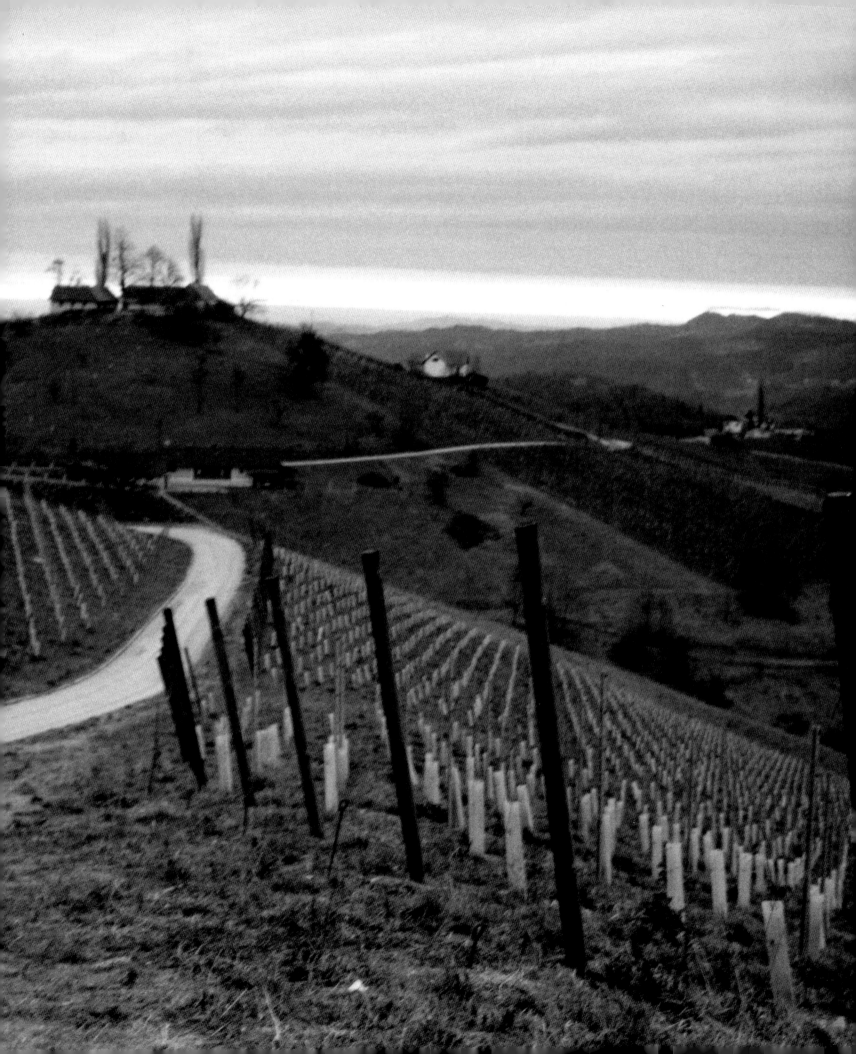

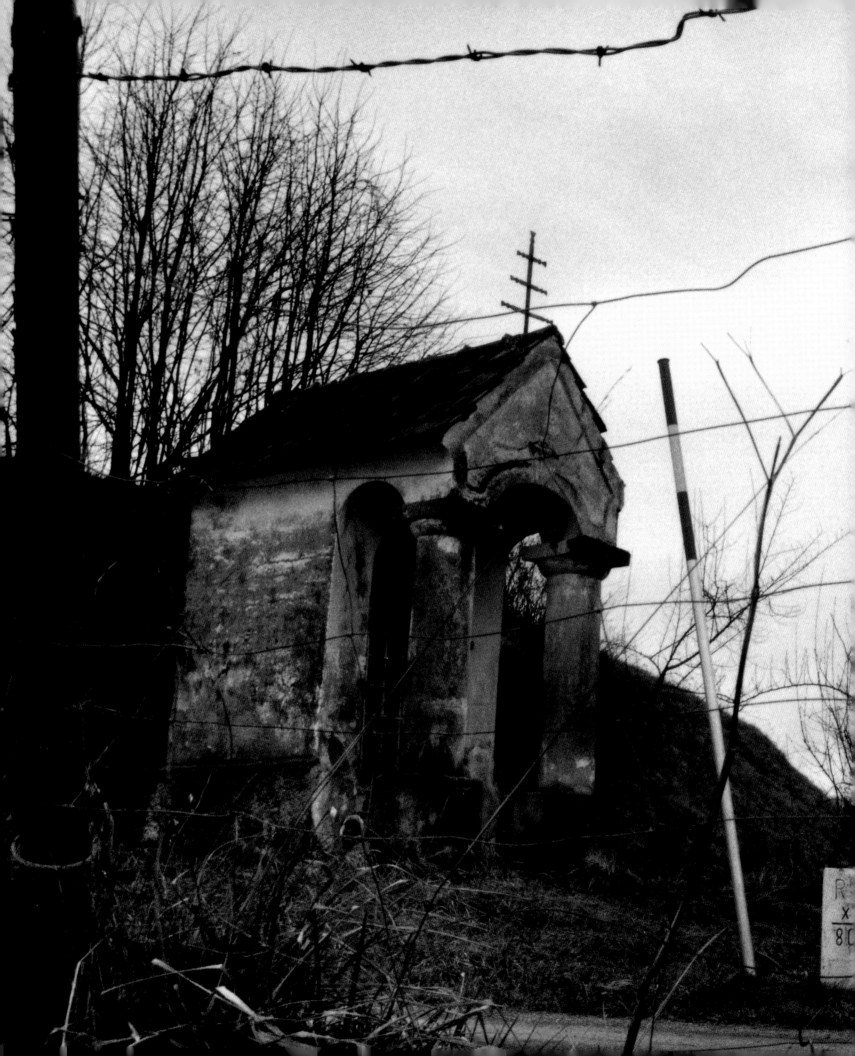

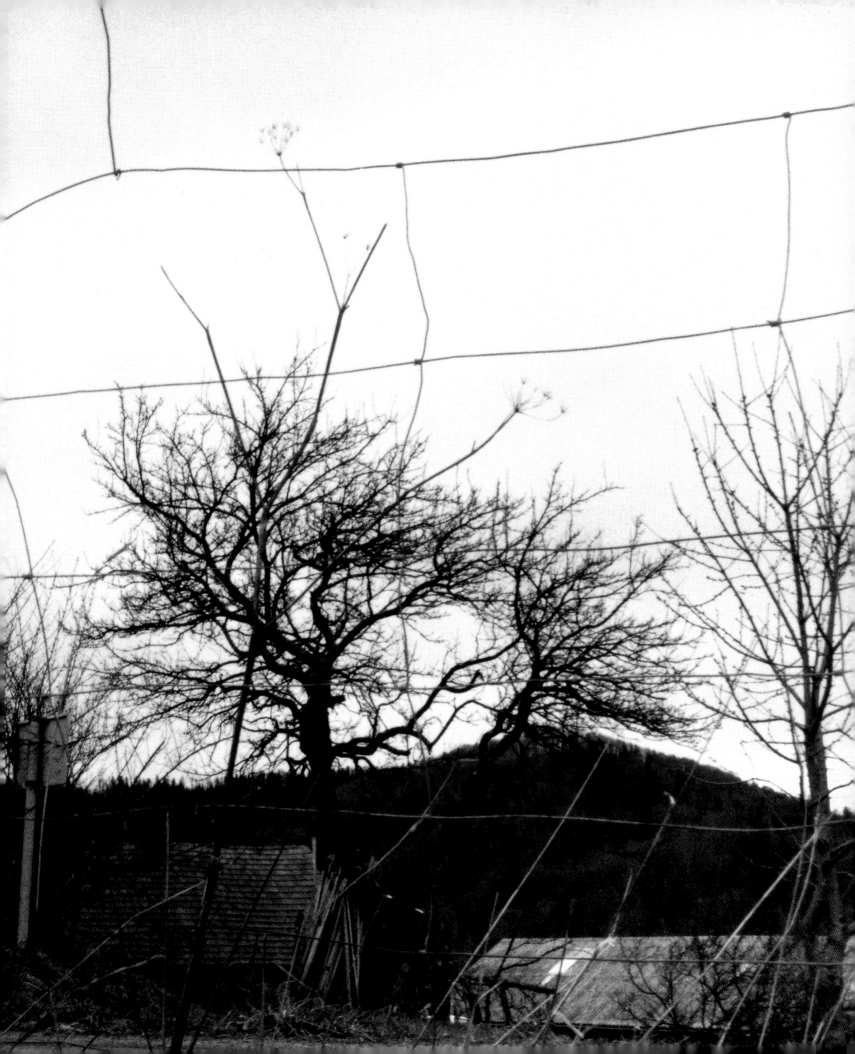

Heiligenstatue und slowenische Aushilfsarbeiter
an der Weinstraße bei Gamlitz.

Statue of a saint, and Slovenian workers on the
wine route near Gamlitz.

Folgende Doppelseite: Haus an der Grenze mit Garten.

Overleaf: House and garden at the border.

Doppelseite 24–25: Landschaft mit Klapotez.

Pages 24–25: Landscape with "klapotez".

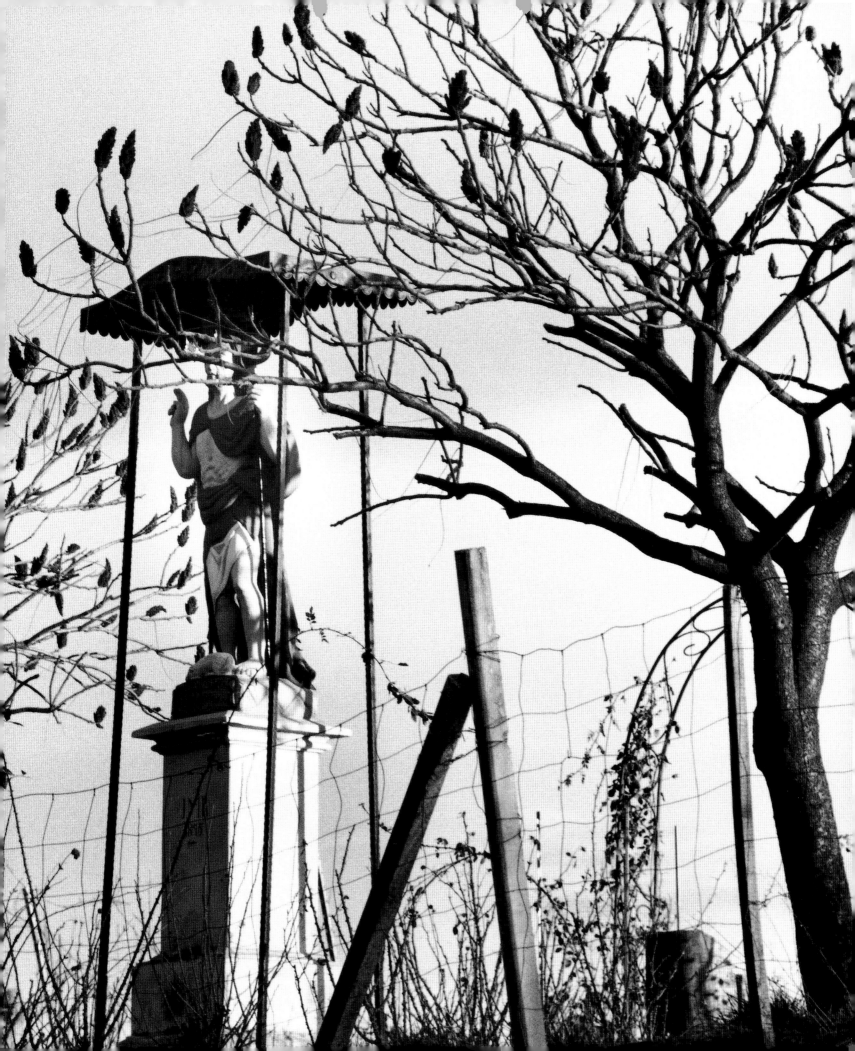

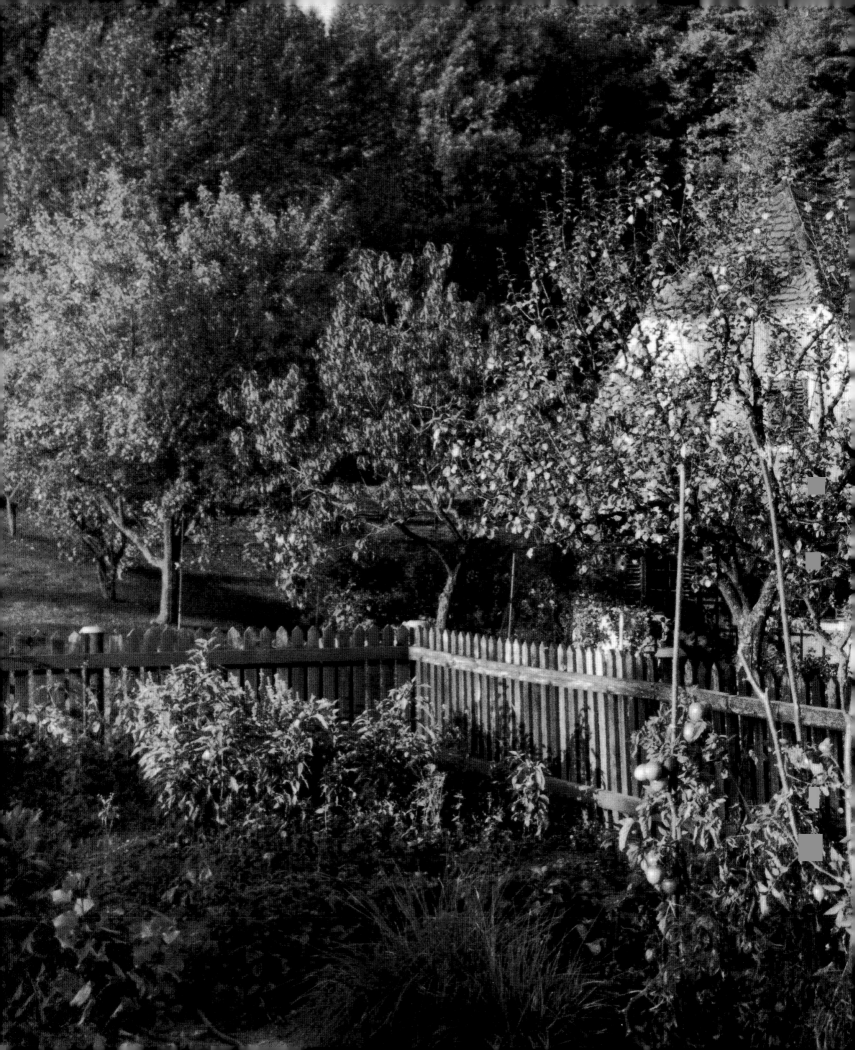

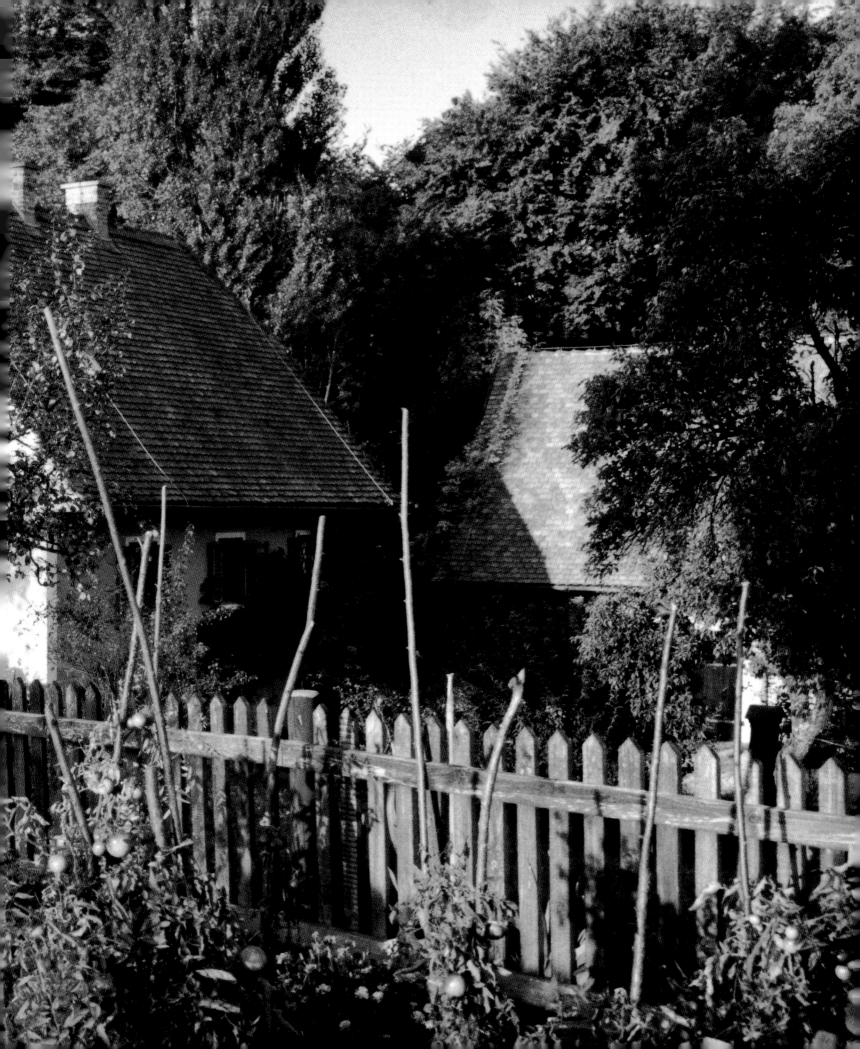

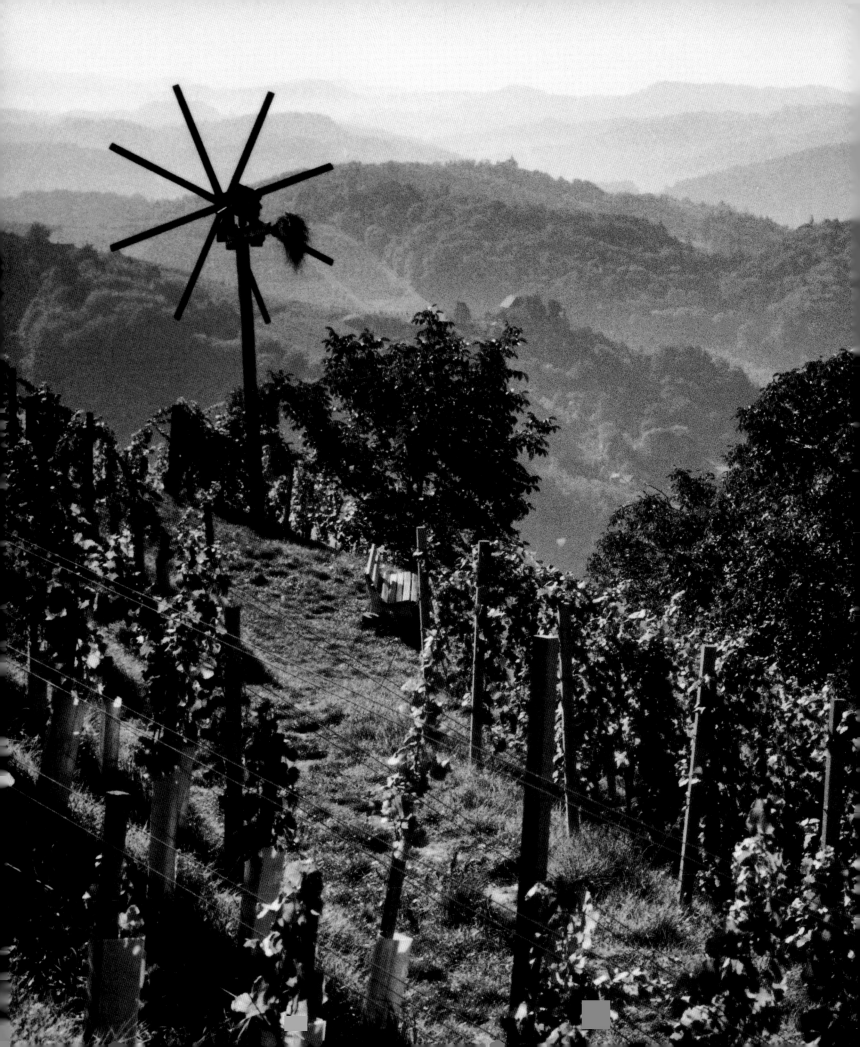

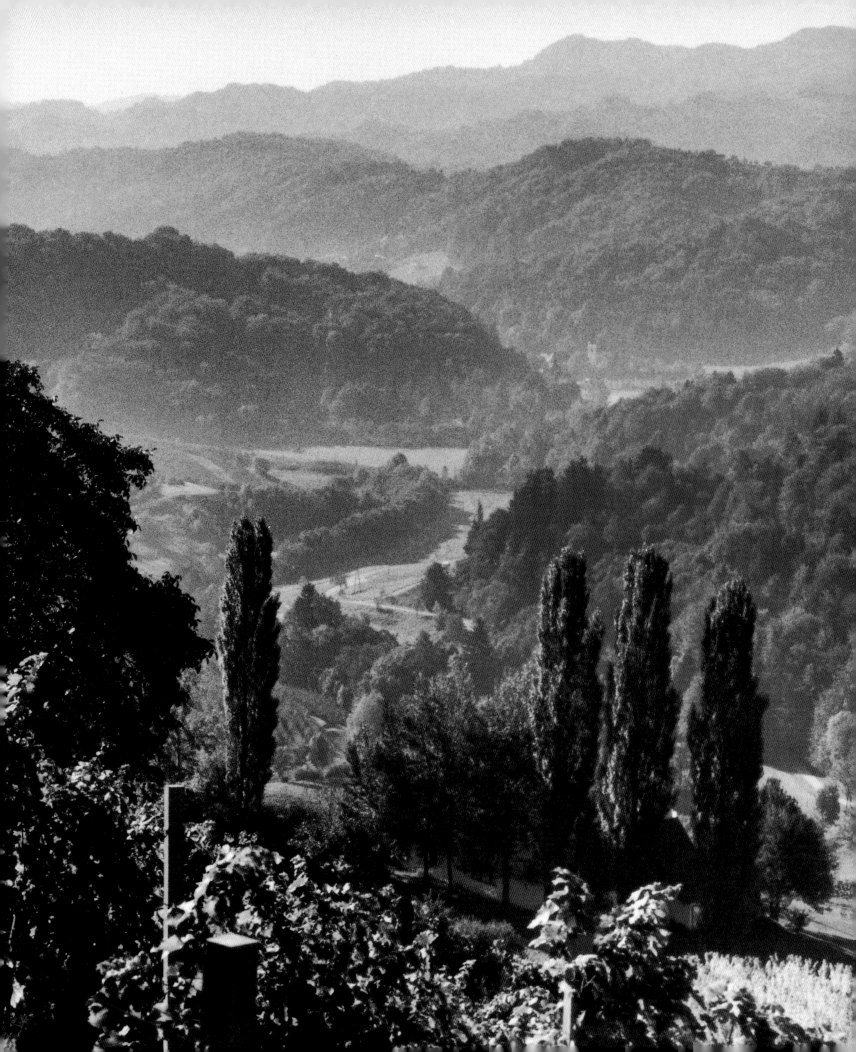

SEHNSUCHT GRENZRAUM

Die Helium-Flamme wallt auf, der Korb mit dem Ballon hebt mit leichtem
Ruck ab. Steigt, steigt – *Leichtigkeit des Seins* über schneebedeckten
Baumwipfeln, waldgesäumten Winterwiesen, Gehöften, Weinbergen.
Inge Morath schaut still vor sich hin.

Der Satz »Dieser Landstrich an der Grenze ist eine heimliche Sehnsucht
von mir – machen wir was«, den sie im Sommer 1999 bei unserer ersten
Begegnung in Wien gesagt hatte, erfüllt sich. Eine photo-filmische Spuren-
suche im Grenzraum, dem Zyklus der Jahres-, Lebenszeiten folgend:
hin und her zwischen einst und jetzt, hüben und drüben, ländlich und
städtisch, alltäglich und speziell. Zu diesem Zeitpunkt ahnt niemand,
daß sich mit dem Erfüllen dieser Sehnsucht für Inge Morath ein Kreis
schließen wird. Die weltgereiste Photographin ist auf einer Zeitreise
dorthin, woher ihre Vorfahren gekommen sind, wo sie aus Kindertagen
an Klapotez, Kürbis, Traubenmünder, Wintermärchen denkt, wo sie in
einem Haus an der Grenze, im Weingarten, Freundschaft für's Leben
geschlossen hat.

Optische Harmonie in Blaßblau-Weiß – Himmel und Erde, Raum und
Zeit, Schweben und Sehnsucht. – Inge Morath visiert mit ihrer Kamera
verästelte Täler, verwunschene Waldkogel, sanfte Hügelwellen an. Von
diesem Grenzland, von dem Dichter sagen, es habe sich zu einem Mikro-
kosmos abgeschlossen und versuche, auf eigene Faust Welt zu sein, von
diesem sagt Inge Morath: »Wenn ich da als Kind mit meinem Großvater
tagelang über die Weinberge und Hügel gewandert bin, wir Muscheln
aus Zeiten gefunden haben, in denen vor tausenden Jahren hier noch
Meer gewesen ist, hab ich mich gefühlt wie in einem Unterseeboot auf
Weltreise.«

Sehnsüchte – wohl eng verwandt mit der Kreativität – waren in der überaus
kunstverliebten Familie Inge Moraths immer präsent. Da war eben dieses

Ballonschatten über Baumwipfel.
Shadow of balloon over treetops.

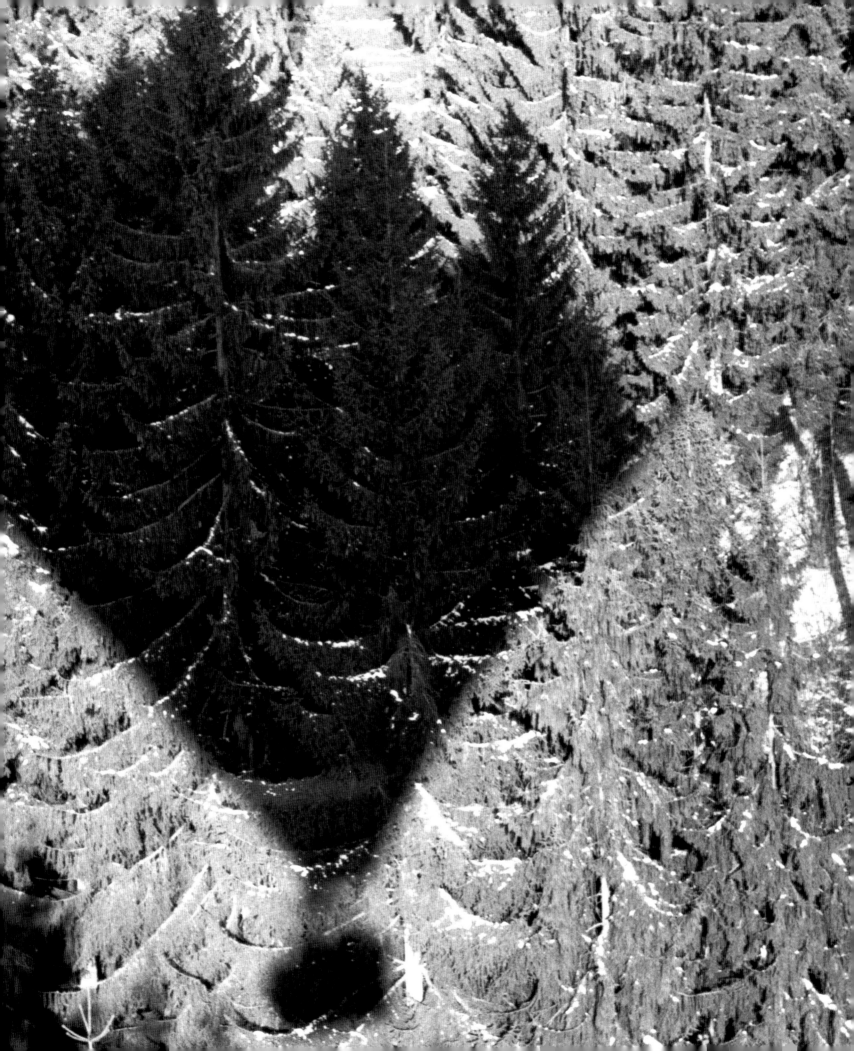

von Eltern und Großeltern verklärte Land jenseits der Grenze, das sie wehmütig »unsere Untersteiermark« nannten. Unzählige »schöne Geschichten« wurden erzählt: von Windischgraz, Hugo Wolf, Marburg, Gesangsabenden, von ihrer Welt, in der sie bis 1918 wunderbar gelebt hatten. Dann Verlust, Wegmüssen, Weitermachen anderswo, an vielen Orten: ein Muster, das in der Familie abgewandelt wiederkehren sollte. Von der ›anderen Seite‹, der slowenischen, von deren Leben, Sprache, Namen wie Štajerska, Slovenj Gradec, Maribor wurde nicht viel geredet, sonst hätte das *Territorium der Träume* ein anderes Antlitz bekommen. Die 1919 entstandene Grenze blieb – wie für viele Deutschsprachige – auch für die Familie Wiesler-Mörath eine Schmerzenslinie. Eine, die im kleinen wie im großen nachhaltige Energien freigesetzt hat – bis hin zu Krieg, Tod, Stacheldraht, Umbruch, und erst viel später – fast schon im neuen Jahrtausend – wieder Öffnung, Aufbruch.

Diese Aspekte der Zeitreise sind Inge Morath weniger vertraut. Sie sagt: »Das Politisch-Historische ist nicht meins, da bin ich eher Zuhörende.« In einem Brief an ihre Freunde Renate und Imo Moszkowicz schreibt sie später: »Wenn das Politische zu viel wird, sag ich NEIN, aber ich machs, weil ich vieles herausfinde, das ich nicht wußte, und weil es mir Gelegenheit gibt, in dieser für mich heimatlichen Gegend viel Zeit zu verbringen. Allein der Gedanke an Euch und den Weingarten ist zu verführerisch!«

Der Wind trägt den Ballon Richtung Südwesten. Auf langgezogenen Hügelketten ragen ab und zu spitze Türme hervor – sie könnten zu den entlang der Grenze gelegenen Kirchen von Sankt Pongratzen, Sveti Primož oder zu anderen gehören… Zum Photographieren sind sie zu weit weg. Mit jedem Höhenmeter weitet sich der Horizont, läßt schemenhaft im Norden, Westen, Süden verschneite Gebirgszüge erahnen – Koralm, Steiner Alpen – drüben Kamniške Alpe genannt –, Pohorje, Tittis geliebter Bachern. – Die sonst so agile, sprühende Morath ist wie entrückt, photographiert nur ab und zu, schaut, schaut… Vielleicht gibt sich die dem Buddhismus Nahefühlende metaphysischen Augen-, Überblicken hin. Rätselt über Jenseitiges vom Horizont, über die Trennlinie von Sichtbar und Unsichtbar, über Vertrautes und Fremdes, über die Grenze der Welt? Das bleiben Sphären des Unausgesprochenen, des Privaten. Einmal sagt sie: »Wenn es in meinem Leben Grenzgänge gegeben hat, die über die der Grenzbalken hinausgegangen sind, dann waren sie kultureller Art. Es war die Sehnsucht, vielen Kulturen, vielen Sprachen nahe zu sein. Und das war dann auch so.« Und wie! Die 1923 in Graz geborene, in der Steiermark und in Nazi-Deutschland aufgewachsene, in Paris, New York und in der Welt beheimatete Morath sehnt sich nach illustrem Weltbürgertum, versucht deutschösterreichische, slawische, jüdische, angelsächsische Verinnerlichung. Eine Gratwanderung mit Bravour! Und der Tribut? Unermüdlichkeit, Zerrissenheit, heimliche Sehnsucht nach Heimkehr?

Irgendwann eröffnet sich ein unglaublicher Anblick: Auf den schneebedeckten Fichten gleitet der Schatten des Ballons, die Wipfel beschneiden bizarr die obere Hälfte – so, als ob sie unsichtbar in einer anderen Welt wäre…

<div align="right">REGINA STRASSEGGER</div>

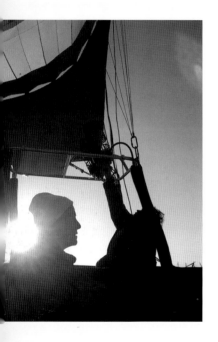

LONGINGS, BORDER SPACE

The gas-flame flares. Balloon and basket lift off with a slight jolt, then climb, climb. *The Lightness of Being* over snow-capped treetops, winter meadows edged with woods, farmsteads, vineyards. Inge Morath gazes silently ahead.

Words that she spoke when we first met in Vienna in summer 1999 have come true. "I secretly long for that stretch of land along the border: let's do something." A photographic journey, in search of past and present in this border area. The cycle of the seasons, and life's seasons. Then and now, there and here, rural

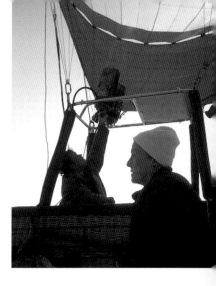

and urban, the everyday and the special. No one as yet suspects that, in fulfilling this dream, Inge Morath herself will come full circle. The world-traveled photographer is on a time-journey to the land of her forefathers, to the "klapotez," pumpkins, grapestuffed mouths and winter fairy tales of childhood, and to a house and vineyard on the border, where she swore friendship for life.

Visual harmonies of pale-blue and white. Sky and earth, space and time, soaring, longing. Inge Morath trains her camera on branching valleys, gently rolling hills, enchanted wood-topped mountains. Speaking of this border area, which poets say has cut loose, become a microcosm striving to be a world in its own right, Inge Morath says: "When my grandfather and I roamed these hills and vineyards all day long in my childhood, and we found shells from thousands of years ago when it was all still under water, I felt as if I were traveling in a submarine."

Longing—so closely related to creativity—was ever present in Inge Morath's art-loving family. Across the border lay the land idealized by parents and grandparents and referred to wistfully as "our Lower Styria." Numberlesss "delightful stories" were told: Windischgraz, Hugo Wolf, Maribor, singing evenings; the wonderful world they had inhabited until 1918. Then loss, expulsion, starting over elsewhere, in lots of places. The pattern would recur in the family, modified. The other—the Slovenian—side—their life, their language, and names like Štajerska, Slovenj Gradec, Maribor—were not talked about much, or else the *territory of dreams* might have acquired a different face. As for many German-speaking people, the border of 1919 was a pain-line for the Wiesler-Mörath family; in matters great and small it was to release formidable energies that led, among other things, to war, barbed wire, revolt—and then, but only much later, almost into the new millennium, to reopening and a new start.

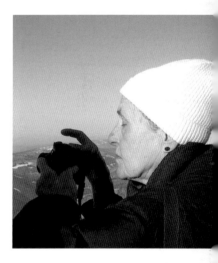

Such aspects of her time-journey are less familiar to Inge Morath. "Politics and history aren't my specialty, I'm better as a listener there." As she writes later in a letter to her friends Renate and Imo Moszkowicz: "When politics gets to be too much, I say NO. Yet I do it because I find out plenty of things I didn't know, and because it allows me to spend time in this area that's native to me. Alone the thought of you both and the vineyard is too bewitching!"

The wind bears the balloon southwest. Spires appear here and there on the extensive hill ranges—too far away to be photographed; perhaps they are the churches in Sankt Pongratzen and Sveti Primož along the border, or maybe others…. The horizon broadens as the balloon climbs; north, west, and south, faint outlines of snow-covered mountain ranges come into view—Koralm, Steiner Alps (known over there as Kamniške Alpe), Pohorje, Titti's beloved Bachern. Morath, usually so nimble and exuberant, seems as if in a trance; photographing only sporadically, she gazes her fill. Is she—she feels an affinity for Buddhism—pondering metaphysical moments and vistas, what's beyond the horizon, the border between the visible and the invisible, the known and the unknown, the limits of the world? Those spheres remain unexpressed, private. Once she says: "If there were any border crossings in my life that went beyond the customs barrier, then they were cultural in nature. I longed to be close to many cultures and many languages. And that's how it was." Indeed. Born in Graz in 1923, brought up in the Austrian part of Styria and in Nazi Germany, and finally at home in Paris, New York, and the world, Morath longed for distinguished cosmopolitanism, and strove to assimilate Austro-German, Slav, Jewish, and Anglo-Saxon elements. A brilliant tightrope walk! And the tribute to be paid? Tirelessness, inner disharmony, a secret longing to return?

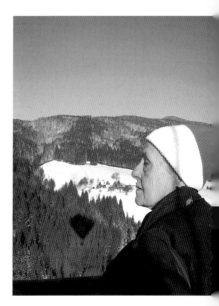

At a certain point an incredible sight presents itself: as the balloon's shadow glides over snow-covered spruce trees, the treetops tear the top half off bizarrely—it is as if it were invisible, in another world…

REGINA STRASSEGGER

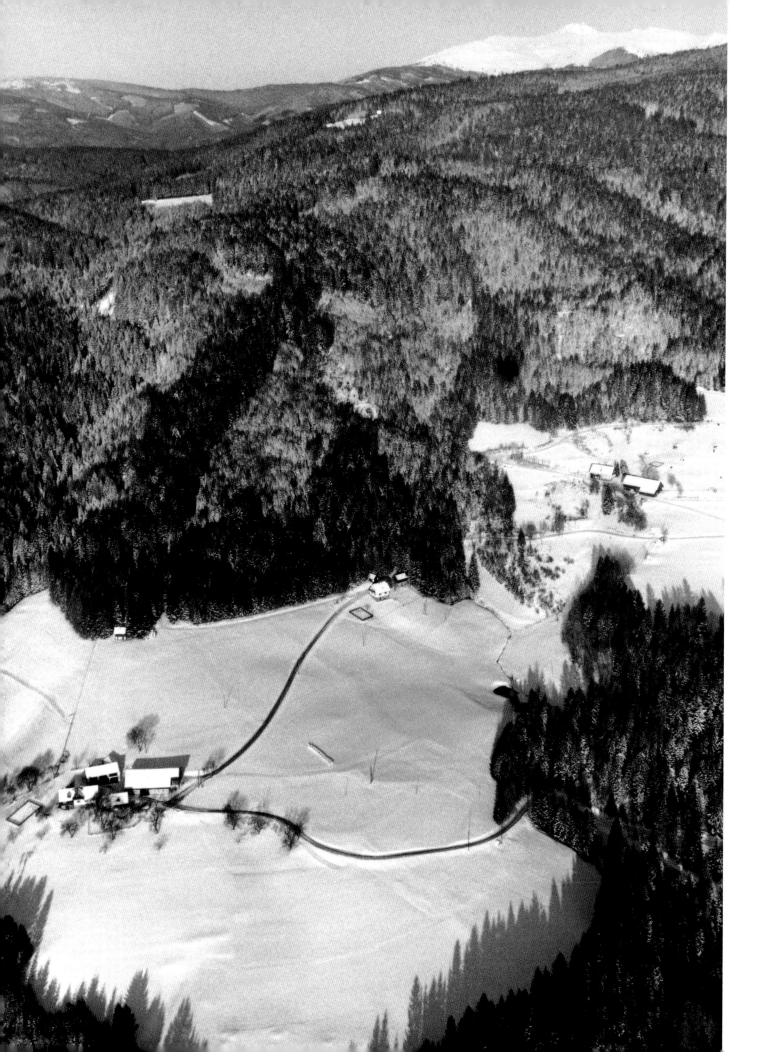

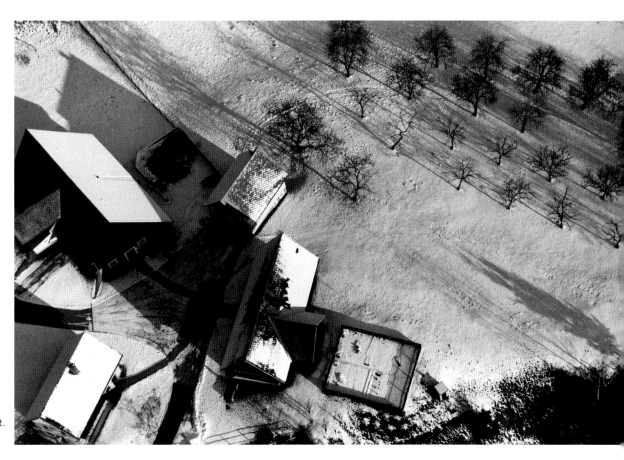

Obstbaumschatten in Schnee- und Dachlandschaft.

Roofs, snow, and the shadows of fruit trees.

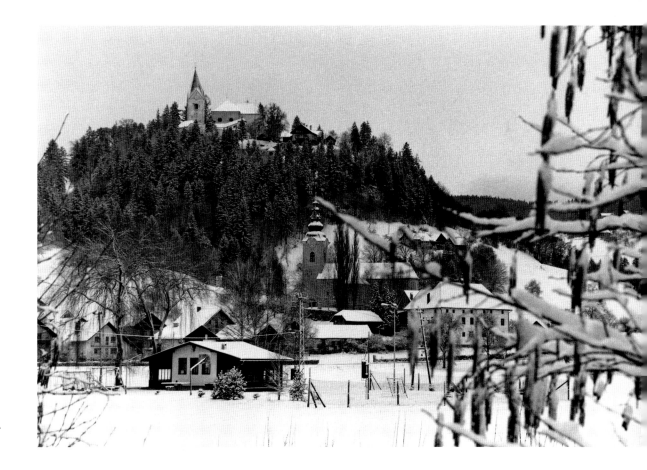

Blick zur mittelalterlichen Kirche auf dem Berg, Slovenj Gradec.

View of the hill-top medieval church, Slovenj Gradec.

Links: Schneelandschaft mit Bauernhäusern.

Left: Snow-covered landscape, farmhouses.

»Blick vom Alten Amtshaus, in dem mein Urgroßvater amtierte, auf den Hauptplatz.«

"View of the main square, from the old Town Hall where my great-grandfather held office."

»Postkarte, die meine Urgroßtante 1913 zum Geburtstag meiner Mutter nach Marburg geschrieben hat.«

"Postcard sent to my mother in Maribor on her birthday by my great-great-aunt, 1913."

»Ingelein, es war wunderbar, mit Dir gemeinsam
in der Heimat unserer Vorfahren Erinnerungen aufleben
zu lassen. Soviel Zeit haben wir seit unserer Trennung
1941 nicht mehr miteinander verbracht. Für mich
hatte das so ferne Windischgraz, das heute Slovenj
Gradec heißt, immer eine besondere Anziehung.
Beim Erzählen unserer Mutter Titti umwehte einen
immer der Zauber der k.u.k. Monarchie. So unrealistisch
das in Wirklichkeit auch gewesen sein mag.«

WERNER MÖRATH, BRIEF AN SCHWESTER INGE

Inge Morath und ihr Bruder Werner Mörath. Beide in ›Steirisch‹.
Inge Morath and her brother Werner Mörath, both in Styrian wear.

"Inge dear. It was wonderful to relive memories
together with you in the land of our family. We've not
spent so much time together since we were separated
in 1941. Windischgraz, so far away, known today as
Slovenj Gradec, always held a particular fascination
for me. When our mother Titti talked about it one
always breathed the magic air of the Habsburg
monarchy. No matter how unrealistic that might in
fact have been."

WERNER MÖRATH, LETTER TO HIS SISTER INGE

Der Maler Karel Pečko im Studio, das er im Dach des Alten Amtshauses ausgebaut hat.
Painter Karel Pečko in his studio in the converted attic of the old Town Hall.

»Mein Urgroßvater, Dr. Hans Tomschegg, Bürgermeister
und Notar der k.u.k.-Verwaltung in Windischgraz, um 1900.«
"My great-grandfather, Dr. Hans Tomschegg, Mayor and Notary
of the Habsburg Administration, Windischgraz, ca. 1900."

»Meine Urgroßmutter, Wihelmine Tomschegg, geborene von Bredow. Die
Familie hatte sieben Kinder. Hier mit einem ihrer Enkel, der 1940 fiel.«
"My great-grandmother, Wilhelmine Tomschegg, née von Bredow. The family
had seven children. Seen here with one of her grandsons, killed in 1940."

»ENTSCHULDIGEN SIE, DAS IST KEIN SPASS! «

Der Gastgeber kredenzt in seinem Atelier unterm Dach des Hauses (in unmittelbarer Nachbarschaft des ehemaligen Rathauses) wunderbaren Wachholderschnaps, trinkt besonders auf Madame, die den weiten Weg von Amerika nach Slovenj Gradec gekommen ist. Auch dem aus Deutschland angereisten Bruder Inge Moraths wird zugeprostet. Karel Pečko gibt in gutem Deutsch Anekdoten zum Besten, streut als rhetorische Floskel immer wieder ein: »Entschuldigen Sie, das ist kein Spaß!« Der Maler ist die graue Eminenz des regen lokalen Kulturlebens, liebt in seiner Malerei die Erotik von Hügellandschaften und der Uršlja gora. Inge Morath nennt den Meister bald »génie local«. Dem Titulierten ist der leicht ironische Unterton nicht entgangen, er blickt kurz über den Brillenrand, dann berichtet er genüßlich über die internationalen Erfolge der Galerie, die er geleitet hatte, über Begegnungen mit Henry Moore und anderen bedeutenden Persönlichkeiten aus der Welt der Kunst... – von wegen Provinz!

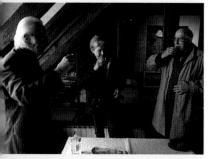

Karel Pečko, Inge Morath,
Werner Mörath.

Werner Mörath, der passionierte Familienforscher, freut sich besonders über die Gelegenheit, mehr über das ehemalige Amtshaus seines Urgroßvaters in Erfahrung zu bringen. Seine Fragen beschließt er mit einem »Kompliment«: »Wie schön, daß Sie das alte Amtshaus unseres Urgroßvaters so gut gepflegt haben. Das ist wirklich eine Freude, daß Ihnen das alte Kulturgut auch am Herzen liegt! « Die Frage galt Karel Pečko, der vierzig Jahre die Galerie geleitet hatte; diese war seit 1954 im ehemaligen Rathaus untergebracht, nachdem die Stadtverwaltung in einen Neubau umgezogen war.

Im alten Gemäuer regen sich unruhige Geister vergangener Tage. Inge Morath zeigt an dieser Art Gespräch wenig Interesse. Sie photographiert beim Fenster hinaus. (Später wird sie zu den Eigentumsfragen bemerken: »Wenn man nur wüßte, wie mir das wurscht ist, was zu besitzen!«) Dennoch: Die drei manövrieren sich gekonnt aus der kurzfristig frostigen Situation.

Karel Pečko, Inge Morath.

Der Gastgeber bittet in den beheizten, winzigen ›blauen Salon‹, läßt Faschingskrapfen kommen. Inge Morath macht Porträts vom Maler, Werner Mörath äußert den Wunsch, vom Meister ein Graphikblatt mit der Uršlja gora zu erstehen. Karel Pečko erzählt: »Wissen Sie, vor einigen Jahren wurde von der Gemeinde die Karel Pečko-Stiftung gegründet und darin wird verfügt, daß nach meinem Ableben zweihundertfünfzig Werke meiner Sammlung in das Eigentum unserer Stadt Slovenj Gradec übergehen. Diese Stiftung vergibt dann auch Begabten-Stipendien. Entschuldigen Sie, das ist kein Spaß.« Anerkennung und Heiterkeit sind jetzt wieder angesagt! Und dann reden die drei tatsächlich noch einmal von den alten Zeiten. »Unsere Eltern erzählten uns so viel vom schönen Leben in der Stadt, von den wunderbaren Wanderungen«, sagt Inge Morath, »von den zahlreichen Kontakten zu Künstlern wie zum Komponisten Hugo Wolf und zum Dichter Ernst Goll. Der soll unseren Tomschegg-Mädchen ja den Kopf verdreht haben.« Das Gespräch wird immer nostalgischer, aber auch nachdenklicher. Werner Mörath, der zwar aus seiner Begeisterung für die alten Zeiten kein Hehl macht, sagt dann durchaus kritisch: »Die Deutschsprachigen haben damals zur slowenischen Bevölkerung Abstand gehalten, und sie waren – wie die Tomscheggs auch – eher machtbewußt. Unsere Mutter hat erzählt, wie der Großvater in seiner Amtsuniform und mit seinem von schwarzen Straußenfedern eingesäumten Dreispitz allen Respekt eingeflößt hat. Ja, das war schon sehr herrschaftlich und hat ja später zu Problemen geführt.« Wie wahr!

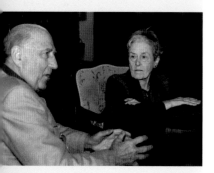

Werner Mörath, Inge Morath.

Inge Morath öffnet die Hirschknöpfe ihrer steirischen Strickjacke, streicht den grünen Seidenschal zurecht, schaut aufmunternd in die Runde, sagt mit ihrem unverwechselbaren Charme: »Auch wenn da vieles nicht so gut gelaufen ist, mir gefällt es trotzdem, daß der Hugo Wolf am Bösendorfer-Flügel unserer Vorfahren gespielt haben soll. Das ist einfach wunderbar. Und daß die Großmutter mit ihrem absoluten Gehör völlig verzückt war, vom melancholischen Wolf, vom zerbrechlichen Goll, vom überschwenglichen Leben.«

Karel Pečko füllt noch einmal die Gläser, sagt »Madame, mein Herr, es ist doch schön, daß wir jetzt in Zeiten leben, wo wir ohne viel Probleme auch nach unseren Wurzeln suchen können. Auf unsere junge Freundschaft!«

AUFGEZEICHNET VON REGINA STRASSEGGER / ÜBERARBEITET VON KAREL PEČKO

"BEGGING YOUR PARDONS—IT'S NO JOKING MATTER!"

Wonderful juniper gin is served in the attic studio (in the immediate vicinity of the former town hall). The host drinks to Madame in particular, who has come all the way from America to Slovenj Gradec. But he raises his glass to Inge Morath's brother as well, who has traveled from Germany. Karel Pečko entertains his guests with anecdotes, told in good German interspersed with rhetorical flourishes: "Begging your pardons—it's no joking matter." The painter is the *éminence grise* in the vivacious cultural life of the locality. The eroticism of hilly landscapes and the Uršlja Gora are themes in his paintings. Inge Morath is soon referring to him as the *génie local*. The mild irony is not lost on Pečko, who casts a glance over his spectacles, then proudly talks of the international successes of the gallery he runs, of meetings with Henry Moore and other important figures in the art world … Backwoods? Not in the least!

Werner Mörath, whose interest in family matters is keen, is glad to be able to learn more about the town hall where his great grandfather once held office, and concludes his enquiries of Karel Pečko with the compliment, "It's reassuring that you're looking after the old town hall—most satisfying that you have the cultural heritage at heart!" For forty years now Pečko has run the gallery here, housed in the former town hall since 1954 when the municipal authorities moved into new premises.

In the old walls the unquiet ghosts of bygone times are stirring. Inge Morath shows little interest in such topics, and shoots photographs from a window. (Later, regarding questions of ownership, she will remark: "If only they knew— I just couldn't care less about owning things!") Yet the three adroitly manoeuvre out of a momentarily frosty corner.

Pečko invites his guests into the tiny, heated "blue salon," and has Carnival doughnuts brought. Inge Morath shoots photographs of the painter. Werner Mörath expresses the wish to purchase one of the master's graphic sheets of the Uršlja Gora. "Some years ago," Karel Pečko relates, "the Karel Pečko Foundation was set up by the municipality. One of its stipulations is that on my death two hundred and fifty works from my collection shall become the property of the town of Slovenj Gradec. The Foundation will also award grants to gifted individuals. Begging your pardons…" The mood brightens. And then they actually speak again about old times. "Our parents told us so much about life in the city, the wonderful rambles and hikes," says Inge Morath, "and about the numerous contacts to artists such as the composer Hugo Wolf and the poet Ernst Goll. Goll is said to have turned the Tomschegg girls' heads." The conversation becomes more and more nostalgic, more thoughtful, too. Werner Mörath, who usually makes no bones about his enthusiasm for times past, says critically: "The German-speaking population kept their distance to the Slovenian country folk. Like the Tomscheggs, they were inclined to make a show of their power. Our mother told us how her grandfather's official uniform and tricorn edged with black ostrich feathers instilled respect in one and all. Haughty stuff. And it led to problems later on." True indeed!

Inge Morath undoes the horn buttons of her Styrian jacket, straightens her green silk scarf, looks encouragingly around, and says in her charming tone of voice: "Maybe not everything was so good back then, but it still thrills me to think that Hugo Wolf played my forefathers' Bösendorfer grand piano. It's simply wonderful. And that my great-grandmother, who had the perfect pitch, was enraptured by melancholy Wolf, frail Goll, and by overbrimming life." Karel Pečko fills the glasses one more time. "Madame, Sir—how lucky we are to live in times when one can go in search of one's roots without too much difficulty. To our young friendship."

DRAFTED BY REGINA STRASSEGGER / REVISED BY KAREL PEČKO

Windischgraz/Slovenj Gradec, um 1890.

Windischgraz/Slovenj Gradec, ca. 1890.

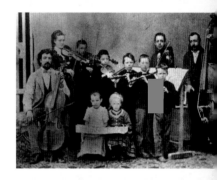

Hugo Wolf als Mitglied des Familien-Orchesters, um 1875 (dritter von links).

Hugo Wolf (third from left) as a member of the family orchestra, ca. 1875.

Photographie des Komponisten Hugo Wolf im Jahr 1888. Er spielte Klavier im Haus der Urgroßeltern.

The composer Hugo Wolf, who played the piano in the house of Inge Morath's great-grandparents; photo 1888.

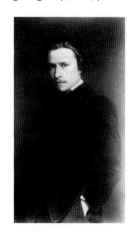

»WILLKOMMEN BEIM KARNEVAL!«
"WELCOME TO THE CARNIVAL!"

»Liebe Inge! In Ptuj, dem früheren Pettau, warst Du selten gelöst und fröhlich – welch ein Geschenk. Es war wunderbar, Dich im bunten Treiben des Karnevals zu sehen, wie Du Dich wie eine Sensationsreporterin in der Menge bewegt hast. So unmittelbar an den Objekten. Da hab ich Stolz auf die große Schwester verspürt und das Gefühl, Dir ganz nahe zu sein.«

WERNER MÖRATH, BRIEF AN SEINE SCHWESTER INGE MORATH

"Dear Inge. In Ptuj, formerly Pettau, you were so relaxed and cheerful—what a gift. It was wonderful to see you in the colorful bustle of Carnival, moving among the crowds like a newspaper reporter, getting in really close. I felt pride in my big sister, and I felt also very near to you."

WERNER MÖRATH, LETTER TO HIS SISTER INGE MORATH

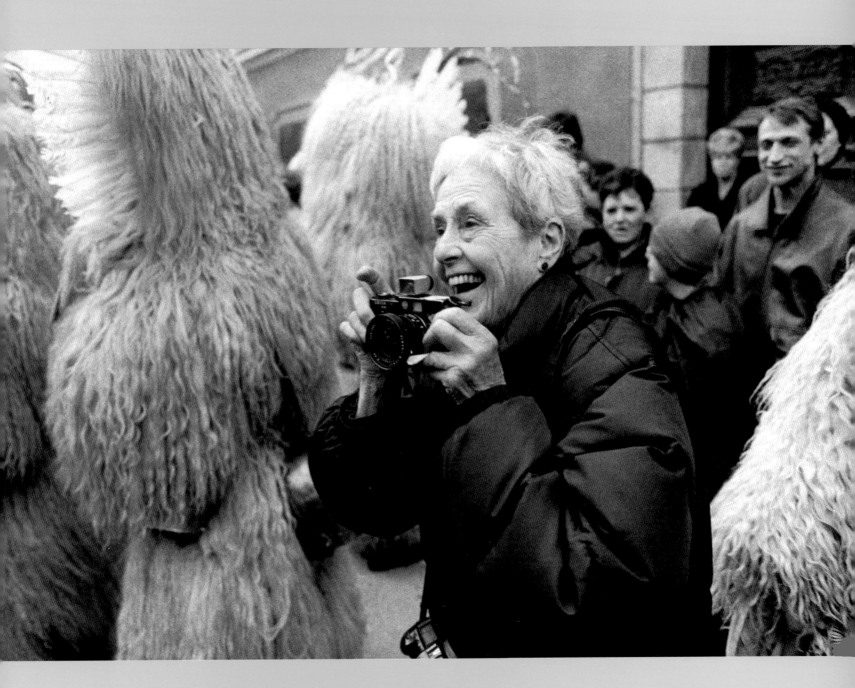

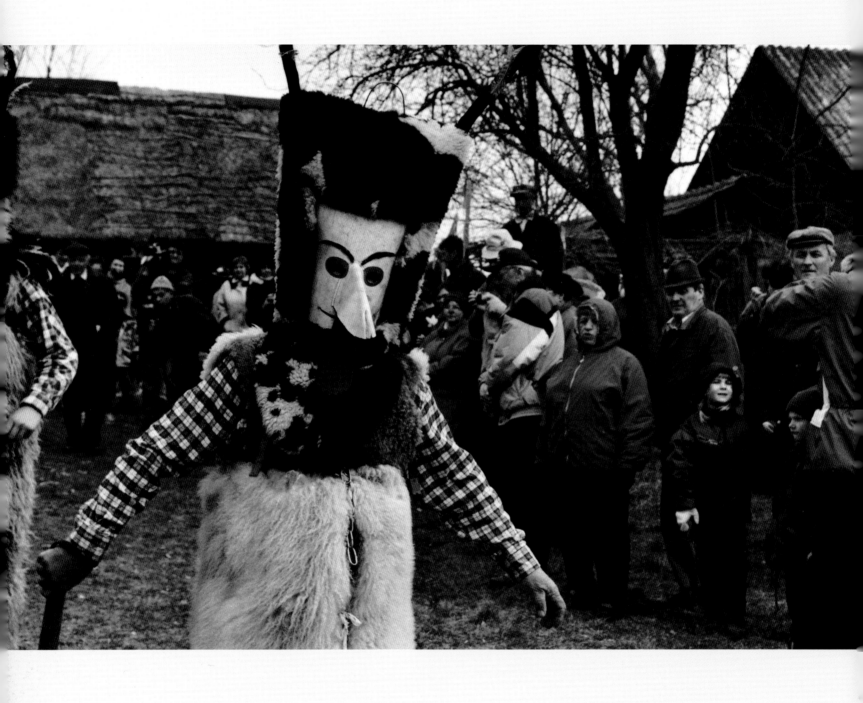

Tanz der Kurenti-Masken zum Austreiben des Winters.
Dance of the Kurenti masks to drive out winter.

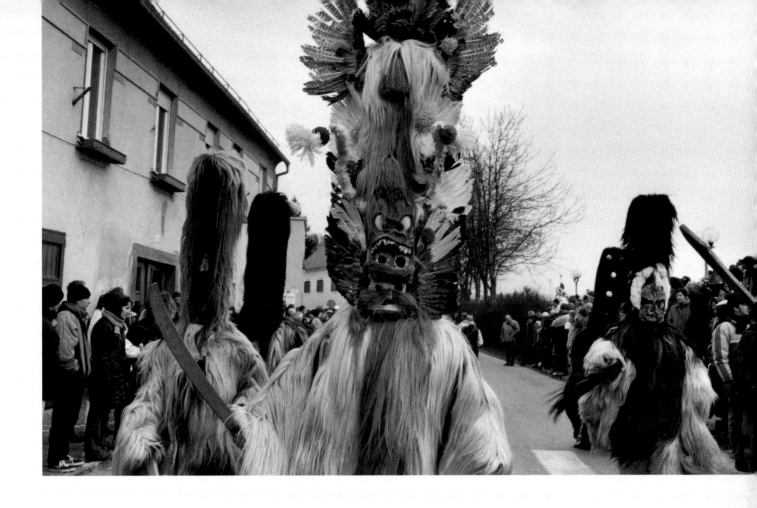

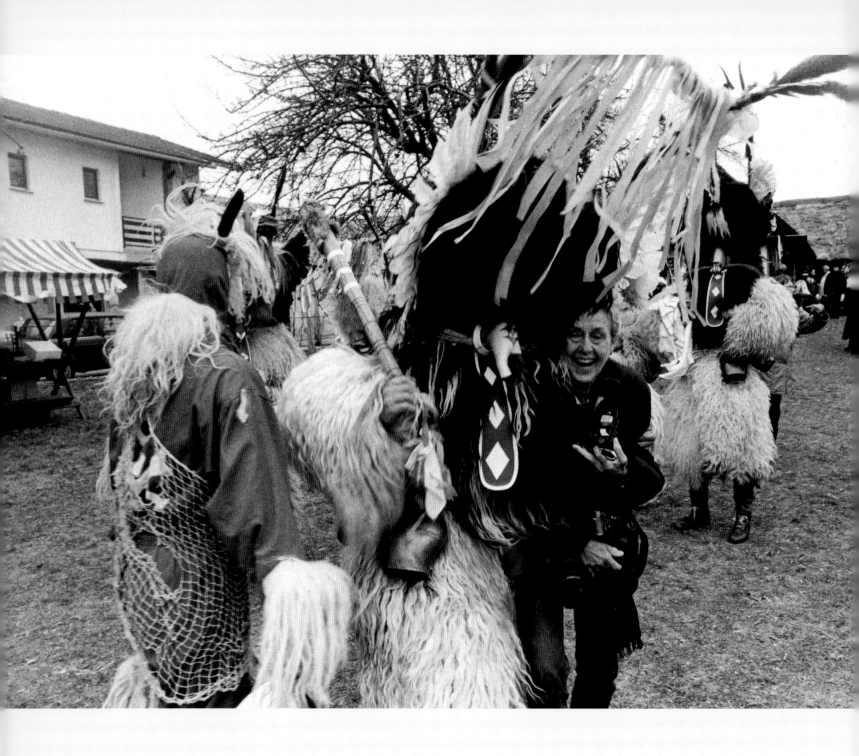

»Dieser Karneval in Ptuj und Markovci ist wirklich toll, kann sich international sehen lassen. Für mich hat das
hier einen besonderen Reiz, weil da plötzlich Bilder aus meiner Kindheit wach werden. Unsere Eltern und Tanten
liebten es, Märchen und Legenden aus der Untersteiermark zu erzählen. Der Zlatorog, der sagenhafte weiße
Steinbock, war ein Renner, aber auch andere mythische Gestalten. All das hat meine Phantasie schon früh
angeregt und sicher dazu beigetragen, daß die Welt der Kunst und der Künstler die meine geworden ist.«

INGE MORATH

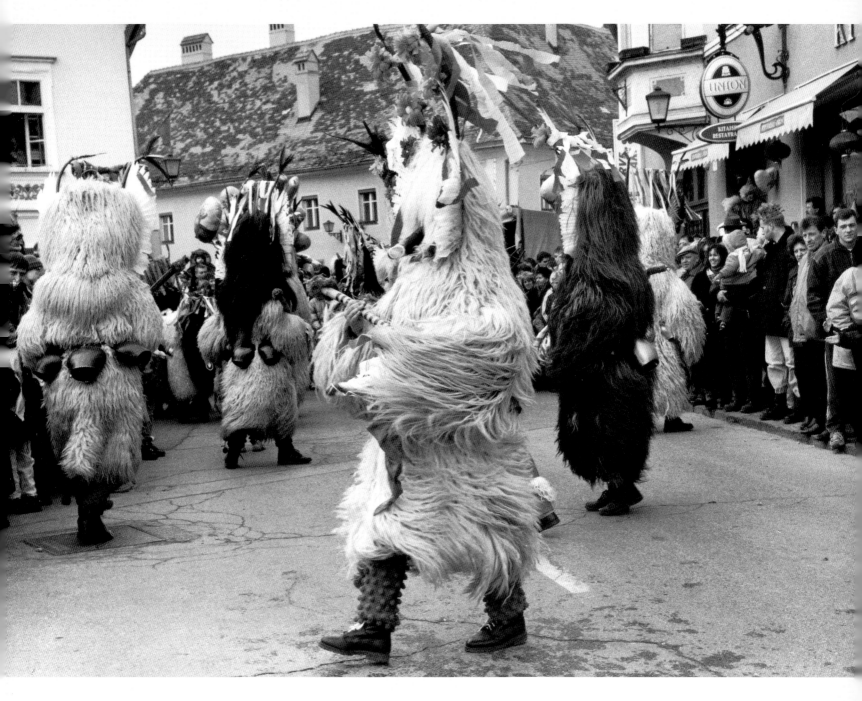

Kurenti treiben den Winter aus – in Pelzen, Ledermasken, Federn, Hörnern.
Hinten am Gürtel schwingen sie Kuhglocken.

Kurenti driving out winter—in pelts, leather masks, feathers, horns.
Cowbells swing from belts at their backs.

"This Carnival in Ptuj and Markovci is just fantastic—international class. It has a particular attraction for me because pictures from my childhood suddenly come to life again. Our parents and aunts loved telling us tales and legends from Lower Styria. The Zlatorog—a fabled white ibex—was a big favorite. But there were other mythological figures, too. It all stirred my imagination at an early age and it was definitely a contributing factor to the world of art and artists eventually becoming my world."

INGE MORATH

Ein Peitschen-Knaller holt aus.

A whip-cracker draws back his arm.

Fenster am Karnevalsmorgen.

Window, morning of the Carnival.

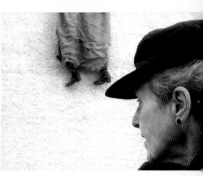
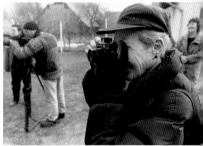
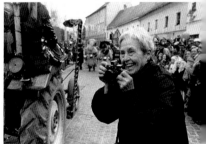

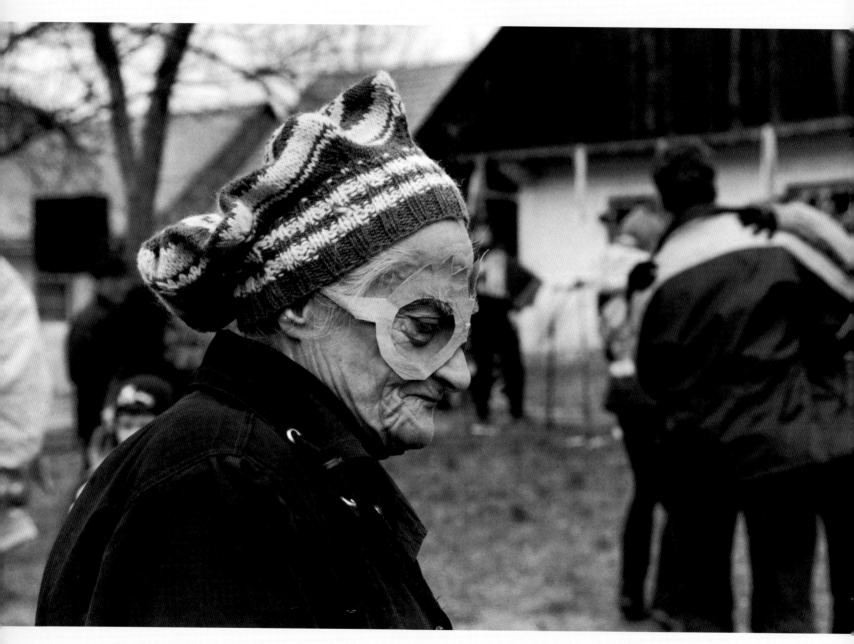

Alte Frau mit Maske am Faschingssonntag.

Old woman in mask, Shrove Sunday.

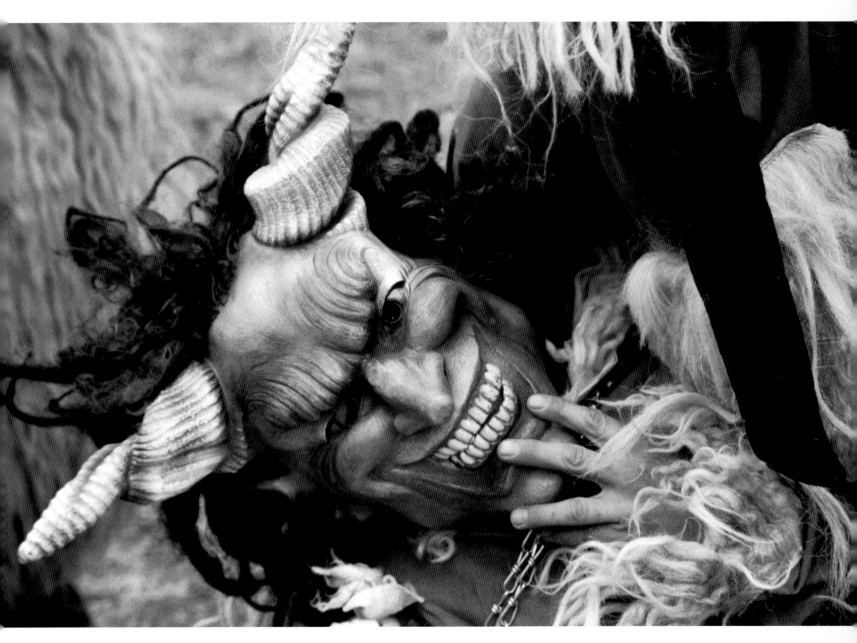

Eine Teufelsmaske.

A Devil mask.

Alles dreht sich.

Everything's turning.

Ein Mythen-Pfahl in einem Hinterhof von Markovci.

A myth-pole in a courtyard in Markovci.

Junges Faschingspaar.
Young carnival couple.

STEIRISCHER BRAUCH

Die schwere Holztüre des Kellerstöckls in Ptujska Gora ist kaum einen Spalt offen, da erklingen Fiedel, steirische Harmonika und Baß. Im Vorhaus des bekannten Photographen Stojan Kerbler umringen Musiker, Literaten, Photographen freudig ihren Gast. Singen spontan »vse najboljše, vse najboljše, draga Inge!« Süßlicher Haloze-Wein wird gereicht. Na zdravje! Auf den schwarzen Hüten der Musikanten stecken Schneeglöckerln. Einer sagt: »Das ist ein steirischer Brauch!« Hier heißt die Steiermark Štajerska, und das nahe an der Drau gelegene, aus

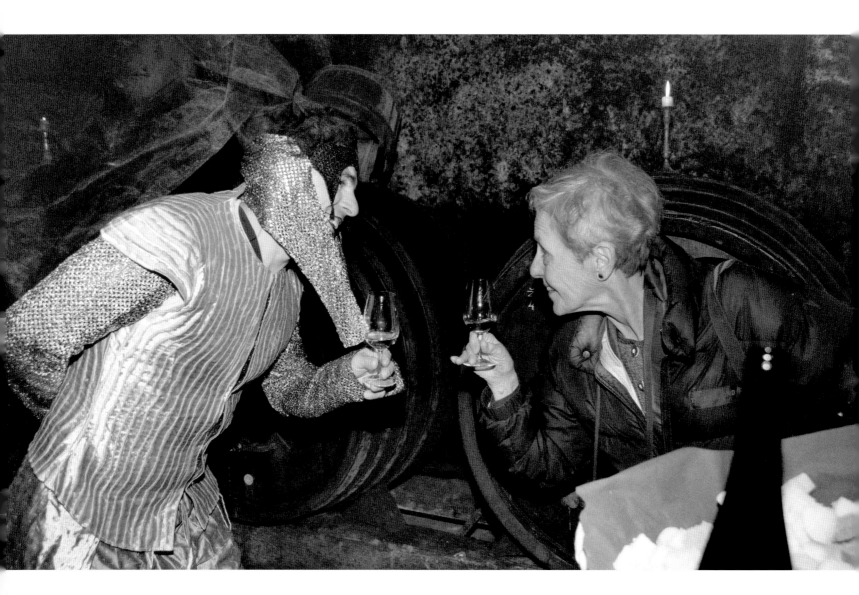

Römertagen stammende Ptuj/Pettau ist die älteste steirische Stadt. »Man vergißt oft«, sagt der in Ptuj geborene, in Graz lebende Photograph Branko Lenart, »daß die Steiermark einen österreichischen und einen slowenischen Teil hat. Das heißt viel Gemeinsames in ihrer Mentalität, Küche, ihrem Liedgut.«
Inge Morath nickt, streckt das Kinn ein wenig nach oben, lächelt bezaubernd. So als wollte sie einen provokanten Kontrast zur Wirklichkeit setzen, zum Zeitalter der Extreme, das diese Landschafts- und Kultur-Verwandtschaft für so lange entzweit hat. Sie sagt: »Aber jetzt wird es ja besser, wie man sieht!« – Die drei Musikanten stimmen ein melancholisches Lied an, nur die Geige begleitet. Zeit der slawischen Seele. Wie dichtete einst Ernst Goll:

»Wundersame Lieder, hebt Euch himmelwärts, gieße Gott uns wieder Jugend in das Herz.« Die Photographin lehnt am Heizkörper, fährt mit einer Hand bedächtig die Rillen entlang. Schaut den eigenen Bewegungen zu. – »Man darf nicht vergessen, daß die slowenische Nationalhymne ein Gedicht auf die Freundschaft zwischen den Völkern ist; auf daß das Glas erhoben wird«, sagt Lenart bedächtig, »und die Gefühle bei diesem Volk, bei seiner melodisch-poetischen Sprache die Seele sind. Das ist etwas, was bei uns über die Grenze verloren zu gehen droht.« Nun ja, Coca Cola & Co sind schon da. Slowenien muß seine Seele gut schützen…

»Inge, Inge«, ruft Stojan Kerbler die berühmte Kollegin, steckt ihr Käse, Schwarzbrot und Apfel zu. Zeigt ihr einige seiner Photographien aus dem Slowenien der 70er Jahre. Sie strahlt, hat vom häufig gereichten Wein schon ganz rote Wangen, sagt zu Kerbler auf Russisch: »Die sind ja atemberaubend schön. Kein Wunder, daß euer Land bei den Dichtern als mystisches Land gilt. Nur eins haben meine Vorfahren nicht kapiert, daß die Slowenen – so zart und auch grob sie sein können – wunderbare Menschen sind.« Beim letzten Teil des Satzes fährt sie ihrem Gegenüber freundschaftlich über den Oberarm, sagt dann: »Ich bin in meinem Leben viel auf der Welt herumgekommen, aber das hier ist etwas ganz Besonderes für mich. Tausend Dank!«

REGINA STRASSEGGER

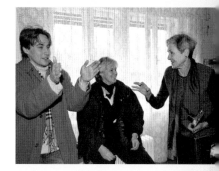

A STYRIAN CUSTOM

The heavy wooden door of the cellar-story in Ptujska Gora is open only a crack, and fiddle, Styrian accordion, and double bass sound from within. Musicians, writers, and photographers surround their guest in the well-known photographer Stojan Kerbler's hallway, greeting her warmly. They break into spontaneous song, "vse najboljše, vse najboljše, draga Inge!" Sweetish *Haloze* wine is passed round. Na zdravje! The musicians have snowdrops pinned in their black hats. "It's a Styrian custom," one of the musicians says. Styria is called Štajerska here. And Ptuj/Pettau, which lies on the River Drava nearby and dates from Roman times, is the oldest Styrian town. "People often forget," says Branko Lenart, a photographer born in Ptuj and living in Graz, "that Styria has an Austrian and a Slovenian part. And so they have much in common—mentality, cuisine, songs."

Inge Morath nods, raises her chin a fraction, and smiles enchantingly. It is as if she wished to set a mark provocatively at odds with reality, this age of extremes that has disrupted the geographical and cultural kinship for so long. "But things are improving now, as one sees," she adds.—The three musicians strike up a melancholy song to a solo violin accompaniment. The Slavic soul. In the poet Ernst Goll's words: "Wondrous songs, rise heavenward, and may God pour youth into our hearts again." Leaning against a radiator, Morath runs a hand over its vanes musingly, observing her own movements.—"One mustn't forget," Lenart says dispassionately, "that the Slovenian national anthem is a poem in praise of friendship among nations to which glasses are raised, and that the people's soul, in the melodious poetry of their language, are their feelings. That's something in danger of being lost across the border." Coca Cola & Co. are there. Slovenia must protect her soul.…

"Inge, Inge," Stojan Kerbler calls to his famous colleague, and brings brown bread, cheese, an apple. He shows her some of his photographs of Slovenia in the 1970s. Beaming, cheeks ruddy from the frequently refilled wineglass, she speaks to him in Russian: "They're breathtakingly beautiful. It's no wonder that the poets view your country as a mystical land. There's one thing my forebears never got—the Slovenians, as coarse as they may sometimes be, and as gentle, are splendid people." Speaking the last few words, she runs a friendly hand over Kerbler's forearm, then says: "In the course of my life I've seen a good deal of the world, but this is very special. A thousand thanks!"

REGINA STRASSEGGER

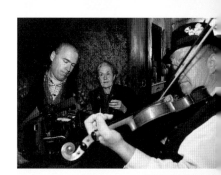

Bassist des Trio Najdenčki.

The trio's double-bass player, Najdenčki

Der Photograph Branko Lenart mit Inge Morath.
Photographer Branko Lenart with Inge Morath.

Stojan Kerbler photographiert Inge Morath.
Stojan Kerbler photographs Inge Morath.

"The best of it was that Stojan was
there too and with his eyes helped me
to see the wonderful Kurenti Carnival.
—Inge Morath"

BESUCH BEI DER ALTEN DAME
VISIT TO AN OLD LADY

»Dieses zerfledderte Schloß Gradišče ist total magisch und seine
Bewohner erst recht. Da kommt so eine Kleine mit Schürze und
wunderbar blauen Augen heraus und lädt uns ein. Sie bringt eine
riesige Whiskyflasche, die mit einem starken Hausbrand gefüllt ist.
Bald ist auch von den Tomscheggs die Rede, von der bettlägrigen
Schwiegermutter, die sie noch gekannt hat. Einfach unglaublich!«

INGE MORATH

"The ramshackle château at Gradišče is pure magic, and its
inhabitants more so. A little woman in a pinafore comes out,
wonderful blue eyes, and invites us in. She fetches a huge whiskey
bottle full of home-made schnapps. The Tomscheggs are soon
being talked about, and the bedridden mother-in-law, who actually
knew them. Simply incredible!"

INGE MORATH

Empfang durch die jetzige Hausherrin Fanika Pečolar auf Schloß Gradišče.
Fanika Pečolar, present owner of Château Gradišče, welcomes her guests.

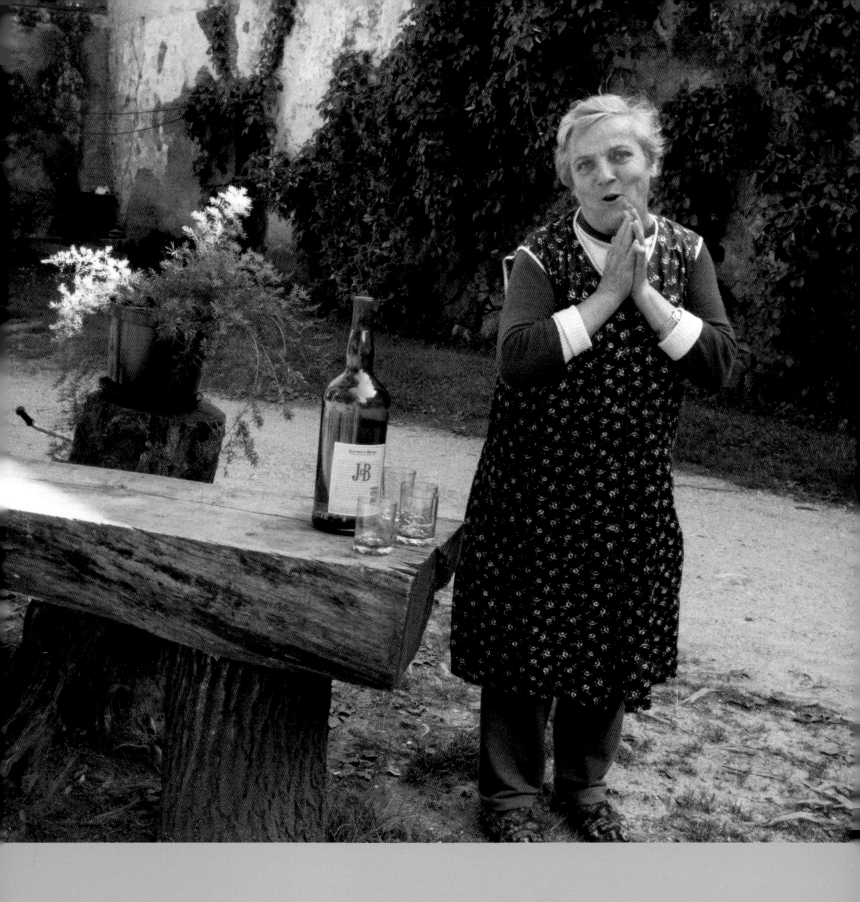

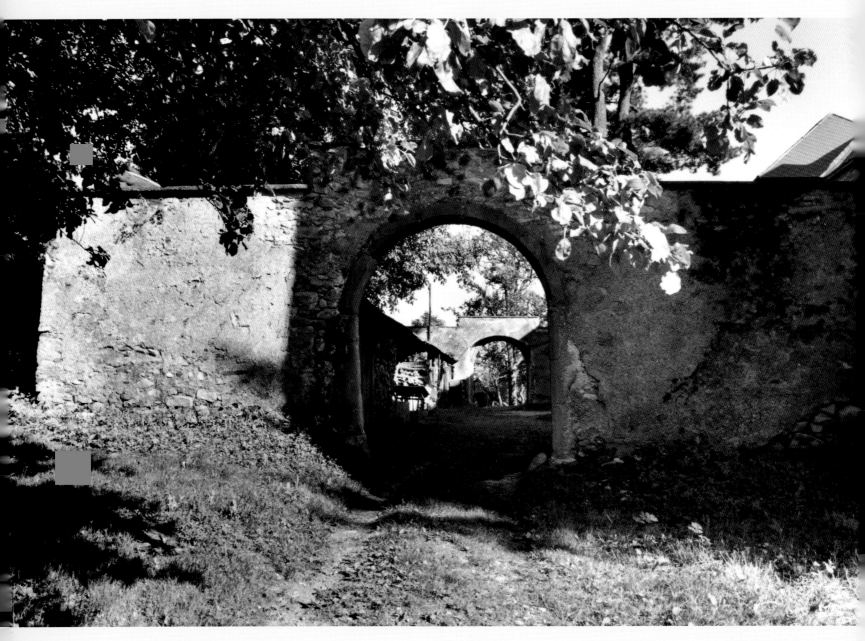

Torbogen am Ende der Allee.

Archway at the end of the avenue.

Schloßhof.

Château courtyard.

Westfassade des Schlosses.

Château, west façade.

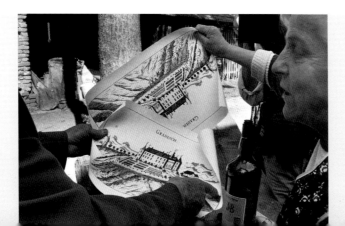

Kopien eines Stiches von 1681.

Copies of an engraving of 1681.

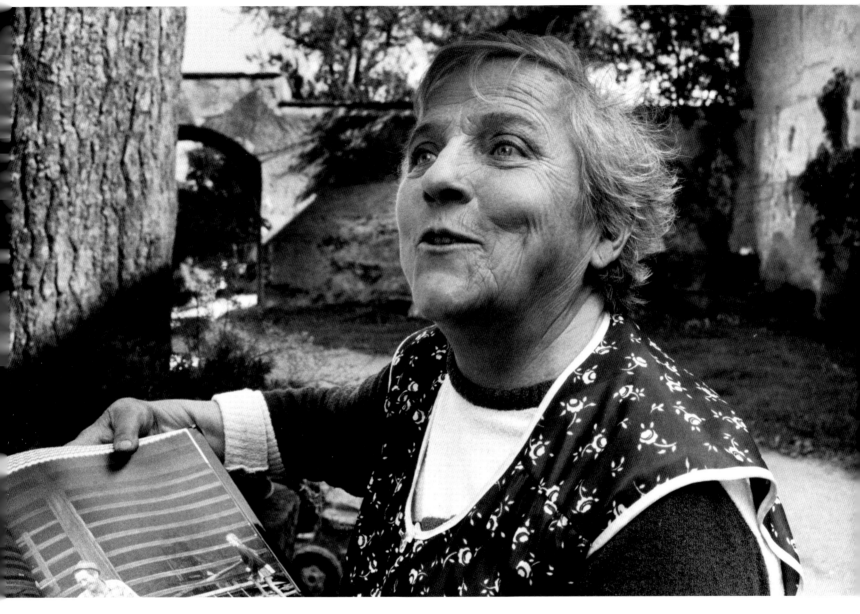

Fanika Pečolar.

Folgende Doppelseite: Bemalte Decke und Speckstange.
Overleaf: Painted ceiling and baconstick.

Karel Pečko, Inge Morath.

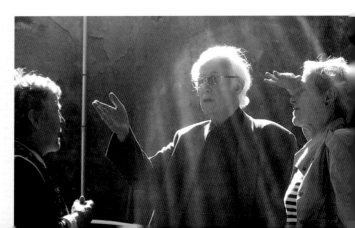

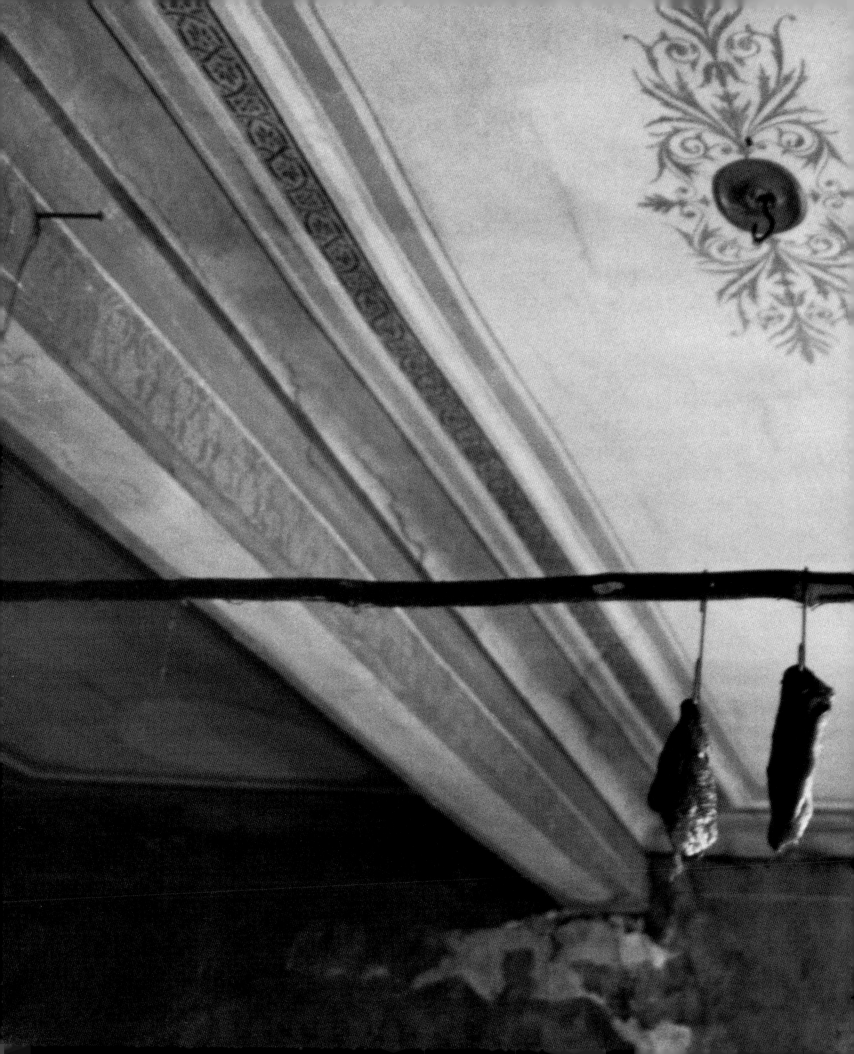

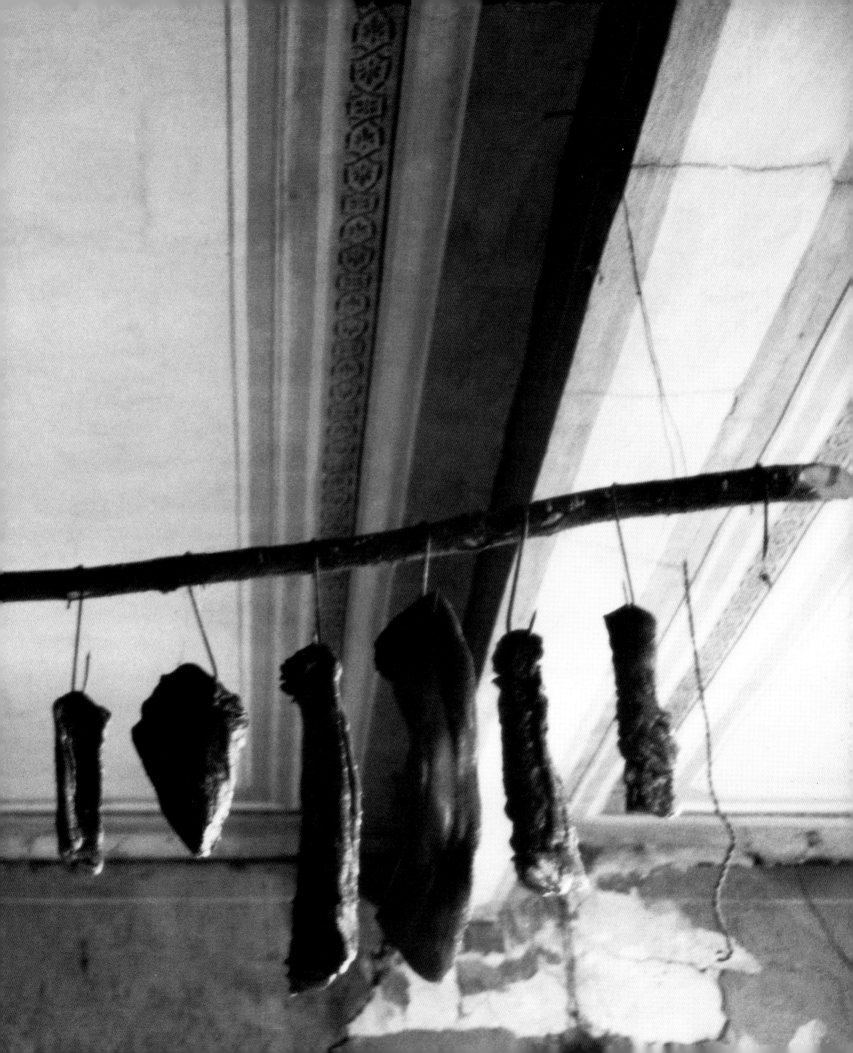

»Aus diesem riesigen Doppelbett schaut ein abgemagertes Gesicht mit zwei riesigen
Augen, die über unseren völlig chaotischen Besuch hoch erfreut ist. Sie versucht sich sogar
aufzurichten. Wir gehen hin und begrüßen sie, halten für eine Weile die zierlichen, kalten
Hände. Sie kann sich zwar kaum rühren und scheint doch so lebendig. Unglaublich – weil
man ja auch weiß, das ist das letzte Bett, das ist der letzte Moment, fast.«

<div align="right">INGE MORATH</div>

"A wizened old face and two huge eyes peer out at us from this huge double bed, their owner
visibly delighted by our chaotic visit. She even tries to sit upright. We go to her, greet her, hold
her frail, cold hands in ours for a while. She can scarcely move, yet she seems so full of life.
Incredible—because one knows it's her last bed, her last moment almost."

<div align="right">INGE MORATH</div>

<div align="right">Marija Pečolar freut sich über Besuch.
Marija Pečolar, glad of a visit.</div>

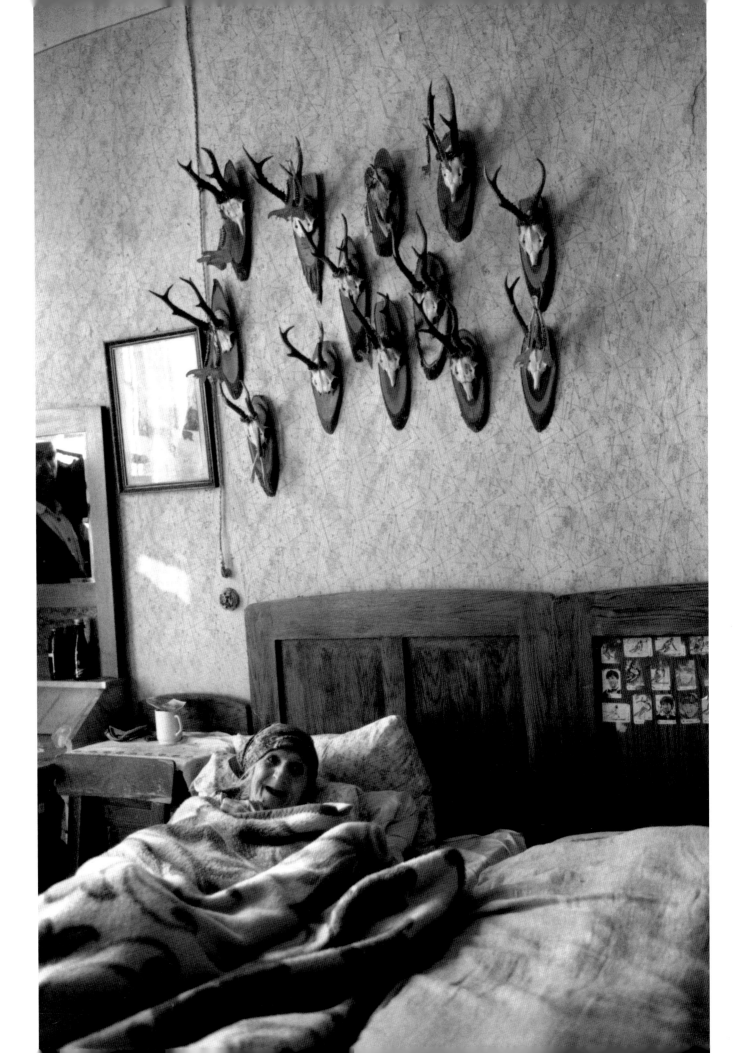

Alte Zeiten.
Old times.

Marija Pečolar.

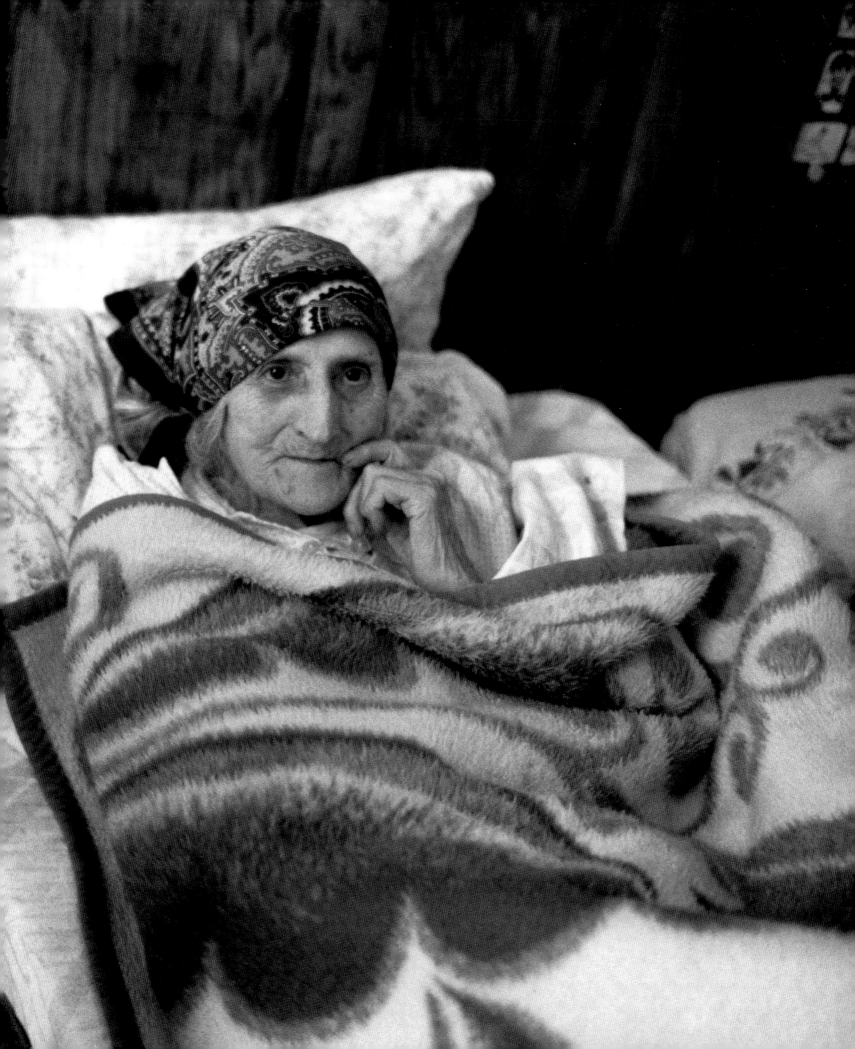

Gesellschaftsbilder
aus der k.u.k.-Zeit.
Society photographs from
Habsburg days.

Fanika und Lojze Pečolar.
Fanika and Lojze Pečolar.

HEIRATSGESCHICHTEN ANNO DAZUMAL

Der wache Blick der alten Frau verklärt sich, sie schaut auf ein paar alte Photos, die sie mit ihren zerbrechlichen Fingern fest umklammert – so als gelte es, zeitloses Glück zu halten. Auf den Schwarzweiß-Photographien mit den gezackten Rändern sind Liebespaare, Hochzeiten, Taufen, Tänzer, Fuhrwerke und ein Auto anno 1904. Der Gast aus Amerika ruft aus: »Das ist ja unglaublich. Diese Geschichte hat mir die Titti erzählt, daß sie 1904 das erste Auto in Windischgraz gesehen hat, dass da die ganze Stadt Kopf gestanden ist. Und da ist es! Phantastisch!« Die fast Hundertjährige ist entzückt, sagt »da, da – ja, ja!« Auch der ausgestopfte Auerhahn, die verstaubten Rehkrickeln an der Wand scheinen Beifall zu nicken. Da capo der wunderbaren Zufälle. Die alte Frau, deren Augen immer leuchtender, größer werden, sagt etwas von »Tomschegg, Gradišče, Sommerfrische«. Aus dem slowenisch-deutschen Begeisterungs-Kauderwelsch geht hervor: Der Tomschegg-Clan, die Morath-Vorfahren also, sind auf dieses schloßartige Landgut öfters zur Sommerfrische gekommen – im Pferdegespann und mit vielen Koffern. Marija Pečolar, damals ein kleines Mädchen, deren Eltern hier im Dienst waren, erinnert sich gut daran. »Hier haben also meine Urgroßeltern mit den Kindern übernachtet«, sagt Morath, während sie unzählige Bilder schießt, »das hätte ja der Fellini nicht besser inszenieren können! Dieses Arrangement mit den ausgestopften Vögeln, die hohen, noblen Zimmer mit Balken – ganz Renaissance.« Im Chaos de luxe winkt die nunmehr unbestrittene Diva horizontale die um zwanzig Jahre jüngere Photographin in der legeren Safarijacke noch einmal zu sich, zeigt ihr strahlend die Konterfeis von zwei Männern. Deutet, sie solle näher hinschauen, so schöne Männer sieht man nicht jeden Tag. Sagt leidenschaftlich »Zlato, zlato! –

Arrangement mit ausgestopften Vögeln und Rehkrickeln.
Arrangement of stuffed birds and antlers.

Goldschätze, Goldschätze!« Es sind Sohn und Ehemann. »Die sehen ja toll aus«, sagt der Gast von weit her, »waren sie auch eine gute Partie?« Und ob, als Marija ihren Ivan geheiratet hat, war er offenbar der Erbe vom Landgut Gradišče. »Zlato, zlato!« Die Morath ist hingerissen und heiter wie selten, sagt mit einem Blick auf das vergilbte Hochzeitsbild: »Die Heiratsgeschichte von meinen Großeltern ist auch nicht schlecht. Die Tomschegg-Tochter Mathilde war eine kunstverliebte Schönheit – und bei den Männern sehr begehrt. Ihr ziemlich despotischer Vater, der Bürgermeister, hatte sie mit einem vermögenden Mann verlobt.« Unerwähnt bleibt in diesem Part der Familiensaga, daß der Vater Tomschegg – laut einem Brief einer Nichte Inge Moraths – ein unsäglich herrischer Mann war, der die zwölf Kinder und seine aus dem preußischen Landadel stammende Frau tyrannisierte.

Höhepunkt des Dramas war ein verhängnisvoller väterlicher Strafakt. Wegen liderlichen Lebenswandels hatte der Vater eine seiner Töchter ins Kloster verbannt. Trotz herzzerreißender Briefe gab es kein Pardon. Die Unglückliche fand dort nicht einmal siebzehnjährig den Tod. – Doch zurück zur glücklicheren Schwester, zur Großmutter-Story der Inge Morath: »Zum Glück stellte sich für die schöne Mathilde heraus, daß der ungeliebte Verlobte eine unangenehme Krankheit hatte. Das war die Chance für meinen Großvater in spe. Der k.u.k. Landvermesser aus ärmlichen Verhältnissen, der schon lange ein Auge auf die Vielumschwärmte geworfen hatte, machte das Rennen. Sie waren über siebzig Jahre glücklich verheiratet.« Die alte Frau versucht zu klatschen, preßt die Lippen voller Rührung aufeinander, schaut dann auf das neben ihr stehende lädierte Kruzifix, sagt mit wäßrigen Augen: »Meine beiden Ivan und Lojze allzu früh gestorben. Leben in mein Herz immer noch!«

REGINA STRASSEGGER

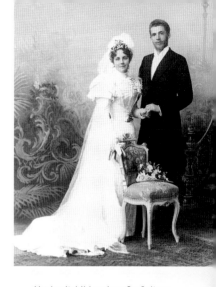

»Hochzeitsbild meiner Großeltern aus dem Jahr 1895 in Windischgraz.«
"Wedding portrait of my grandparents taken in Windischgraz, 1895."

WEDDING STORIES FROM WAY BACK

The old woman's alert gaze seems transfigured; she looks at the old photos clasped in her brittle fingers, as if to hold onto timeless happiness. The black-and-white deckle-edged photographs show romantic couples, weddings, christenings, dancers, horse-drawn vehicles, and a car from the year 1904. The guest from America cries out. "I don't believe it! Titti told me this story once about seeing the first automobile in Windischgraz and how the whole town was flabbergasted. And there it is! Amazing!" The nearly one hundred-year-old is enraptured, says, "Da, da—ja, ja!" The stuffed capercaillie and dusty antlers on the wall seem to nod approval, too. The old woman, her eyes growing larger and brighter by the minute, stammers out "Tomschegg, Gradišče, summer vacation." Her enthusiastic jumble of German-Slovenian syllables conveys that the Tomschegg clan—in other words Morath's forebears—used to come to this palace-like estate for their summer vacation in a horse-drawn vehicle, and with plenty of suitcases. Marija Pečolar, a small girl at the time, her parents domestics, remembers it well. "So this is where my great-grandparents and their children will have slept," says Morath, shooting countless pictures. "Fellini couldn't have staged it better—the arrangement of stuffed birds, the high ceiling, the stately room: pure Renaissance."

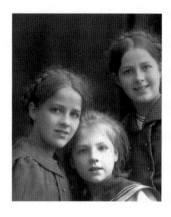

»Meine Mutter Mathilde Titti Wiesler mit ihrer Zwillingsschwester Else und der jüngeren Schwester Grete.«
"My mother, Mathilde Titti Wiesler, with her twin sister Else and younger sister Grete."

The now undisputed, supine diva—in chaos de luxe—motions the twenty-year-younger photographer in casual safari jacket to her side. Beaming, she shows her photos of two men, gesturing her to look closer, such handsome men are no everyday sight. "Zlato, zlato!" she says, passionately—"treasures, treasures." It is her son and husband. "They look wonderful," says the overseas guest, "—a good match?" And how! When Marija married Ivan he was apparently heir to the Gradišče estate. "Zlato, zlato!" Morath is delighted and seems uncommonly blithe. Glancing at the yellowed wedding photograph, she says: "My grandparents' wedding story isn't bad, either. The Tomschegg daughter Mathilde was an art-loving beauty—much sought after by the men—whom her domineering father, the mayor, had betrothed to a wealthy man." What goes unmentioned in this family saga is that old man Tomschegg, according to a niece of Inge Morath's in a letter an impossibly despotic character, tyrannized his twelve children and wife of Prussian nobility. The climax of the drama came when the father, in order to punish one of his daughters for "disorderly living," banished her to a convent. Despite heartrending letters there was no pardon. The unhappy girl died there before she was even seventeen. But to return to her happier sister, Inge Morath's grandmother: "Fortunately for the beautiful Mathilde, it turned out that the unloved fiancé had an unpleasant disease. This was the chance for my future grandfather, a Habsburg surveyor from a poor background, who had long counted himself among her adorers, and he won the race. They were happily married for over seventy years." The old woman attempts to clap her hands, presses her lips together in emotion, glances at the battered crucifix at the bedside, and, eyes watery, says: "My Ivan and Lojze died all too soon. But they still live in my heart."

REGINA STRASSEGGER

»70. Hochzeitsjubiläum von Eduard und Mathilde Wiesler in Graz.«
"Eduard and Mathilde Wiesler on their 70th wedding anniversary, Graz."

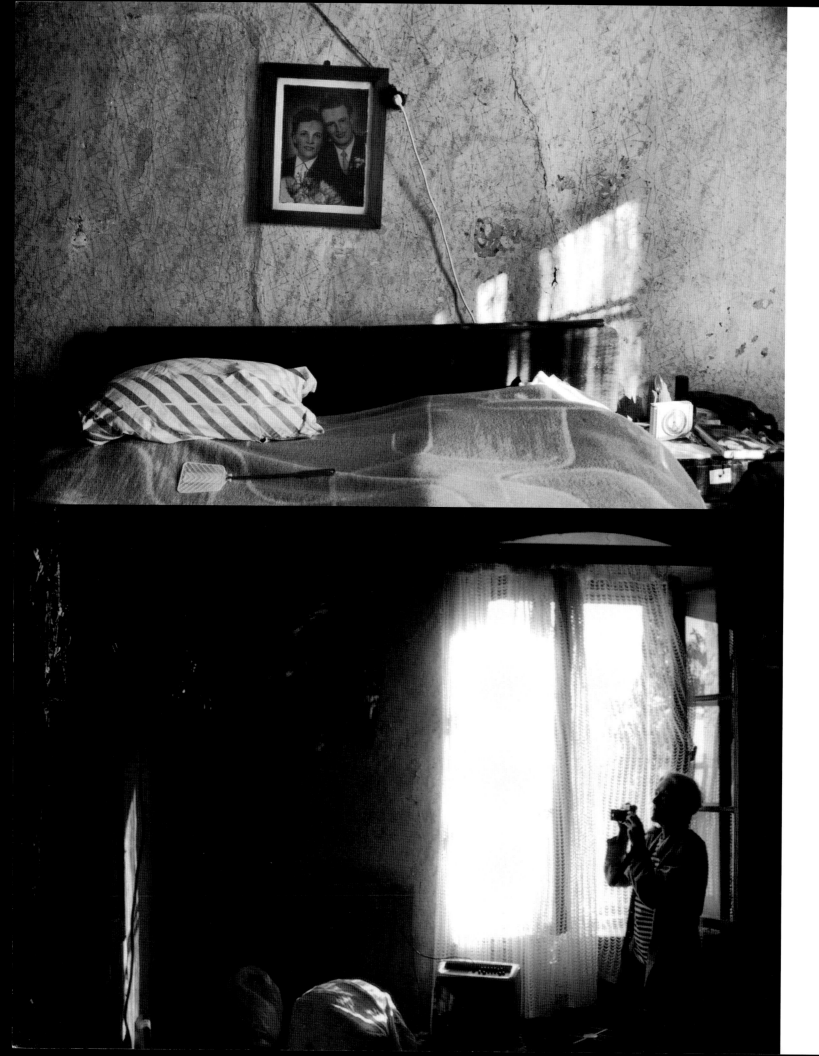

Das lädierte Kreuz der
Marija Pečolar.
Marija Pečolar's battered
crucifix.

Links/left:

Idylle von der Ewigen Liebe.
Idyll of eternal love.

Inge Morath im Bann des
Wandschmucks.
Inge Morath, captivated by
the wall decoration.

BEI DEN LEUTEN IN DER ŠTAJERSKA
AMONG THE PEOPLE IN THE ŠTAJERSKA

»Wie schreibt der Handke über Slowenien und die Slowenen so trefflich? Ein mystisches Land, ein Territorium
der Träume. Seine Menschen, die durch die Jahrhunderte Königlose, Staatenlose, Handlanger, Knechte
gewesen waren, sind trotzdem oder vielleicht deshalb voller Schönheit, Selbstbewußtsein, Verwegenheit,
Aufsässigkeit, Heldentum... So ungefähr heißt es in dem wunderbar epischen Reiseroman *Die Wiederholung*.«

INGE MORATH

"How does Handke put it, writing about Slovenia and the Slovenes in
his wonderful epic novel *Repetition*? A mystical land, a territory of dreams,
whose people, over the centuries, were kingless, nationless, labourers,
farmhands—despite which, or perhaps for that very reason, they are still
full of beauty, pride, daring, rebelliousness, heroism.—Words to that effect."

INGE MORATH

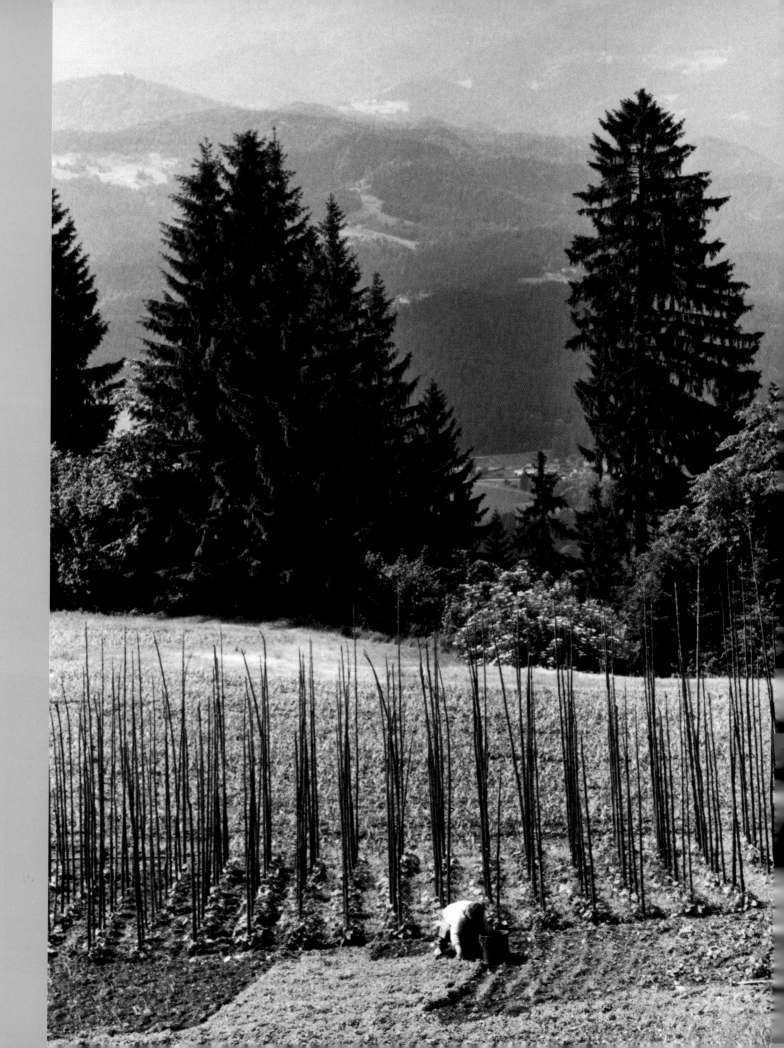

»Blick auf den Ursulaberg, Lieblingsberg meiner Mutter als junges Mädchen. Dort soll das Knie der hl. Ursula aufbewahrt sein.«

INGE MORATH

"View of the Ursulaberg, my mother's favorite mountain when she was a young girl. St. Ursula's knee is said to be preserved there."

INGE MORATH

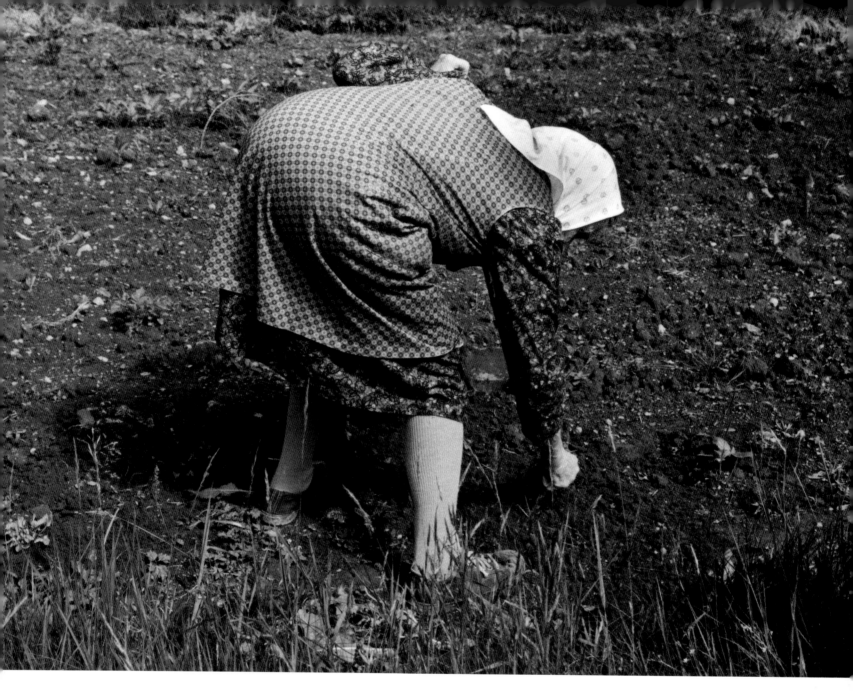

Bäuerin bei der Feldarbeit.

Farmer's wife at work in the fields.

»Alter Bauer freut sich über Abwechslung. In seinem Geburtsjahr 1912 ist die Omi mit ihren Töchtern auf den Berg gegangen. Man erwartete mit dem Halleyschen Kometen den Weltuntergang. Als der Komet nicht gekommen ist, haben sie ihre Brote ausgepackt und sind danach wieder fröhlich nach Hause gegangen.«

INGE MORATH

"Old farmer glad of diversion. In the year of his birth (1912), Grandma took her daughters up onto the mountain. Halley's comet was expected, and the end of the world. But the comet failed to appear. They unpacked and ate their sandwiches, and blithely returned home again."

INGE MORATH

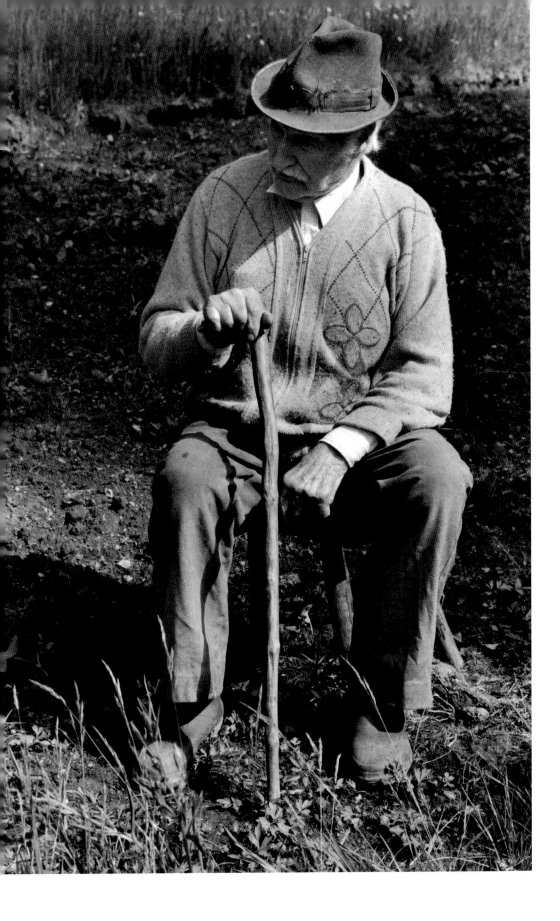

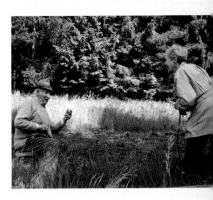

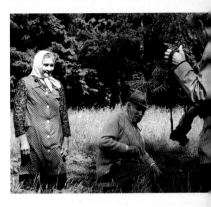

Inge Morath bei den Bauersleuten.
Inge Morath with the farmer and his wife.

»Schindelmacher Franc Placet bei der Arbeit.
Wunderbare Handwerksfertigkeiten der Leute,
die viel daraus machen.«

"Shingle-maker Franc Placet at work.
The people are wonderfully skilled manual
workers and make a lot out of it."

Berta Placet mit dem Hofhund. Im Hintergrund die Drau.
Berta Placet and farm dog; in the background the Drava.

Rechts: »Der weiße Hirsch erinnert an den legendären Zlatorog.«
Right: "The white stag, reminiscent of the legendary Zlatorog."

Folgende Doppelseite: Wäscheleine bei Sveti Primož. Im Hintergrund die Grenzberge.
Overleaf: Clothesline near Sveti Primož; in the background the border mountains.

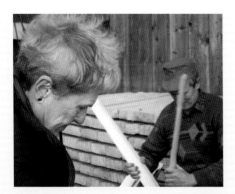

Mit Berta und Franc Placet.
With Berta and Franc Placet.

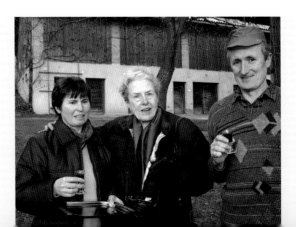

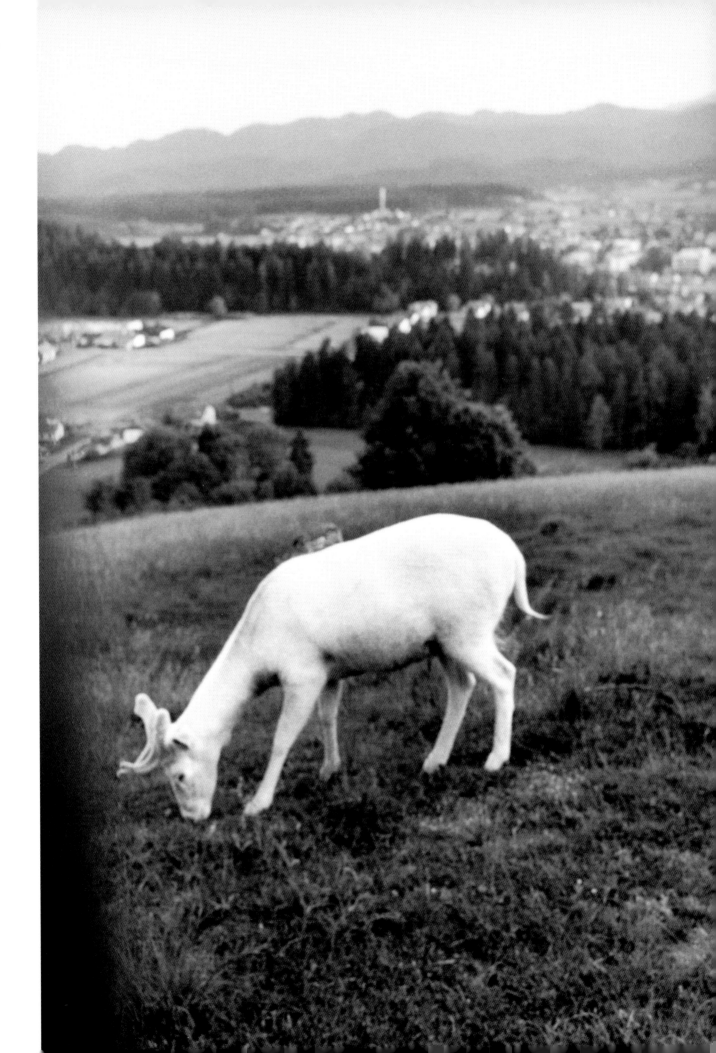

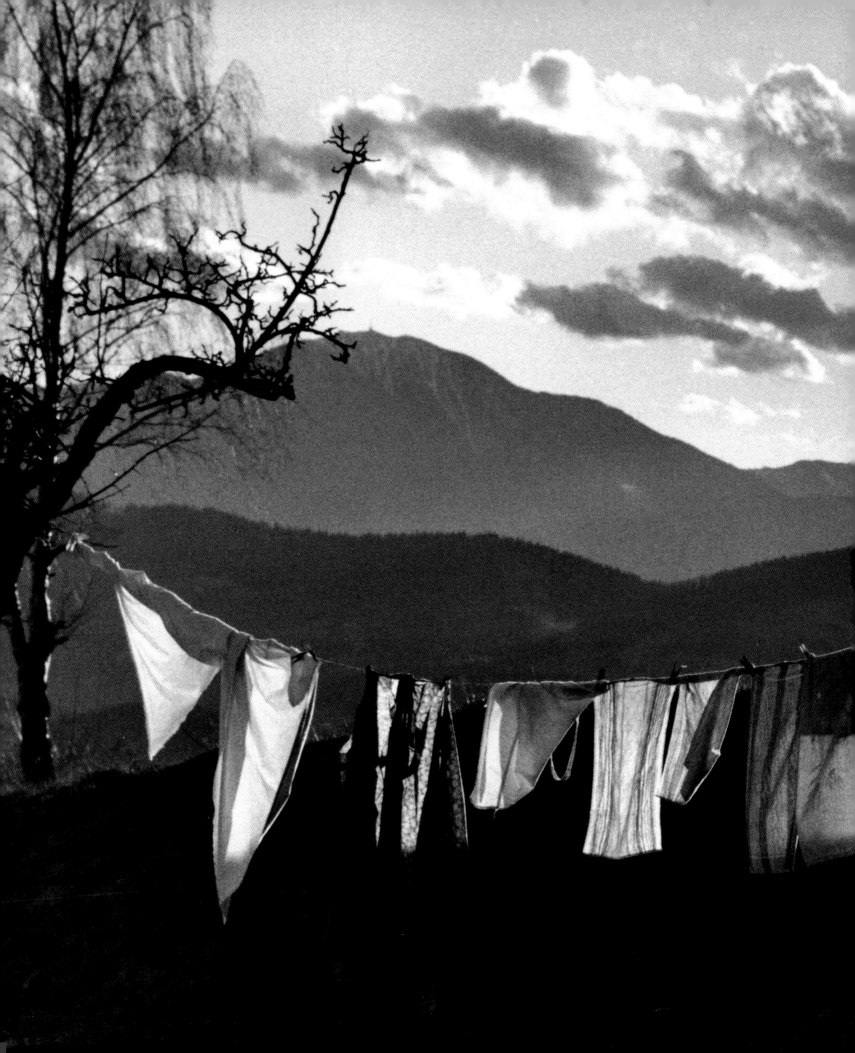

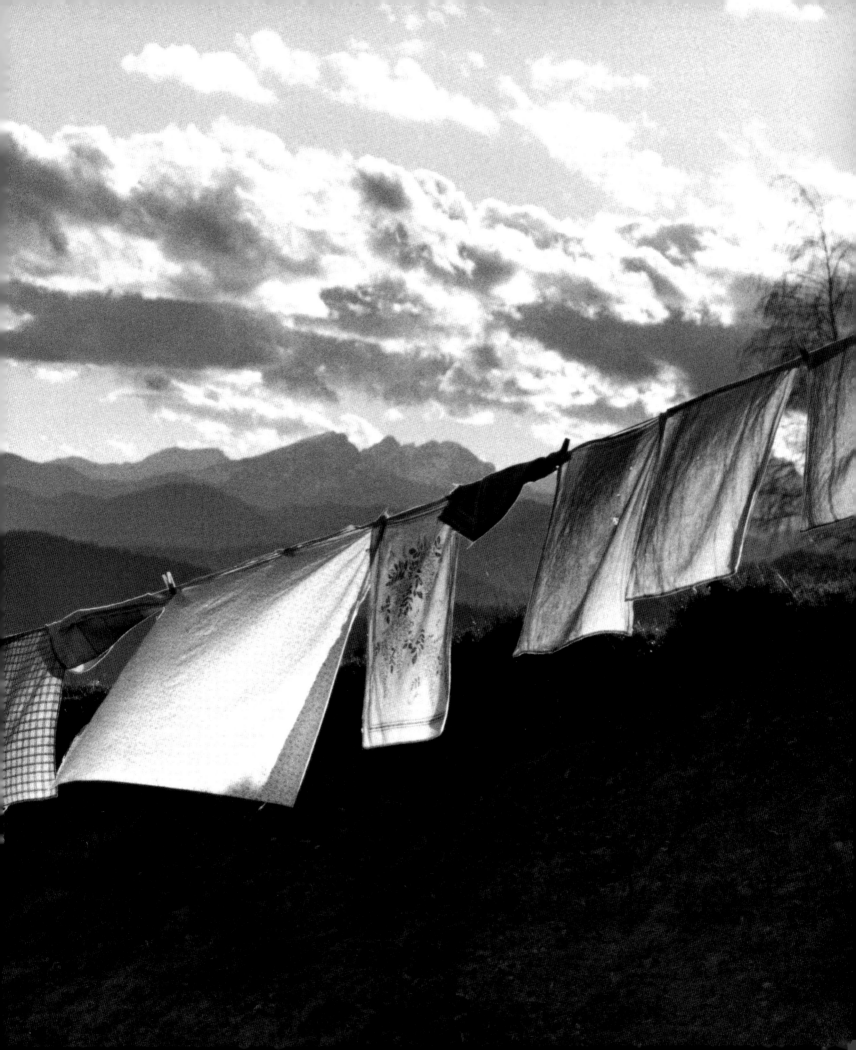

SPRACHENLEHRE

»Schauen, da, Buch Schule«, sagt der Schwiegersohn der Novaks, den sie
respektvoll »Pensionist« nennen. Der 51jährige Metallarbeiter aus Jesenice,
der wie viele dort seine Arbeit verloren hat, zeigt der Besucherin stolz sein
Sprachbuch – Schulbuchverlag der DDR, Leipzig 1984. Morath blättert
darin interessiert. »Da ist ja sogar ein Vorwort von der Margot Honecker«,
bemerkt sie, fügt schelmisch hinzu: »Genosse Erich hat ja seine bessere
Hälfte immer gut mit Posten versorgt. – Das waren Zeiten.« Fric Novak,
der 76jährige Schwiegervater, der stolz ist, über all die bewegten Jahre
den kleinen Hof im Grenzgebiet gehalten zu haben, steht auf, nimmt eine
Flasche aus der Holzkredenz, bedeutet seiner Frau Kristina, Schnapsgläser
für alle zu holen. Tochter Manica, die im Herrgottswinkel von einem
Jesusbild und Devotionalien eingerahmt wird, sagt leise: »Jetzt lustig!« –
so als würde die geduldig erwartete Vorstellung erst richtig beginnen. Ihr
um fünfzehn Jahre älterer Mann springt auf, schlägt gezielt eine Seite auf,
sagt zur Photographin: »Du auch lernen. Slowenisch!« Der Mann fährt mit
dem Zeigefinger eine Zeile entlang, während er langsam buchstabiert:
»Želim ti dobro ztravje in dolgo življenje – ich wünsche euch Gesundheit und
ein langes Leben!«

Das Ehepaar Novak mit ihrem
Schwiegersohn.
The Novaks and their son-in-law.

Links: Moraths Sprachnotizen.
Left: Morath's language notes.

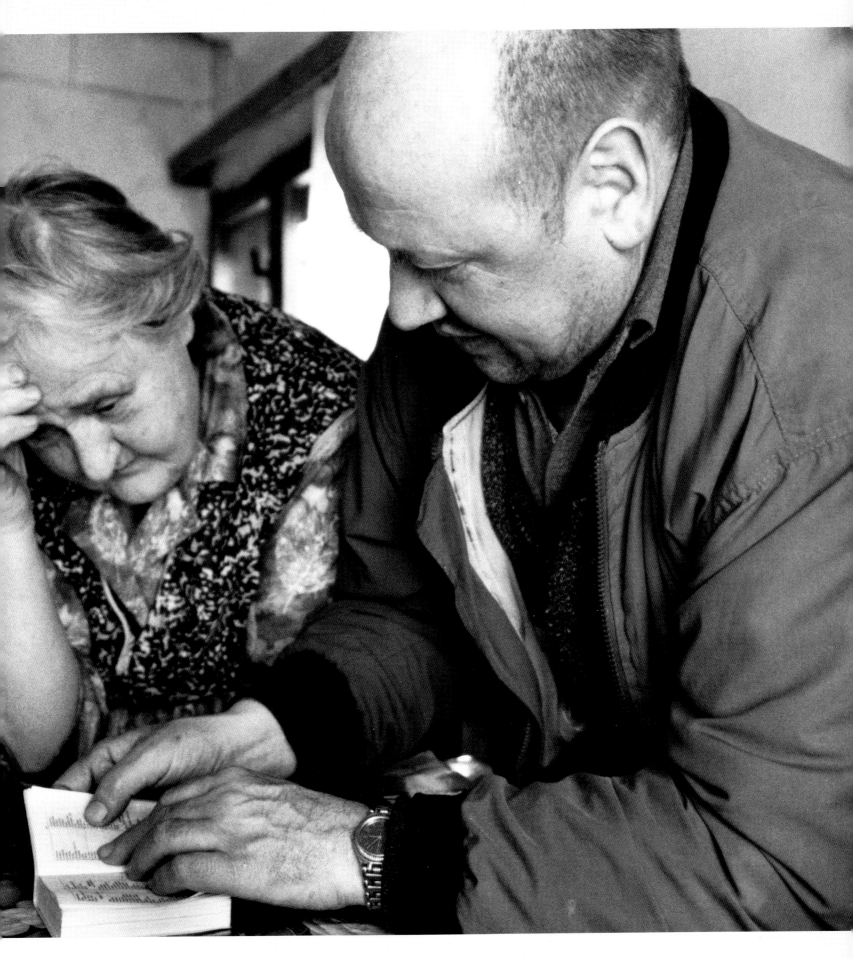

Die Morath, die sieben Sprachen – darunter Russisch, Mandarin, Rumänisch, Italienisch – spricht, spielt zum Gaudium aller gekonnt mit. Bei jeder neuen Phrase heißt es »Dobro, dobro!« und bald auch »Na zdravje«. Für jeden Erfolg ein Stamperl! Bald kommen auch hausgemachtes Brot, Schmalz, Knoblauch auf den Tisch. Inge Morath entdeckt in dem mit Früchten bedruckten Wachstischtuch ein neues Unterrichtsutensil, sagt: »Das ist eine Erdbeere, das ist eine Weintraube... Und wie heißt das auf Slowenisch?« Im Nu ist ein vergnügliches Früchtespiel im Gang. Alle machen mit. Nach einer Weile hält der zur Hochform auflaufende Schwiegersohn inne, schaut auf die Uhr, sagt: »Achtung, Achtung – Überraschung!« Es ist wenige Sekunden vor Drei. Plötzlich bricht aus vier verschiedenen Uhren ein Vogelkonzert los. Kuckuck, Papagei, sonstiges Federvieh. Die stolzen Besitzer sind entzückt, die Morath ist für einen Augenblick verblüfft, inspiziert komödiantisch die Uhren Made in Hongkong, zählt in ihrer unverwechselbaren Klangfarbe in verschiedensten Sprachen die Vogelnamen auf. Der alte wortkarge Bauer lüftet erstmals seinen Hut und spricht: »Dos hobn's scheen g'sogt. Hob i so g'hört no nie.«

REGINA STRASSEGGER

LANGUAGE LESSON

"Look, here, book, school," says the Novaks' son-in-law, respectfully referred to as the "pensioner." The 51-year-old metalworker from Jesenice, like many others there, lost his job; he proudly shows the visitor his language book—Educational Publishing House of the GDR, Leipzig 1984. Morath leafs through it with interest. "There's even a foreword by Margot Honecker," she observes, and adds mischievously, "Comrade Erich always saw to it his better half got good positions.—Those were the times." Fric Novak, the 76-year-old father-in-law, proud to have held onto the little farm near the border through all the troubled years, stands up, fetches a bottle from the sideboard, and indicates to his wife Kristina to bring schnapps glasses. Manica, the daughter, framed in the devotional corner by a picture of Jesus and other objects, says, "Fun now!"—as if the show, so impatiently awaited, were at last about to begin. Her husband, some fifteen years older, jumps to his feet, opens the book at a page, and says to the photographer: "You—also—learn." Bowing his head over the page, he runs a finger along a line, reading slowly: "Želim ti dobro stravje in dolgo zivljenje—I wish you health and a long life!"

Morath—who speaks seven languages including Russian, Mandarin, Romanian, and Italian—plays along expertly, to the delight of all. Each new phrase is greeted with "Dobro, dobro!" and soon "Na zdravje." A drink for each success! Homebaked bread, lard, and garlic are brought forth. Inge Morath discovers a new pedagogical tool in the oilcloth table-covering and its printed fruits. "This is a strawberry," she says, "and that's a grape.... And in Slovenian?" A diverting fruit-game is soon underway. All play along. The Novaks' son-in-law, really getting into his stride now, pauses after a while, looks at the clock, and says: "Achtung, Achtung—Surprise coming up!" It is not quite three o'clock. Suddenly a concert of birds erupts from four different clocks. A cuckoo, a parrot, other fowl. The proud owners are tickled pink. Puzzled for a moment, Morath investigates theatrically—"Made in Hong Kong" —and recites the birds' names in numerous languages in a tone of voice all her own. The old, taciturn farmer lifts his hat for the first time and, in dialect, says: "And very nicely said, too. I never have heard that before."

REGINA STRASSEGGER

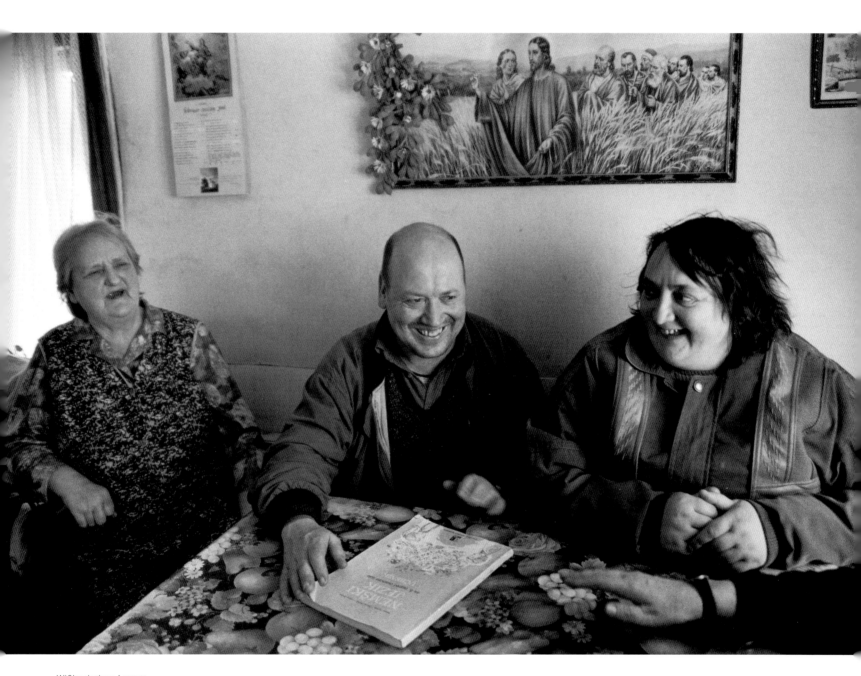

Wißbegieriges Lernen.

Eager to learn.

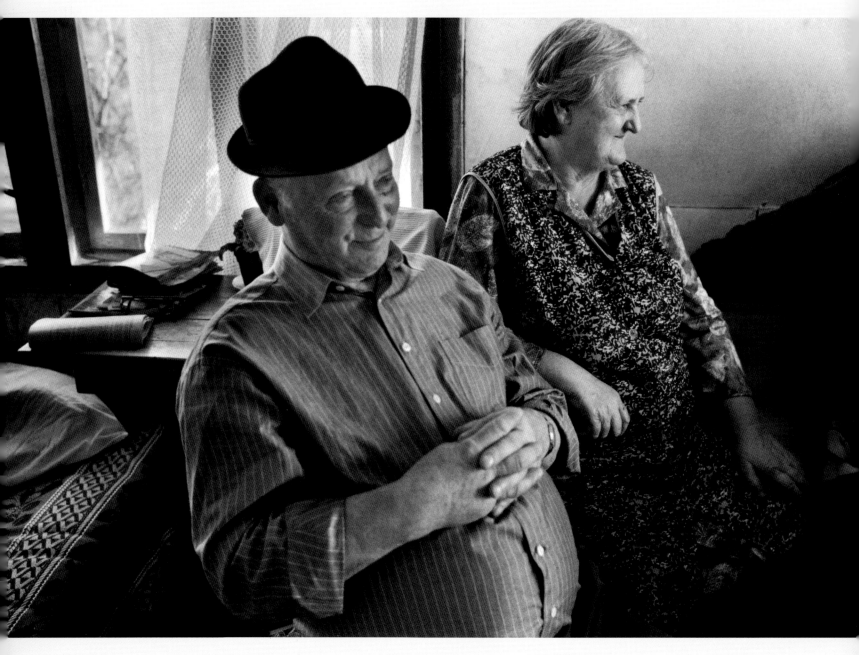

Fric Novak und seine Frau Kristina.
Fric Novak and his wife Kristina.

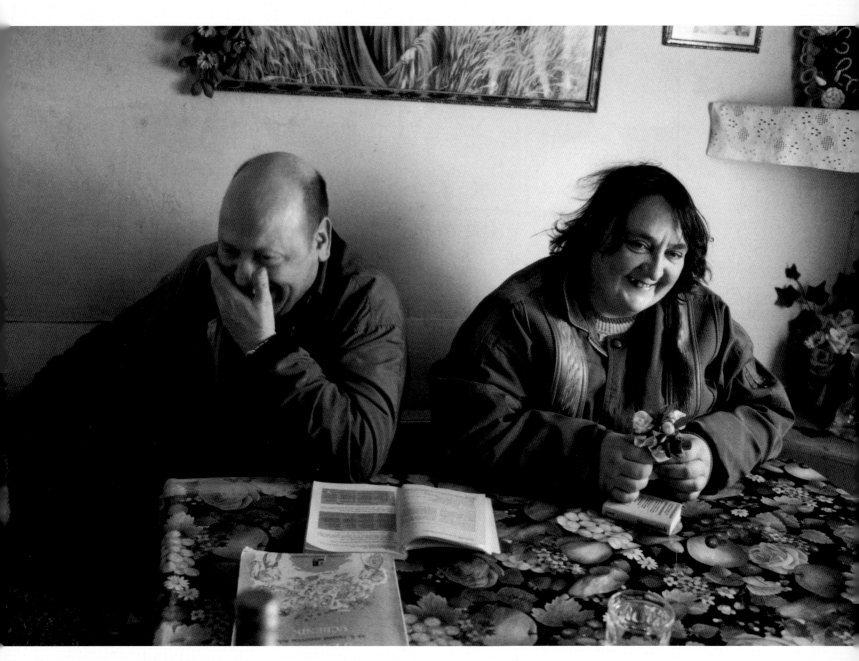

Tochter Manica und der pensionierte Schwiegersohn der Novaks.

Daughter Manica and the Novaks' pensioned-off son-in-law.

AUF DEN SPUREN DER MUTTER
IN SEARCH OF TITTI'S WORLD

»Meine Mutter hatte schon als Kind einen starken Willen.
So wollte sie 1912 als einziges Mädchen unbedingt in ein
Realgymnasium. Das war damals ein abenteuerlicher Gedanke.
Aber die Titti hat ihren Kopf durchgesetzt, und so kam sie von
Windischgraz nach Marburg. Das war ja seit Erzherzog Johanns
Zeiten schon per Bahn erreichbar.«

INGE MORATH

"Even as a child my mother was strong-willed. So in 1912 she
insisted on attending a Classical Gymnasium as the only girl.
An extraordinary notion back then. But Titti got her way and
changed schools from Windischgraz to Maribor. A rail connection
had made it accessible since as early as Archduke Johann's time."

INGE MORATH

»Meine Schwester Inge hat den Ehrgeiz, das Talent und die Härte von unserer Mutter.«

WERNER MÖRATH

"My sister Inge has our mother's ambition, talent, and toughness."

WERNER MÖRATH

Schaffner, Zug Dravograd – Maribor.
Conductor, train from Dravograd to Maribor.

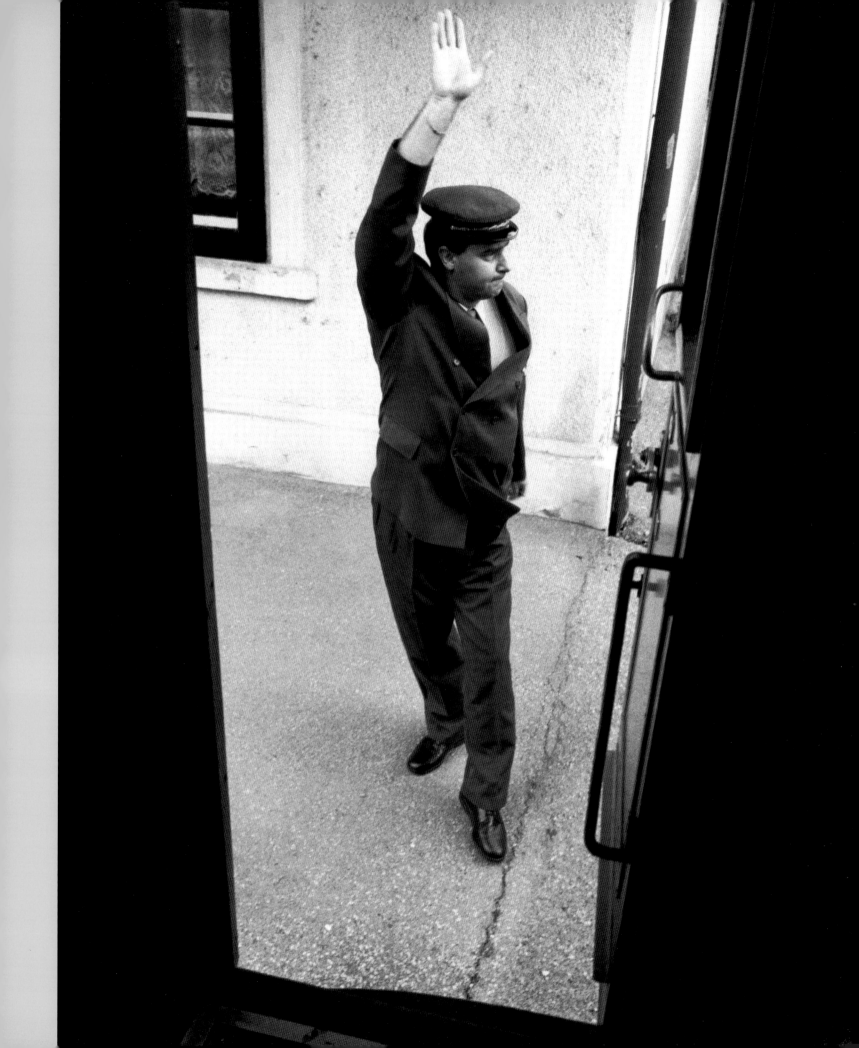

GESPRÄCH ZWISCHEN INGE MORATH UND SCHÜLERIN

Zala Lužnik: Ich habe gehört, daß Ihre Mutter in unserer Stadt, in Slovenj Gradec, geboren wurde und später Wissenschafterin geworden ist. Wie ist ihr das gelungen?

Inge Morath: Meine Mutter ist in einer Familie aufgewachsen, in der der Vater der Techniker mit einem absoluten Gehör und die Mutter die musisch Künstlerische war. Meine Mutter hatte – was ja nicht so überraschend ist – von beiden etwas. Und sie war unglaublich zielstrebig. So setzte sie sich in den Kopf, unbedingt ins Gymnasium zu gehen. Dafür mußte sie 1915 nach Marburg. Das war eine richtige Mutprobe. Die Buben sekkierten sie natürlich, arg war, als ihr einer die schönen blonden Zöpfe abschnitt!

Z.L.: Das klingt ja wie im Mittelalter. Heute sind es oft wir Mädchen, die in der Klasse den Ton angeben und auch besser lernen!

I.M.: Das war bei meiner Mutter später auch so. Sie hat die Zähne zusammengebissen und wurde Klassenbeste. Denn bei uns hat es immer geheißen, Probleme sind da, um gelöst zu werden. Wer das nicht kann, hat ein Problem. – So wurde meine Mutter auch für die Faulpelze und Dummköpfe in der Klasse interessant. Außerdem war sie als Vorzugsschülerin vom Schulgeld befreit. Das war gut für die kargen Familienfinanzen.

Z.L.: Wie war das bei Ihnen? Hatten Sie es schon leichter?

I.M.: Wie man's nimmt. Als ich 1929 in die erste Klasse gekommen bin, war gerade die große Weltwirtschaftskrise. Auch meine Eltern, die damals schon in Deutschland mit mir und meinem Bruder Werner lebten, hatten schwer zu kämpfen, Arbeit zu finden. Wir zogen ununterbrochen um. Ich hab zehn Mal die Schule gewechselt – das war den Eltern wurscht. Aber es hat mir nicht geschadet. Dadurch hab ich zum Beispiel schon früh Französisch gelernt.

Z.L.: Ich habe irgendwo gelesen, daß Sie auch Russisch können. Stimmt das?

I.M.: Ja, das ist auch so eine Geschichte, wie man aus der Not eine Tugend machen kann. Es war kurz nach dem Zweiten Weltkrieg, als mein Vater und ich bei einem befreundeten russischen Adeligen Russischstunden genommen haben. Das war schwer, aber toll. Ich wollte schon als Kind Russisch können, das hängt wahrscheinlich mit meiner Liebe zur slawischen Seele zusammen. Deshalb mag ich den weichen Klang Eurer Sprache auch so gern.

Z.L.: Schade, daß Sie nicht länger bei uns bleiben. Es tut sich ziemlich viel im neuen Slowenien. Musik, Theater, Literatur – alt und neu natürlich. Gerade in Marburg ist viel los. Da kommen auch viel Jugendliche von drüber der Grenze. Die mögen unsere Clubs, Konzerte, Theater und natürlich auch unsere guten Restaurants, die noch nicht so teuer sind.

I.M.: Meine Mutter hat Marburg sehr geliebt. Das Schifferlfahren auf der Drau, das Berggehen auf den Bachern. Schön ist es bei Euch!

<div align="right">REGINA STRASSEGGER</div>

Zala Lužnik, Schülerin aus Slovenj Gradec.
Zala Lužnik, schoolgirl from Slovenj Gradec.

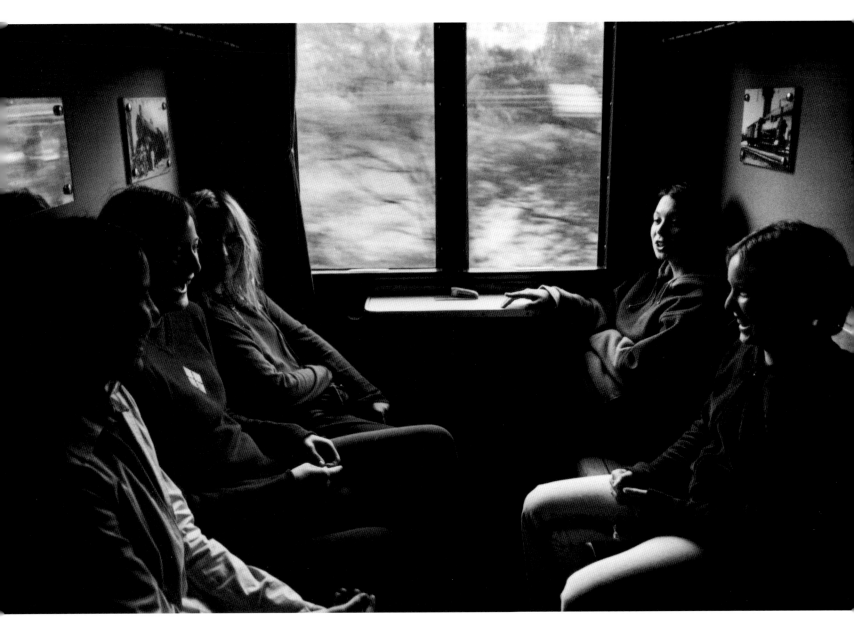

Schüler aus Slovenj Gradec unterwegs nach Maribor.
Pupils traveling from Slovenj Gradec to Maribor.

CONVERSATION BETWEEN INGE MORATH
AND A SCHOOLGIRL

Zala Lužnik: I've heard that your mother was born here in Slovenj Gradec and that she later became a scientist. How was that possible?
Inge Morath: My mother grew up in a family with a technically-minded father who had the perfect pitch and an artistically-gifted mother. My mother had—unsurprising really—aspects of both of them. And she was incredibly determined. For example, she set her mind on going to a Classical Gymnasium at all costs. In 1915 that meant going to Maribor. It was a real test of courage. The boys made fun of her of course; worst was when one of them cut off her beautiful blond plaits!

Z.L.: It sounds like in the Middle Ages. Today it's often us girls who call the tune in class. And we're better learners.

I.M.: It was the same with my mother later on. She gritted her teeth and was soon top of the class. Our family has always looked on problems as a challenge—they're there to be solved. If you can't do that, you've got a problem. So even the lazy and dumb kids in the class found my mother interesting. And then, as an honor-roll pupil, she was exempted from school fees, which was good for the family's precarious finances.

Z.L.: What was it like for you? Were things easier?

I.M.: That depends how you see it. When I started going to school in 1929 the Great Depression was on. My parents together with me and my brother Werner already lived in Germany, and for them, too, it was a hard struggle finding work. We were constantly moving. I changed schools ten times—my parents didn't care a bit. But it didn't do me any harm. And that way I was able to learn French early on.

Z.L.: I once read somewhere that you know Russian. Is that true?

I.M.: Yes, that's another story about making virtues out of necessities. It was shortly after World War II, and my father and I took Russian lessons from a Russian nobleman we were friends with. It was difficult, but marvellous. As a child I had always wanted to learn Russian, likely a result of my love of the Slavic soul. That's why I like the soft sounds of your language so much.

Z.L.: It's a pity you can't stay with us longer. There's pretty much going on in the new Slovenia: music, theater, literature—old and new, of course. Maribor in particular has a lot to offer. Lots of young people come from across the border. They like our clubs, concerts, theaters, and of course our good restaurants, too, which still aren't so expensive.

I.M.: My mother loved Maribor dearly. Boat trips on the Drava, hiking on the Bachern. Your locality is very beautiful.

REGINA STRASSEGGER

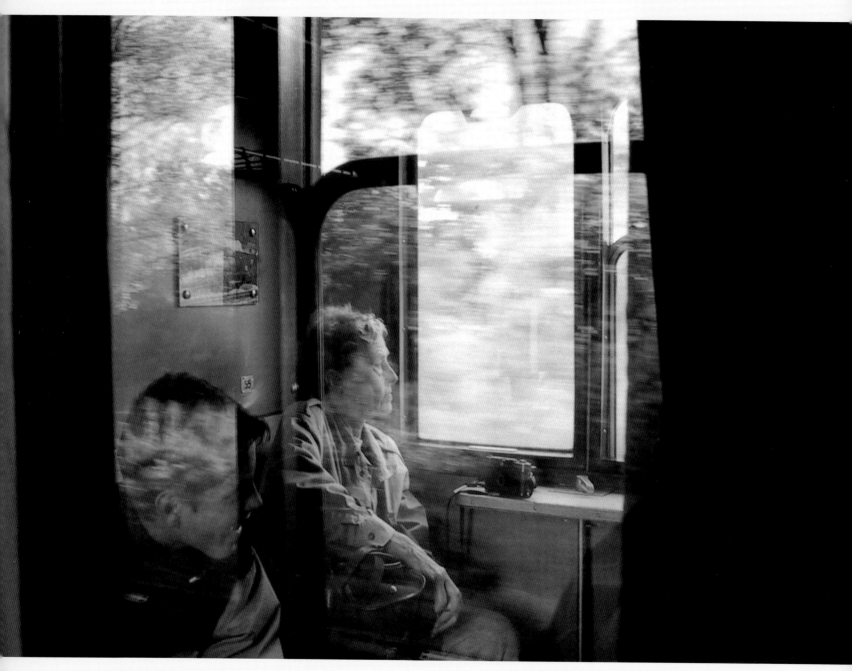

Inge Morath zwischen den Zeiten.
Inge Morath in-between times.

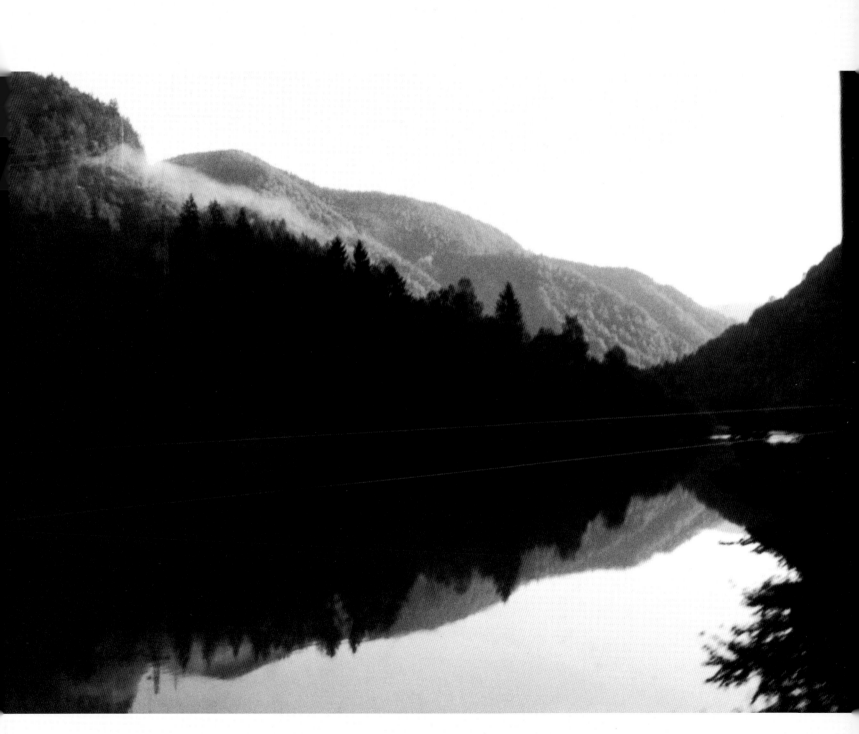

Die Drau vom Zug aus gesehen.

The River Drava from the train.

Inge Morath vor und auf der historischen Drau-Brücke.
Inge Morath in front of and on the historical Drava Bridge.

Straßenszenen in Maribor.
Street scene, Maribor.

Verlassenes Haus.
Deserted house.

Seitengasse in Maribor.
Side alley in Maribor.

Arkaden.

Arcades.

»Maribor erinnert sehr an Graz.«
"Maribor reminds one of Graz."

»Marburg in der Zukunft«, 1915.
"Marburg in the future," 1915.

Der vierhundertjährige Weinstock.
The 400-year-old grapevine.

Marburg, Poststempel 1898
Marburg, postmark 1898.

Stadtpark von Maribor.

Municipal park, Maribor.

»Stadtpark in Maribor. Der Pavillon, neben dem der Erzherzog
meine Mutter als Schülerin ansprach, als sie einmal zeichnete.«

"Municipal park, Maribor. The pavilion near which the Archduke
spoke to my mother when she was drawing here once as a schoolgirl."

Titti und Verehrer in den Weinbergen.
Titti and admirer in the vineyards.

Edgar Mörath in kaiserlicher Uniform.
Edgar Mörath in Imperial uniform.

Stellung im Ersten Weltkrieg,
Dolomiten, 1916.

Defense position in World War I,
Dolomites, 1916.

DER ERZHERZOG UND DER GENERAL

Späte Zeit. In die Baumkronen des Stadtparks von Maribor fällt goldenes Licht. Die Sonne zeichnet scharfe Konturen: Statuen, Personen, Bäume – Schattenrisse. Die Photographin bleibt immer wieder stehen, positioniert ihren Blickwinkel im Sucher der Kamera, sucht im Hier und Jetzt auch die ›Welt von Gestern‹, die der Mutter. Beim baumumsäumten Teich zum Beispiel, dem Treffpunkt romantischer Liebespaare, Jungfamilien. »Den hat die Titti geliebt, da gab es Sonntag nachmittags bei Picknicks extravagante Damen in ausgefallener Mode, schnittige Offiziere zu sehen.« Die Welt war längst aus den Fugen. Die Schüsse in Sarajewo waren schon gefallen, hatten nicht nur auf das Thronfolgerpaar, sondern auf die morbid gewordene Vielvölker-Monarchie gezielt. Erstmals Weltkrieg! Viele hatten es noch nicht begriffen, bekränzten die in den Krieg ziehenden Soldaten, träumten vom schnellen Sieg, waren noch in der abgehobenen Welt der Picknicks, Bälle, Feste versunken... An solch einem Nachmittag hatte die damals 17jährige Mathilde Wiesler eine wundersame Begegnung. »Meine Mutter liebte es, mit ihrem Zeichenblock in den Stadtpark zu gehen. Zum Teich oder zu diesem Pavillon«, erzählt Inge Morath, während sie auf den kleinen Rundbau schaut. »Bei diesem Pavillon ist bei der Titti – von dieser aufregenden Geschichte hat sie öfter gesprochen – ein Mann in prächtiger Uniform, der sich später als irgendein Erzherzog entpuppte, stehengeblieben und hat sich lobend über ihre schönen Zeichnungen ausgesprochen. Bei der Gelegenheit hat sie natürlich auch voller Stolz erzählt, daß sie – das einzige Mädchen im Marburger Realgymnasium – später Chirurgin werden wollte.« Das junge Mädchen – aus ihm wurde eine Pharmazeutin – ahnte damals nicht, wie sehr die kommenden Zeiten auf medizinische Reparaturkunst angewiesen sein sollten, wie nahe die vertraute Welt dem Kollaps war. Wie sehr auch das slowenische Volk auf Eigenständigkeit brannte, wie es den unterprivilegierten Status der ›Windischen‹ satt hatte, das Ignorieren ihrer Sprache. »Ich hab meine Mutter öfter gefragt, warum sie alle kein Slowenisch sprechen, obwohl sie dort geboren und aufgewachsen sind. Ihre Eltern wollten es nicht. Es hieß sogar, "Wer lernt schon Windisch!"« Das war die kleinliche Rückseite der sagenhaften k.u.k. Kosmopolie – besondere Menschen, Mythen, Märchen, beseelt von Vielsprachigkeit, Kunst, Philosophie, Musik. So wunderbar beschrieben vor allem von jüdischen Autoren dieser Zeit. Diesen vielfältigen Zauber mochten die einfältig Nationalen nicht. Die Morath sagt nüchtern: »Meine 100jährige Tante, die jüngere Schwester meiner Mutter, hat es erst kürzlich auf den Punkt gebracht. "Wir haben vieles nicht begriffen, auch das Slowenische nicht. Wir waren einfach zu blöd, trotzdem wir so g'scheit waren!"« Auf die dunkle Eisenbüste des lokalen Volkshelden, Rudolf Maister, fällt fahles Licht. Morath sagt: »Den haben wir schon als Grafitti, da war er schöner.« Dieser slowenische General war es, der im Chaosjahr 1918, in dem in der k.u.k. Monarchie alles zusammengebrochen ist, mit der Besetzung der damaligen Untersteiermark, der Štajerska, sowie Landstrichen nördlich der heutigen Staatsgrenze das militärische Signal zur Loslösung von Österreich gab. »Unsere Eltern haben nie viel über diesen Umsturz erzählt. Sie haben es verschwiegen, verdrängt, wollten sich diese schöne Zeit wie einen Traum bewahren.« Der Traum war ausgeträumt. Noch im Dezember 1918 gingen die slowenischen Behörden rigoros mit Aufrufen, Erlässen gegen die bis dahin im Land dominierende deutschsprachige Bevölkerung vor. Von feindlichen Bürgern, gefährlichen Vereinen war die Rede, deren Vermögen im Land zu bleiben hatte. Zwischen 1918 und 1919 mußten 14 000 Deutschsprachige – hauptsächlich Beamte, Berufssoldaten und Eisenbahner – das Land verlassen. Zeit der Abrechnung, Zeit der Abwehrkämpfe, Zeit der aufgerissenen Gräben!

REGINA STRASSEGGER

THE ARCHDUKE AND THE GENERAL

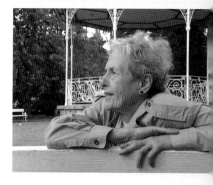

Inge Morath vor k.u.k. Pavillon.
Inge Morath in front of a
Habsburg Pavillion.

Early evening. Golden light falls among the foliage of the trees in Maribor's municipal park. The sun casts harsh shadows: statues, people, trees—silhouettes. The photographer keeps pausing to assert her vision through the viewfinder, seeking in the here and now, among other things, the "world of yesterday," her mother's world. The pond ringed with trees, for example, rendezvous for romantic couples and young families. "Titti loved this pond. On Sunday afternoons you could see picnickers, extravagant ladies in flamboyant fashions, and handsome officers." The world was long since out of joint.

The shots in Sarajevo, aimed not just at the royal successor and his consort, but at the moribund multinational monarchy—had already been fired. World War! Many were slow to grasp, dreamt of a quick victory, crowned the soldiers with wreaths as they marched to war; they were still living in a dreamworld of picnics, balls, and banquets.... One afternoon around this time, Mathilde Wiesler, who was then seventeen years old, experienced a magic encounter. "My mother loved coming down to the park with her drawing block, to the pond or the pavilion there," says Inge Morath, looking at the small circular structure.

"A man in glittering uniform, who turned out to be some Archduke or other, stopped near the pavilion where Titti was—she talked about this thrilling adventure several times —and spoke admiringly of her fine drawings. Of course, she did not miss the opportunity to say proudly how she—the sole girl at the Classical Gymnasium in Maribor—wanted to become a surgeon." The young girl—she became a pharmaceutical chemist—had no idea how badly medicine's powers and the surgeon's art would soon be needed, how close the familiar world was to chaos; or how ardently the Slovenians yearned for independence, how sick and tired they were of their underprivileged—"Windisch"—status, and of their language being ignored. "I asked my mother several times why none of them spoke Slovenian, although they were born and grew up there. Her parents were against it. They even said, "Who learns Windisch!" That was the petty reverse side of the fabulous cosmopolitan Habsburg polity—singular people, myths, and fairy tales, polyglottal, endowed with art, philosophy, music. In particular Jewish authors of the period described it wonderfully. The one-sided nationals had no time for this many-sided magic. "My one hundred-year-old aunt—my mother's younger sister," Morath says matter-of-factly, "put it in a nutshell recently: "There were lots of things we didn't understand, including Slovenian. So clever on the one hand, yet so dumb.""

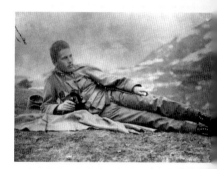

Vater Mörath im Ersten Weltkrieg.
Inge Morath's father, World War I.

Pale light falls on the iron bust of the local national hero, Rudolf Maister. Morath: "He looks better in that graffiti we photographed." This was the Slovenian general who, in the chaos of 1918 when the entire Austro-Hungarian monarchy had collapsed, gave the signal to break away from Austria by occupying what was then Lower Styria, Štajerska, and areas north of the present border. "Our parents never talked much about this revolt. They passed over it in silence, repressing it. They wanted to preserve the happy past like a dream." The dream was over. By December 1918 the Slovenian authorities were already taking rigorous action against the till-then dominant, German-speaking population with proclamations and edicts. Between 1918 and 1919 fourteen thousand German-speaking nationals—mainly state officials, professional soldiers, and railwaymen—had to leave the country. Settling of accounts. Defense measures. Sinking of dividing lines.

REGINA STRASSEGGER

Slowenisches Kriegsmuseum
mit Kreuzen von österreichischen
Gefallenen.

Crosses of Austrian dead in the
Slovenian War Museum.

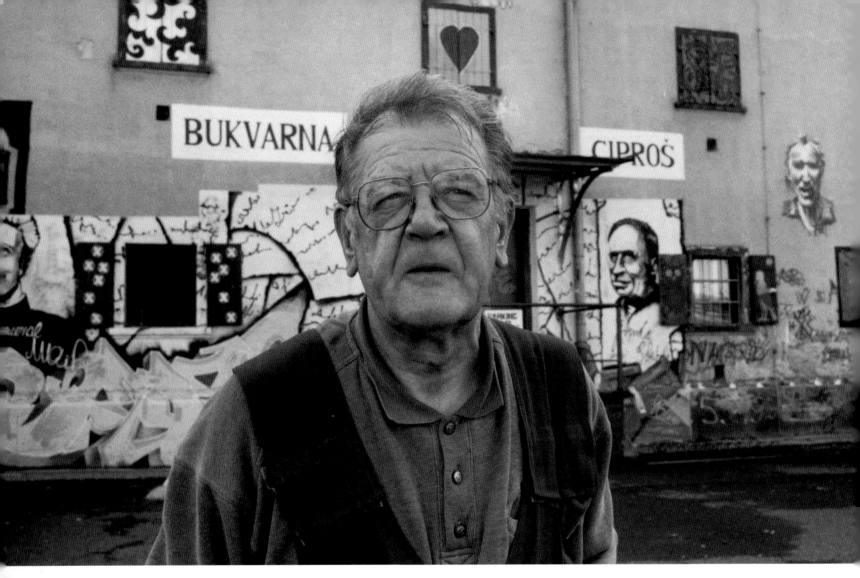

Ferdinand Wenzel, ein slowenischer Altösterreicher.

Ferdinand Wenzel, a Slovenian old-Austrian.

General Maister, der Rebell gegen die Österreicher,
als Grafitti.

General Maister, rebel against the Austrians, as graffiti.

General Maister beim historischen Aufruf
›Staatsbürger! Südslaven!‹.

General Maister's historic proclamation:
"Citizens! South Slavs!"

GRENZEINSCHNITT
BORDER INCISION

»Grenzland – Problem ohne Ende. Nie kann man sein eigen nennen, was einem so kostbar ist. Stets muß man teilen. Und wenn niemand außer dem eigenen Volk darauf Anspruch erhebt, dann existiert das Land nicht mehr, das einem so kostbar war.«

<div align="right">

AUS: *DIE POETIK DER GRENZE*, HRSG. VON DER LITERATURZEITSCHRIFT

LICHTUNGEN 77, 20. JG., 1999

</div>

"Borderland—an endless problem. That which is most precious to one, one can never call one's own. One must always share. And when no one except one's own people lays a claim to it, the country that was so precious to one no longer exists."

<div align="right">

FROM "DIE POETIK DER GRENZE," ED. *LICHTUNGEN*

(LITERARY JOURNAL) 77/20, 1999.

</div>

Österreichisch-slowenischer Grenzstein: St Germain 1919.
Austro-Slovenian boundary stone: St. Germain 1919.

Inge Morath beim Grenzspaziergang. – Mit der Grenzziehung 1919 verliert Österreich ein Drittel der Steiermark und ein Drittel der steirischen Bevölkerung. Die Grenze 1919 verlieh dem slowenischen Nationalbewußtsein internationale Anerkennung.

Inge Morath walking at the border. When the border was drawn in 1919 Austria lost a third of Styria and a third of its Styrian population; with the 1919 border, Slovenian nationalist aspirations received international recognition.

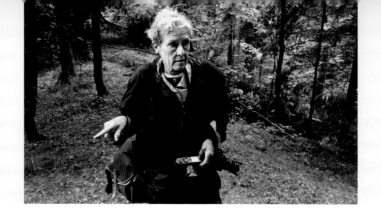

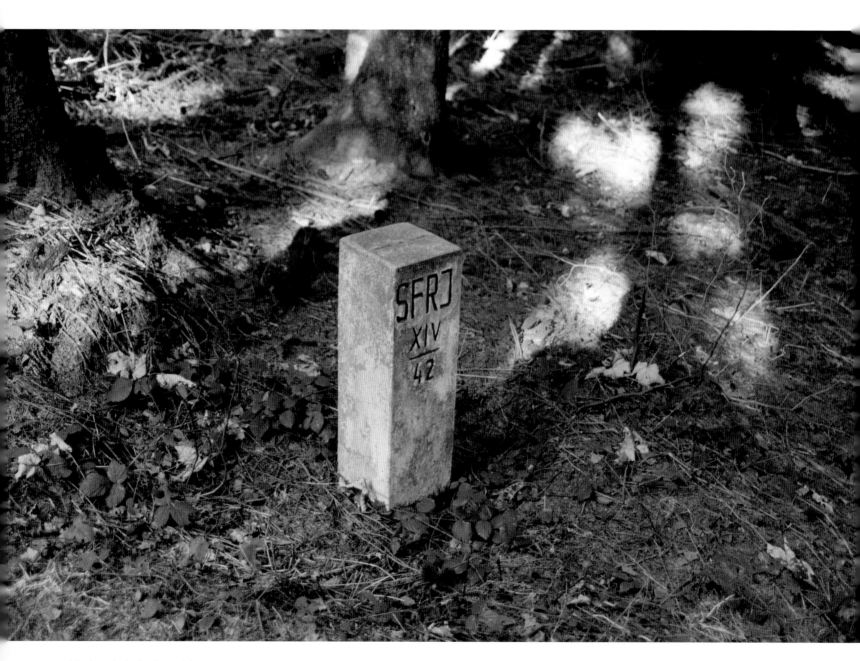

Alter jugoslawischer Grenzstein.

Old Yugoslavian boundary stone.

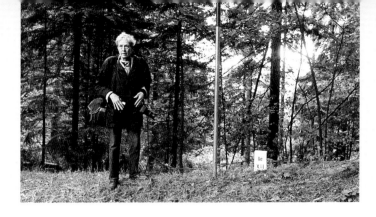

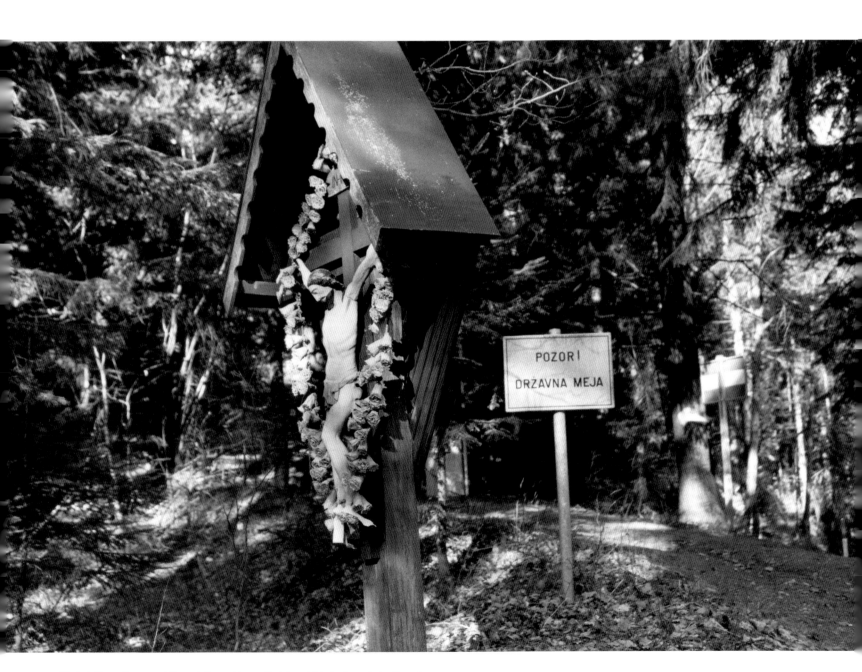

Marterl, Grenzstange und Grenzstein markieren die österreichisch-slowenische Grenze.
Wayside cross, boundary post, and boundary stone mark the Austro-Slovenian border.

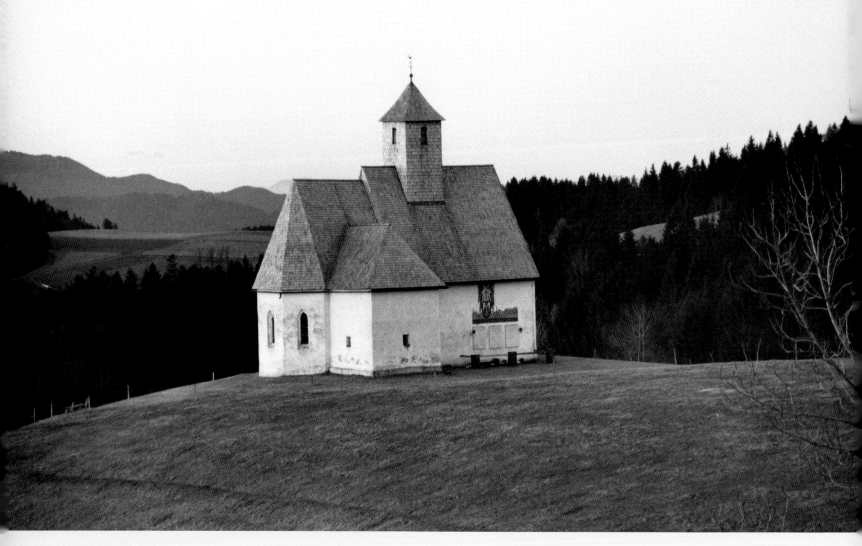

Leonhardi-Kapelle (17. Jh.), die bei der Grenzziehung 1919 an das Königreich
der Serben, Kroaten und Slowenen fiel; nach 1921 wieder bei Österreich.

17th-century chapel of St. Leonard; with the 1919 border it fell to the Kingdom
of Serbs, Croats, and Slovenes; after 1921 it reverted to Austria.

Kreuze auf dem Friedhof von Sankt Lorenzen.

Crosses in the cemetery at Sankt Lorenzen.

Mutter Prassnik vor ihrem Haus.
Mother Prassnik in front of her house.

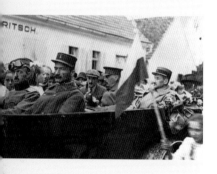

Grenzkommission 1921 mit
japanischem Grenzkommissär.
1921 Border Commission with
Japanese Chief Commissioner.

»Die Geschichte der Maria Prassnik ist extraordinär.
Mir wird von ihrem heute weit über 80jährigen Sohn
erzählt, daß durch die Grenzziehung von 1919 der Hof
der Eltern und weitere sechs Höfe an das Königreich
der Serben, Kroaten und Slowenen gefallen sind.
Das war für die deutschsprachigen Bauern ein großes
Unglück. Aber die resolute, überaus gläubige Ortsbäuerin
hat immer an Wunder geglaubt. Sie hat nicht locker
gelassen, hat Briefe geschrieben, und so ist im Juni
1921 noch einmal eine Grenzkommission gekommen,
der ein japanischer Offizier vorgestanden ist. Vor den
hat sich die damals 37jährige Maria Prassnik auf den
Boden geworfen, seine Knie umfaßt und dabei gefleht,
die Höfe mögen doch zurück in die Heimat kommen.
Das hat den Japaner so beeindruckt, daß die Grenze
tatsächlich noch einmal verlegt worden ist. Ähnliche
Geschichten werden aber auch von der anderen Seite
der Grenze erzählt.«

INGE MORATH

"Maria Prassnik's story is extraordinary. Her over
eighty-year-old son tells me that when the border was
drawn in 1919 her parents' farm and six others fell
to the Kingdom of the Serbs, Croats, and Slovenes,
a grave misfortune for the German-speaking farmers.
But Maria Prassnik, resolute, exceedingly pious
daughter of local farming stock that she was, had
always believed in miracles. She dug in her heels,
wrote letters, and, in June 1921, a second Border
Commission came with a Japanese officer in charge.
The then thirty-seven-year-old Maria Prassnik threw
herself on the ground at his feet, clasped his knees,
and begged him to return the farms to the homeland.
This made such an impression on the Japanese officer
that the border really was redrawn. Similar stories are
also told on the other side of the border."

INGE MORATH

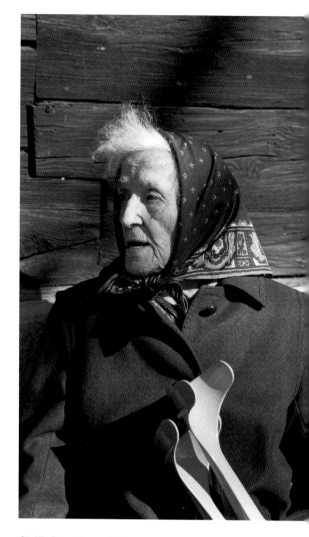

Cäcilia Prassnik war Tochter eines Doppelhofbesitzers.
Cäcilia Prassnik, daughter of the proprietor of a double farm.

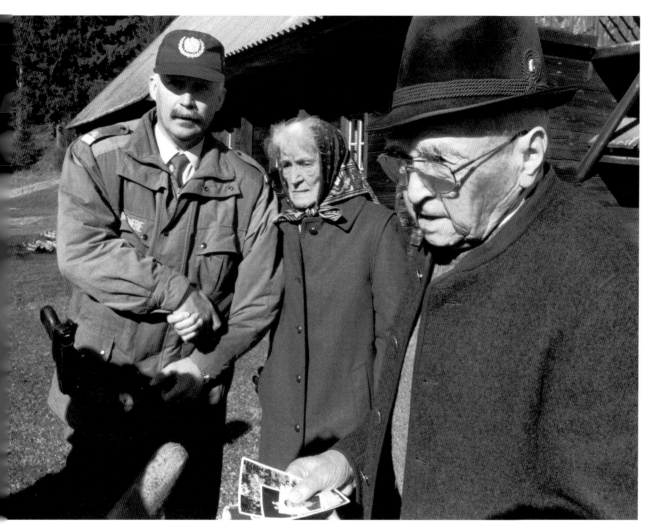

Franz Prassnik und Frau mit Grenzgendarm.
Franz Prassnik and wife, with border guard.

Grenzinsignien.
Border insignie.

»Unsere Eltern haben uns Kindern nie etwas über dieses plötzliche Wegmüssen aus der Untersteiermark erzählt. Klar war, sie haben sehr viel zurücklassen müssen. Katastrophal war auch, daß der Großvater, der ja – wie die meisten Deutschsprachigen dort – Beamter war, sofort pensioniert worden ist. Die sind da praktisch vor dem Nichts gestanden. Unsere Mutter hat, hartnäckig wie sie war, trotzdem 1918 in Graz zu studieren begonnen.«

INGE MORATH

"Our parents never told us children anything about their sudden, enforced departure from Lower Styria. Of course, they had to leave almost everything behind. It was a catastrophe that Grandfather—a state official like most of the German-speaking people—was immediately pensioned off. It put them on the brink of ruin. Despite which, being the determined woman she was, my mother began studying in Graz in 1918."

INGE MORATH

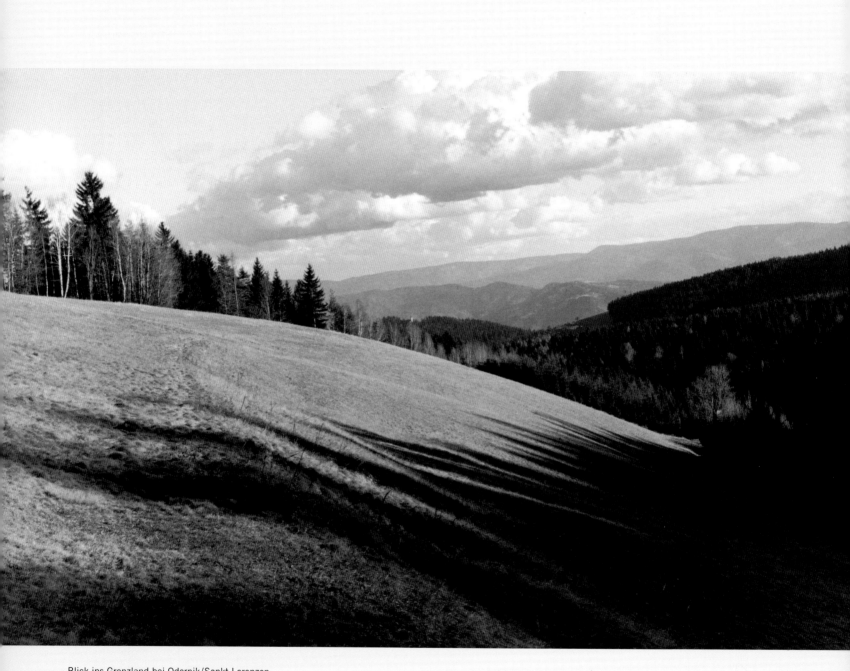

Blick ins Grenzland bei Odernik/Sankt Lorenzen.

Borderland near Odernik/Sankt Lorenzen.

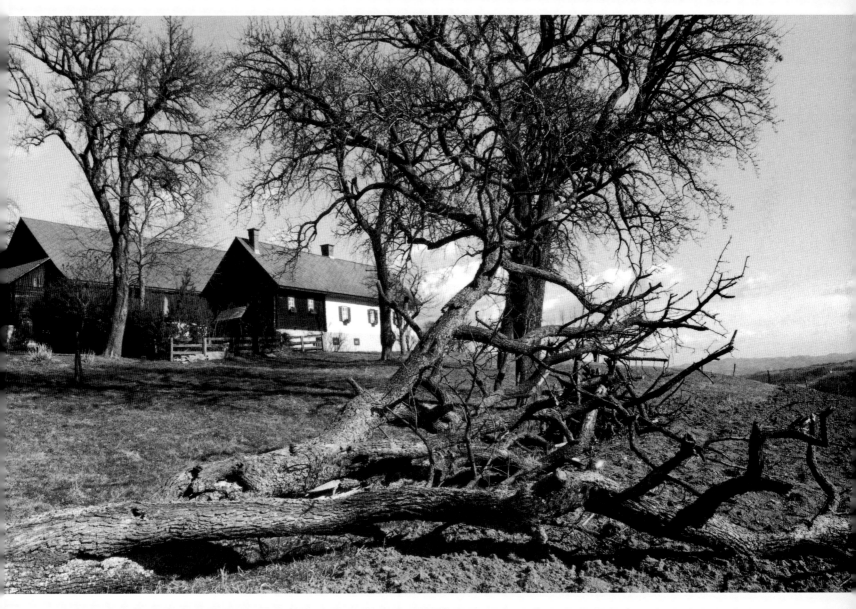

Doppelbesitz: eine Hälfte in Österreich, eine in Slowenien.

Double farm: one half in Austria, one in Slovenia.

Folgende Doppelseite:
Besucher am Doppelhof.

Overleaf:
Visitors to the double farm.

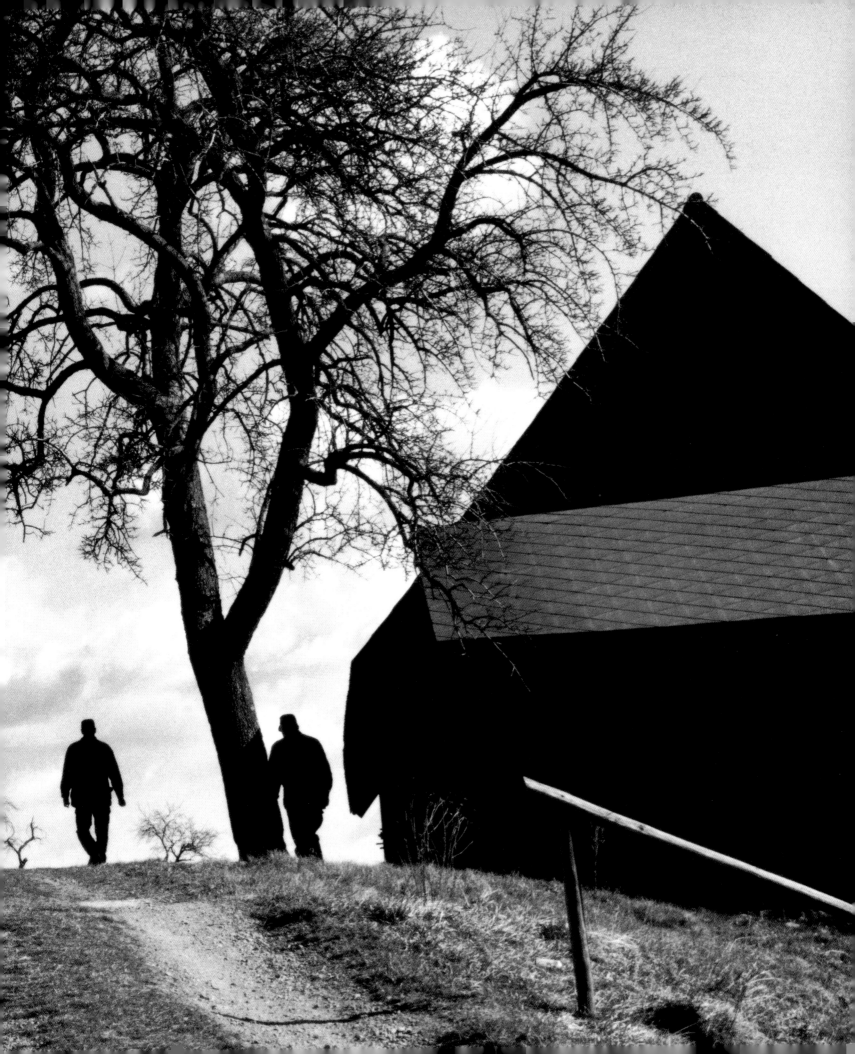

KINDHEIT IM HAUS AN DER GRENZE
CHILDHOOD AT THE BORDER

»Renate, Schatzilein – muß gerade an Dich denken. Mache Krautsalat mit dem
wunderbaren Kernöl von Deiner Wachteleierfrau. Wir treffen uns viel zu selten in
diesem herrlichen Paradies, im Weingarten, wo wir als Kinder wohl die schönsten
Zeiten verbracht haben. Schwammerl suchen, Schlangen schauen, Trauben essen.
Manchmal werde ich ganz melancholisch.«

INGE MORATH, BRIEF AN RENATE MOSZKOWICZ

"Renate, darling—I just thought of you. I'm making coleslaw with the
wonderful seed oil from your quail-egg lady. We meet far too seldom in that
magnificent paradise, the vineyard where we spent such wonderful times as
children. Gathering mushrooms, watching snakes, eating grapes. I sometimes
get awfully melancholy."

INGE MORATH, LETTER TO RENATE MOSZKOWICZ

Haus an der Grenze.
House at the border.

Blick vom Kogel ins benachbarte Weinland.

View from the hill into neighboring wine country.

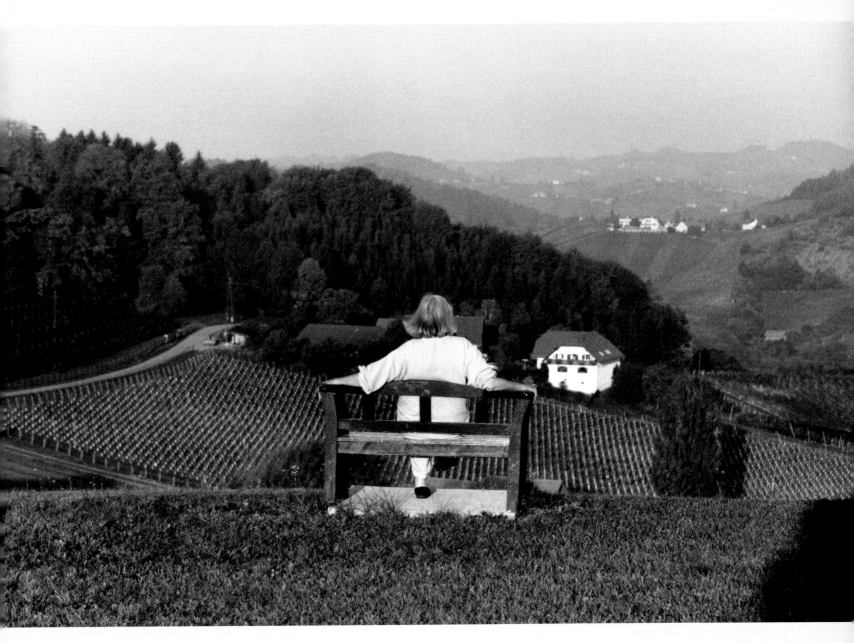

»Renate Moszkowicz schaut ins Paradies unserer Kindheitssommer.«

"Renate Moszkowicz gazing out into the summer paradise of our childhood."

»Meine Eltern Vilma und Armin Dadieu waren mit den Möraths gut
befreundet. Beide Familien hatten bis 1919 in Marburg gelebt und
unter dem Verlust der Heimat sehr gelitten. Sie haben viel miteinander
über die schönen Zeiten ›damals‹ geredet. Beide Familien waren
deutschnational eingestellt. Meine Eltern haben anläßlich meiner
Geburt 1927 und aus Heimweh nach der Untersteiermark das Haus an
der Weinstraße gekauft und dort mit uns Kindern und ihren Freunden
wundervolle Zeiten verbracht. Bis dann der Krieg gekommen ist.«

RENATE MOSZKOWICZ

"My parents Vilma and Armin Dadieu
and the Möraths were good friends.
Until 1919 both families had lived in
Maribor and they suffered greatly through
the loss of their homeland. They talked
much together about the good times
"back then." Both families were German-
nationalist in their thinking. My parents,
on the occasion of my birth, and because
they were homesick for Lower Styria,
bought the house on the wine route where
they spent wonderful times with us children
and their friends. Until of course the war
came along."

RENATE MOSZKOWICZ

Vilma und Armin Dadieu mit Tochter Renate.
Vilma and Armin Dadieu, with daughter Renate.

Kindheitsbilder. Die befreundeten Familien
Dadieu und Mörath.
Childhood photos. The Dadieu and Mörath
families.

Edgar und Mathilde Mörath.
Edgar and Mathilde Mörath.

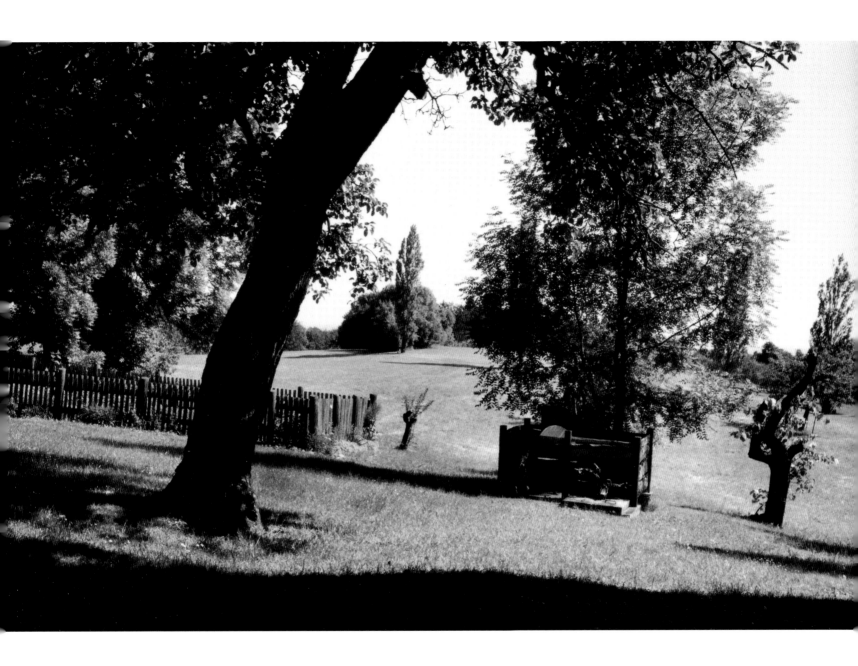

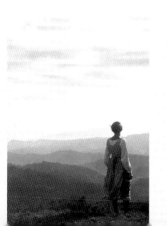

Vilma Dadieu.

Inge Morath und ihr Bruder Werner.
Inge Morath and her brother Werner.

Inge Morath, 1934.

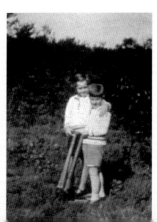

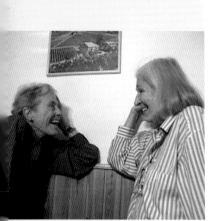

Inge Morath mit Freundin
Renate Moszkowicz.

Inge Morath and friend
Renate Moszkowicz.

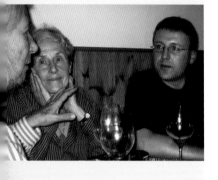

DIALOG ZWISCHEN RENATE MOSZKOWICZ UND INGE MORATH

I.M.: Kann man da auf dem Bild sehen, wo wir damals vom Haus heruntergegangen sind?

R.M.: Da ist der Rebenhof, die hatten immer so wunderschöne Ostereier, und da dazwischen sind wir dann herunter nach Svečina/Witschein.

I.M.: Ich kann mich noch erinnern, da gab's in einem dieser Weingärten diese herrlichen Pfirsiche. Einfach köstlich – noch dazu von Nachbars Garten...

R.M.: Und die vielen Schwammerln zum Heidensterz. Am besten war der aber im Gasthaus gegenüber der Kirche in Witschein. Das gibt's heute nicht mehr.

I.M.: Und beim Zurückhinaufgehen war's dann nicht so schön – nach dem vielen Essen.

R.M.: Aber am besten erinnere ich mich an den Herbst. Am Tag die Weinlese, am Abend und die ganze Nacht ist es dann mit dem Pressen weitergegangen. Dann haben sie die windischen Lieder gesungen. Wenn ich die hör', fang' ich heute noch zu weinen an.

I.M.: Die waren soo schön – unglaublich!

R.M.: Und das leise Knarzen des Preßbaums. Die Weinhanderln haben draußen gezirpt – das ist so eine seltene Sorte von Grillen.

I.M.: Und das Schlagen der Klapoteza im Wind. Es war wie im Paradies. Wunderwunderschön!

DIALOGUE BETWEEN RENATE MOSZKOWICZ AND INGE MORATH

I.M.: Can one see in the picture where we used to go down from the house?

R.M.: There's the Rebenhof, they always had such wonderful Easter eggs, and between them is where we used to go down to Svečina.

I.M.: I remember there were these magnificent peaches in one of the vineyards. Simply delicious—from a neighbour's garden into the bargain....

R.M.: And the mushrooms with "Heidensterz" [hot polenta dish]—that was best at the inn opposite the church in Svečina. It no longer exists today.

I.M.: And then having to climb the hill on the way back wasn't so nice after all—after a big meal.

R.M.: I remember the fall best. Harvesting grapes by day, then pressing them in the evening and right through the night. It was then they sang the Slovenian songs. Hearing them still makes me cry even today.

I.M.: They were sooo beautiful—unbelievable!

R.M.: And the gentle creaking of the winepress. The "Weinhanderl" would be chirruping outside—an uncommon kind of cricket.

I.M.: And the "klapotez" clacking in the wind. It was like being in paradise. Utterly wonderful.

Weg nach Svečina.
Road to Svečina.

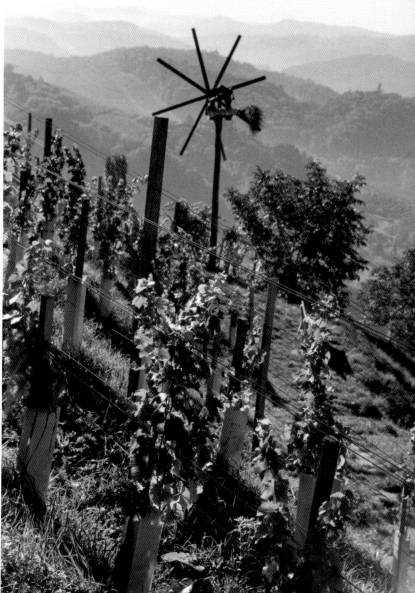

Der Klapotez soll Vögel von den reifen Trauben fernhalten.
"Klapotez" for keeping birds away from the ripe grapes.

Folgende Doppelseite: Kinder vergnügen sich im Heu.
Overleaf: Kids enjoying themselves in the hay.

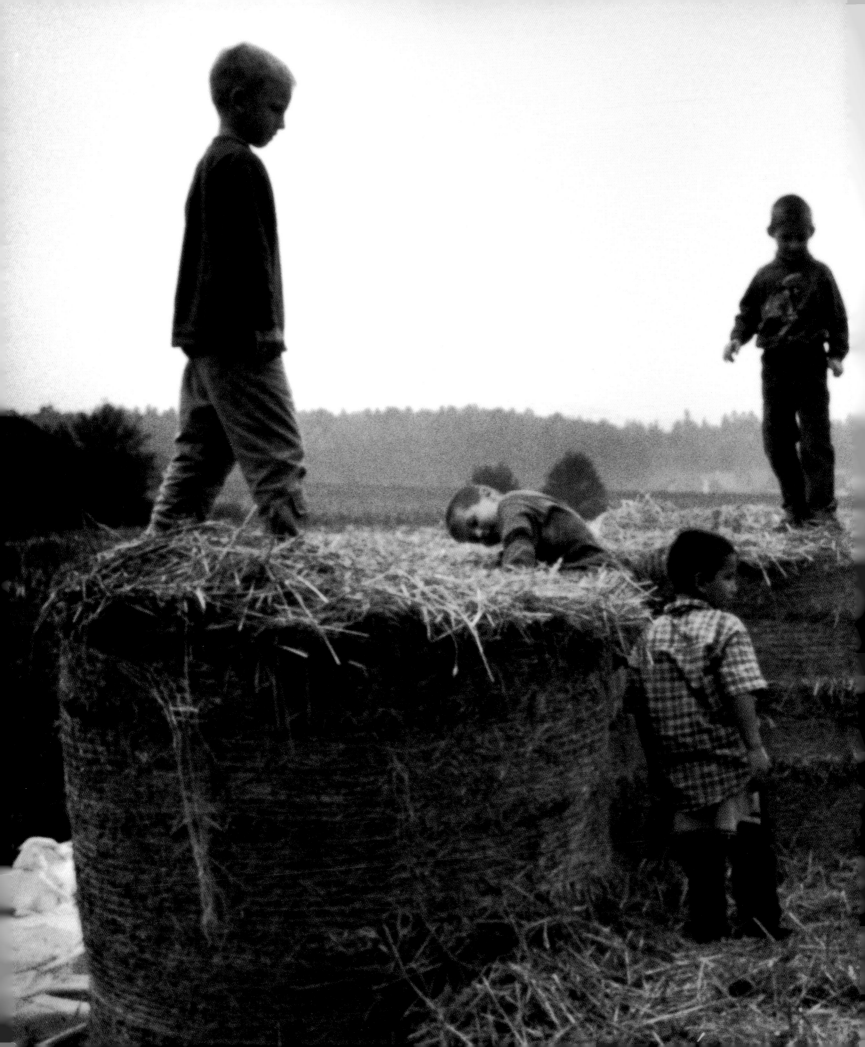

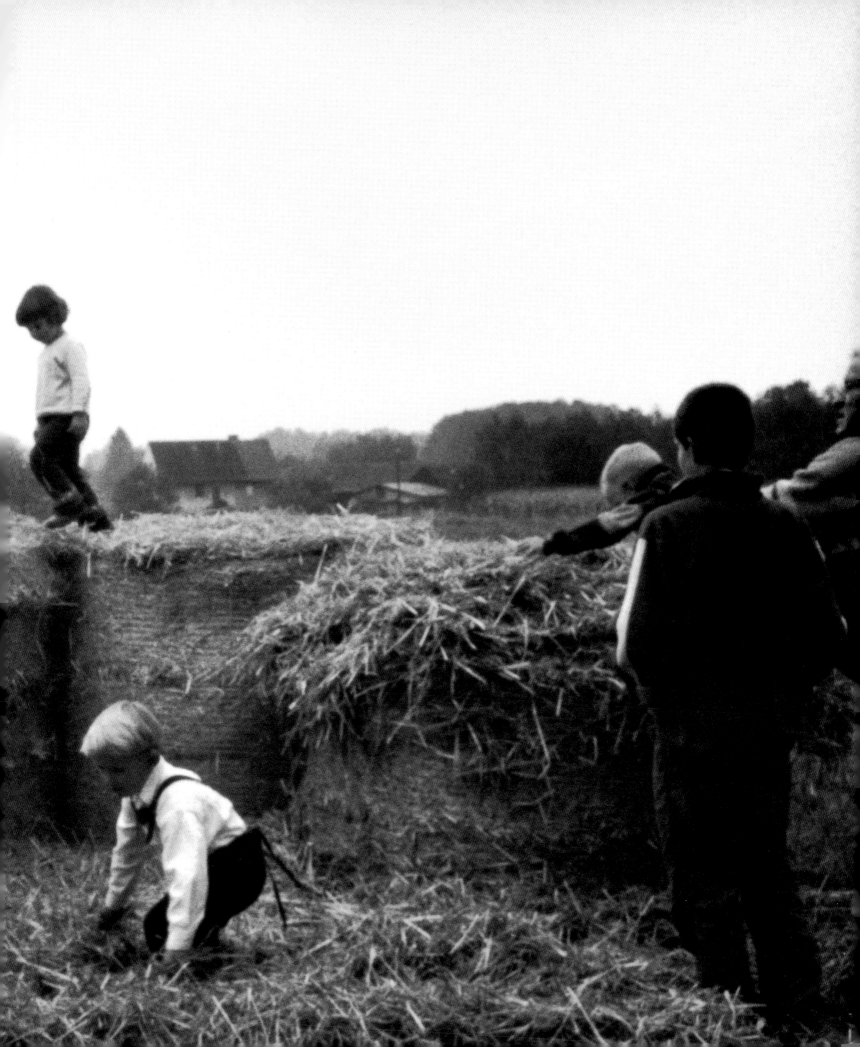

Bub mit Parasol.

Boy with mushroom.

Mein Ingelein!

Wer hätte das gedacht, daß diese Dreharbeiten uns so weit in unsere Kindheit zurückführen; uns Beglückendes von einst wiederbescheren, aber uns auch in Räume führen würden, die wir bisher vermieden haben.

Mir ist zum Beispiel erst jetzt richtig bewußt geworden, daß ich als Kind von der Grenze kaum was gespürt hab', obwohl unser Haus beinah mitten drauf gestanden ist. Im Nachhinein erscheint manches unwirklich. – Erinnerst Du Dich, wenn wir schon im Bett gelegen sind und meine Mutter mit dem Kaplar, das war der Obere der serbischen Grenzsoldaten, vor dem Fenster gesessen ist? Die haben leise miteinander geredet und Zigaretten geraucht, die waren einfach befreundet, da hat sich niemand darum geschert, auch nicht, wenn sie mit den Grenzern unten in der Karavla, das war die Baracke, mit denen gebratenes Lamm und noch allerlei Gutes gegessen und Slibowitz getrunken haben. Deshalb konnten wir auch so unbeschwert hin und hergehen, auch weil das alte Haus am Kogel über der Grenze früher einmal unser Wohnhaus gewesen ist. Und dann ist ja der April 1941 gekommen. Erinnerst Du Dich? Da war ein unglaublicher Trubel. Unsere Eltern haben feierlich auf die Untersteiermark angestoßen. Von ›Heim ins Reich‹ war die Rede. – Wir waren damals zu blöd, um zu begreifen, was wirklich passiert war. Du weißt ja, die Nazis haben mit dem Überfall auf Jugoslawien, das damals noch ein Königreich war, eine weitere Front im Zweiten Weltkrieg aufgemacht. Nur: Ich war damals so in mein Leben eingesponnen und habe nicht bemerkt, wie viel Unglück in der Welt war. Du hast sicher mehr davon mitbekommen, Du bist einige Jahre älter und hast ja schon in Berlin gelebt und konntest nur mehr unter großen Schwierigkeiten zu uns kommen. Aber unser Kontakt ist ja nie abgerissen. Und trotzdem haben wir über die schreckliche Zeit in Berlin nie wirklich gesprochen, was wir doch aber einmal tun sollten. Vielleicht weißt Du gar nicht, daß Du immer schon eine so wichtige Freundin für mich warst, die ich immer bewunderte: Deine Schönheit, Deine Gescheitheit und daß Du eben Du bist. Ich umarme Dich!

Deine Renate

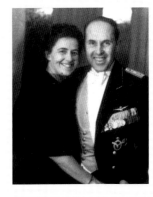

Großvater Wiesler, der Grenzvermesser.
Grandfather Wiesler, the border surveyor.
Maribor.

Mathilde und Edgar Mörath, 1941.
Mathilde and Edgar Mörath, 1941.

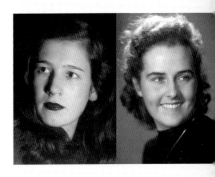

Die Freundinnen Renate
und Inge, 1940.
Friends Renate and Inge, 1940.

My little Inge,

Who ever thought that shooting this film would take us so far back into our childhood, bringing back happy memories but also leading us into spaces we've avoided until now. For example, it's only now I've fully realized how I scarcely perceived the border as a child—although our house practically stood right on it. Looking back, certain things seem unreal.—Do you remember when we were already in bed and my mother would sit by the window outside with the *kaplar*, the captain of the Serbian border guards? They would chat away quietly, smoking cigarettes; they were just friends, no one could care less, or when they ate roast lamb with the border soldiers down at the *karavla*—the barracks—and all sorts of other good things, and drank slivovitz. That was why we were free to go back and forth as we wished; also because the old house on the hill over the border used to be ours. And then April 1941 came. Remember? It was an incredible fuss. Our parents toasted Lower Styria ceremoniously. They talked about it "coming home to the Empire."—We were simply too dumb at the time to realize what had really happened. As you know, in invading Yugoslavia, still a kingdom then, the Nazis had opened up another war front. Only I was so wrapped up in my life at the time that I didn't notice how much misery there was in the world. You picked up more than I did, I'm sure. You were a few years older and had already lived in Berlin. It was only with great difficulty that you could visit us. But we never lost touch. Despite which—we've never talked about your terrible time in Berlin, though we ought to one day. You may not know it, but you were always a very important friend for me. I always looked up to you—your beauty, your intelligence, and simply because you are you.

I embrace you.

Renate

Nazi-Einmarsch in
Maribor/Marburg, April 1941.
The Nazis enter Maribor, April 1941.

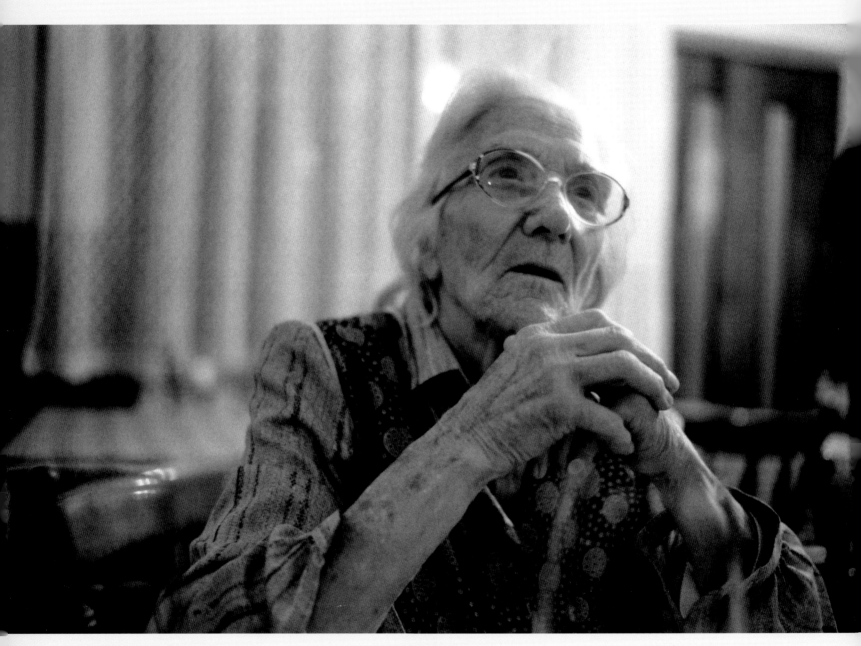

Frau Valdhuber erinnert sich an Krieg, Besetzung und Partisanen.
Furchtbare Geschichten auf beiden Seiten.

Frau Valdhuber reminisces about war, occupation, and partisans.
Terrible stories are told on both sides.

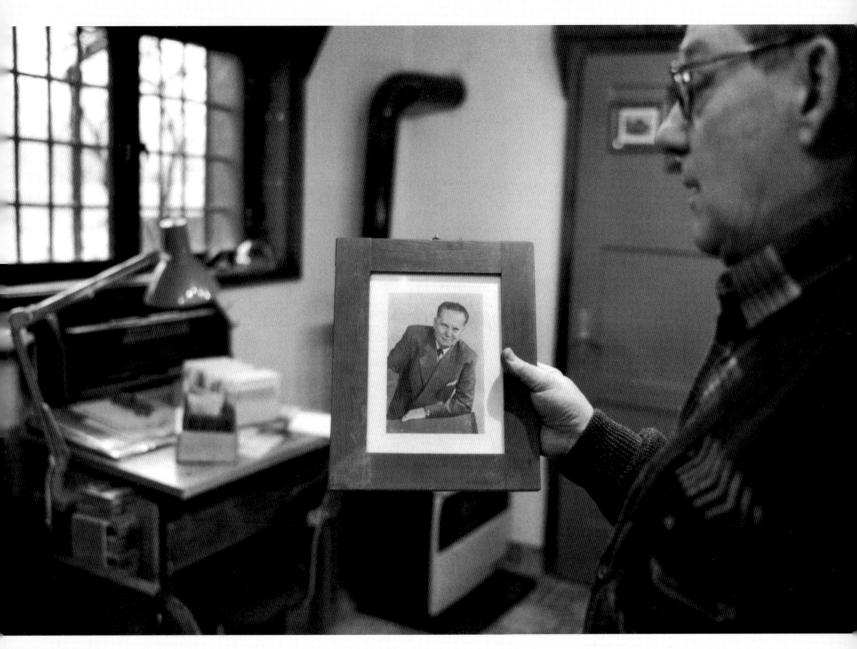

Ferdinand Leitinger mit Foto von Tito in Zivil.
Sein Vater war ein großer Titoverehrer.

Ferdinand Leitinger with a photo of Tito in civilian clothes.
His father was a great Tito admirer.

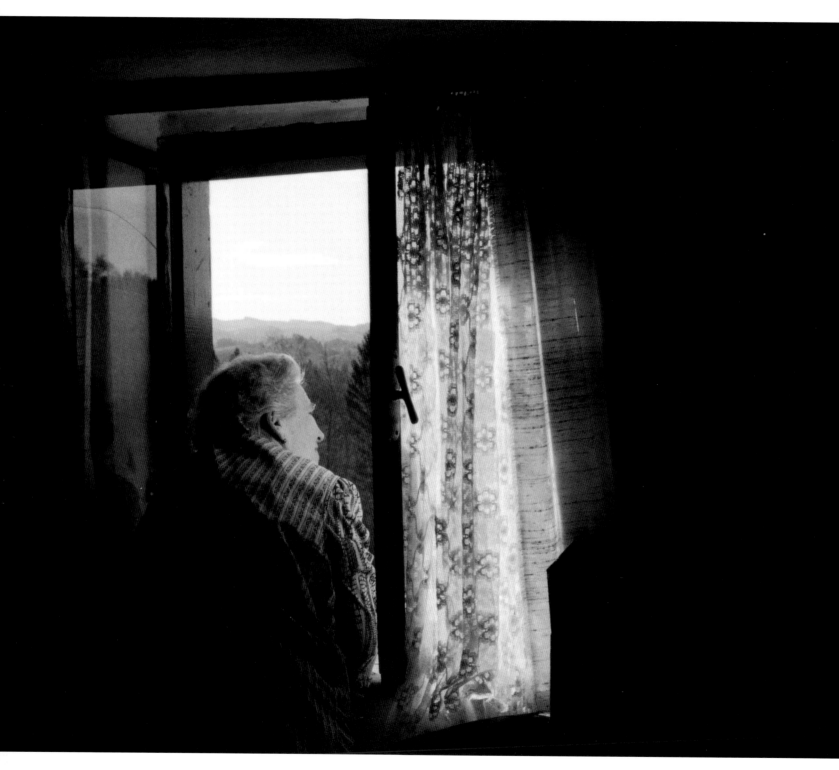

Rosa Weiland. Blick zur Grenze.

Rosa Weiland looking out toward the border.

»Haus an der Weinstraße, in dem jüdische Familien auf ihrer Flucht kurzfristig Zuflucht gefunden haben.«

"House on the wine route where fleeing Jewish families found temporary refuge."

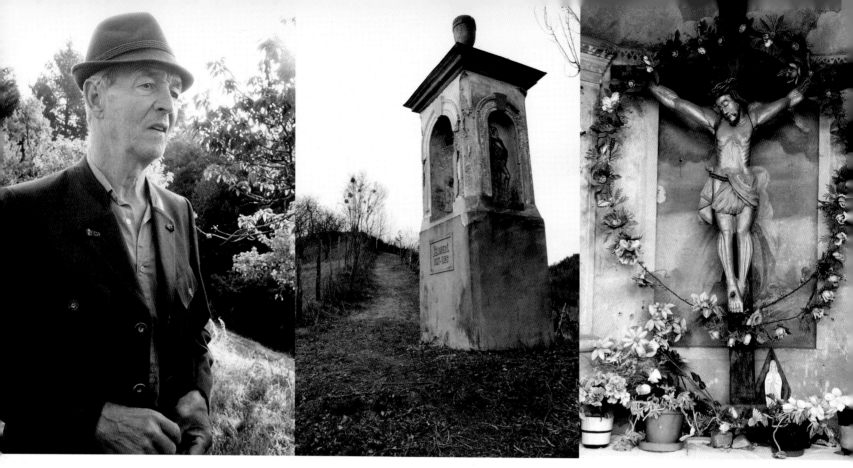

Ivan Finster erinnert sich.
Ivan Finster reminisces.

Grenzmarterl.
Border shrine.

Mit Blumen geschmücktes Kruzifix am Wegrand.
Wayside crucifix adorned with flowers.

SPURENSUCHE IM GRENZWALD

Der Mann im grünen Jägeranzug zieht seinen Hut, streckt der zierlichen Frau mit der Kamera, dem weißhaarigen Mann in Blue Jeans und dessen freundlicher Frau scheu die Hand zum Gruß hin: »Dobro jutro!«. Ein befreundeter Winzer übersetzt. Am Wiesensaum liegt glasiger Tau, über dem Grenzwald verdunsten Nebelschleier.

Ivan Finster ahnt nicht, daß er, der slowenische Kleinbauer, an diesem frühen Morgen als Erzähler bei den ihm unbekannten Freunden Sensibles berühren wird; daß die aus jüdischen bzw. aus deutsch-nationalen Elternhäusern stammenden Personen trotz jahrzehntelanger Lebensfreundschaft bisher vieles aus der Nazi-Zeit einander nur bruchstückhaft mitgeteilt haben.

Die Photographin aus Amerika hält Ivan Finster im Bild fest: Er zeigt auf einen Hohlweg im Wald. Die Gruppe setzt sich in Bewegung. Im Gehen erklärt Finster, beantwortet Fragen. Nach und nach wird die ganze Dramatik des Geschilderten lebendig: Auf diesen Wegen versuchten nach dem November 1938, als Synagogen brannten, die Gestapo ihre wüsten Willkürakte gegen jüdische Mitbürger begannen, tausende jüdische Flüchtlinge aus Österreich und sogar Deutschland illegal über die Grenze in das Königreich der Serben, Kroaten und Slowenen zu kommen. Die Kultusgemeinden waren auf dubiose Gestalten, auf Schlepper, angewiesen, die wiederum mit Gestapo, Zöllnern, Grenzbauern ihre Geschäfteln machten und Kinder – wie Ivan Finster – als Kuriere einsetzten. Für Augenblicke verschluckt der mit Farnen und Geäst überwachsene Hohlweg fast tunnelartig die kleine Gruppe. Ihre Schatten wirken bizarr zerrissen. Finster weiß nicht, daß der weißhaarige Mann Auschwitz überlebt, aber

seine sechs Geschwister und seine Mutter in KZs verloren hat. Er weiß auch nicht, daß die wunderbar bodenständige Ehefrau des Mannes einen hochrangigen SS-Mann zum Vater hatte, der nach dem Krieg von Juden versteckt wurde, denen er als Gauhauptmann das Leben gerettet hatte. Dem Mann bleibt schließlich auch verborgen, daß der Großvater der bekannten, mit einem weltberühmten jüdischen Dramatiker verheirateten Photographin als Landvermesser die neue, alte untersteirische Grenze für das Dritte Reich vermessen hat. Daß über Inge Moraths Zeiten in Berlin bisher vor allem in den *Zeitkurven* des prominenten Schriftstellergatten von ihrer Zwangsarbeit in der Fabrik die Rede war. Die Personengruppe taucht auf, bewegt sich in grellem Gegenlicht. Die Sonne ist jetzt voll über den gezackten Horizont der Fichtenwipfel gebrochen. Am Wegrand steht ein mit Blumen geschmücktes Kruzifix. Der Mann in Grün hat, so gut er sich erinnern konnte, alles erzählt. Die Freunde schweigen, sind aufgewühlt.

REGINA STRASSEGGER

Ivan Finster mit Inge Morath,
Imo und Renate Moszkowicz.
Ivan Finster with Inge Morath
and Imo and Renate Moszkowicz.

ON PAST TRAILS: BORDER WOODS

The man in green hunting jacket raises his hat and shyly extends a hand to greet the delicate woman with the camera, the white-haired man in jeans and his friendly wife. "Dobro jutro!" A vintner friend translates. The edge of the meadow glitters with dew; over the border woods, misty veils are dispersing. Ivan Finster, a Slovenian small farmer does not suspect that what he has to tell on this early morning will touch on sensitive areas for these people; nor that—concerning much of the Nazi past, despite their having been friends for decades—these three, who come from both Jewish and German-speaking backgrounds, have so far exchanged only fragmentary details.

The visitor from America photographs Ivan Finster as he points to a hollow way in the woods. The group sets off. Finster talks as they walk, answering questions. Gradually the whole drama of what once happened here unfolds. After November 1938, when synagogues were burned down and the Gestapo began perpetrating gratuitous acts of violence against Jewish citizens, thousands of Jewish refugees from Austria and even Germany tried to cross the border illegally here into the then Kingdom of Serbs, Croats, and Slovenes. The Jewish communities had to rely on dubious characters, smugglers who also fixed deals with Gestapo, customs officials, border farmers, and who used children—such as Ivan Finster—as go-betweens. For a few moments the tunnellike hollow way, overgrown with branches and ferns, swallows up the little group. Their shadows appear bizarrely torn. Finster does not know that the white-haired man survived Auschwitz but lost his mother and six brothers and sisters in concentration camps. Nor can he know that the father of the man's wonderfully down-to-earth wife was a high-ranking SS official, who, after the war, was hidden by Jews whose lives he had saved as district captain. What likewise remains concealed from him is that the grandfather of the well-known photographer married to a world-famous Jewish playwright was surveyor for the "new" old Lower Styrian border for the "Third Reich;" as also that Inge Morath's time in Berlin, her compulsory factory work, has so far been dealt with mostly in her prominent husband's work *Timebends: A Life*.

The group reappears, moving into harsh brightness. The sun has now risen clear of the jagged horizon of spruce trees. At the wayside is a crucifix decorated with flowers. The man in green has told everything he recalls to the best of his ability. The friends are silent, inwardly churned up.

REGINA STRASSEGGER

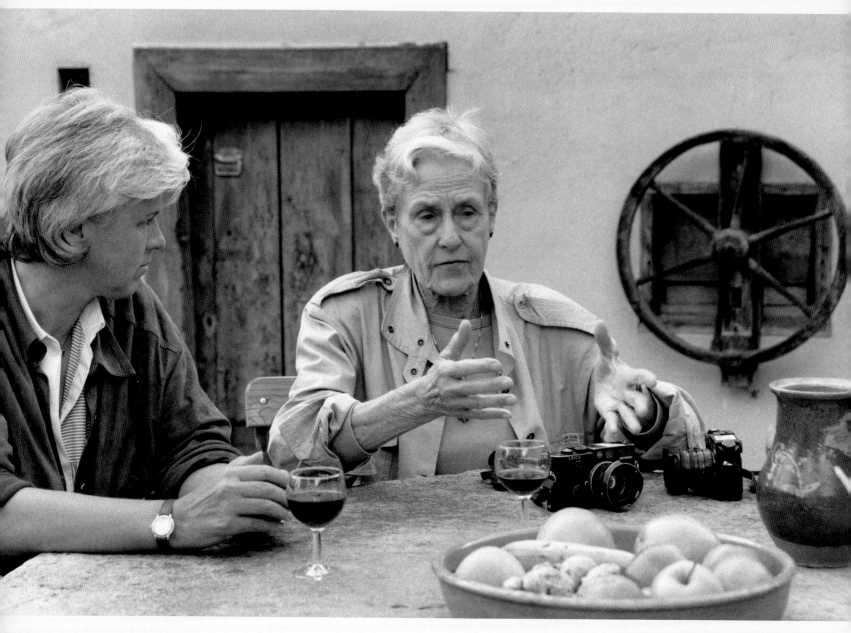

Regina Strassegger und Inge Morath im Gespräch.

Regina Strassegger and Inge Morath in conversation.

Fest an der Grenze – Schüler, Lehrer, Bevölkerung wandern über die Grenze.

Border festival—schoolchildren, teachers, and others walking across the border.

Fest an der Grenze – Kinder von beiden Seiten der Grenze spielen zusammen, tauschen selbstgefertigtes Kunsthandwerk, Speisen aus.

Border festival—children from both sides of the border playing together and exchanging homemade art objects and eatables.

Fest an der Grenze – slowenischer Lehrer herzt österreichischen Schüler.

Border festival—a Slovenian teacher hugging an Austrian schoolboy.

Fest an der Grenze – dem doppelt beinamputierten Ivan Dreisiebner wurde die Grenze zum Schicksal.

Border festival—the border proved fateful for Ivan Dreisiebner; he has had both legs amputated.

»Ivan Dreisiebners Vater blieb mit seinem Hof bei dem kommunistischen Jugoslawien, als er die Wahl hatte, zu Österreich zu gehören. Der Rest der Familie optierte für Österreich. Beim Fest an der Grenze kam der Dreisiebner-Neffe zu seinem Onkel. Das erste Mal seit Jahrzehnten!«

INGE MORATH

"When given the chance to become Austrian, Ivan Dreisiebner's father chose to stay with his farm in communist Yugoslavia. The rest of the family opted for Austria. During the border festival a Dreisiebner nephew visits his uncle—for the first time in decades."

INGE MORATH

IM FLUSS DER ZEIT
THE RIVER OF TIME

»Wasser hat es mir schon immer angetan. Strömendes Wasser,
Flußwasser. Reisen haben es mir angetan, wo das Fahren von einem
Ort zum anderen Auskunft gibt, sich vertiefen läßt, der Weg sich
bahnt und unbeirrbar weitergeht bis zum Ende.«

INGE MORATH

"Water has always appealed to me. Flowing water, river water.
Travel has always appealed to me, the kind where moving from
one place to the next instructs, or deepens knowledge, and the
way unfolds and goes on unerringly to the end."

INGE MORATH

Kahn auf der Mur.
Barge on the Mura River.

Die Mur auf ihrem Weg zur Donau und zum Schwarzen Meer.

The Mura on its way to the Danube and the Black Sea.

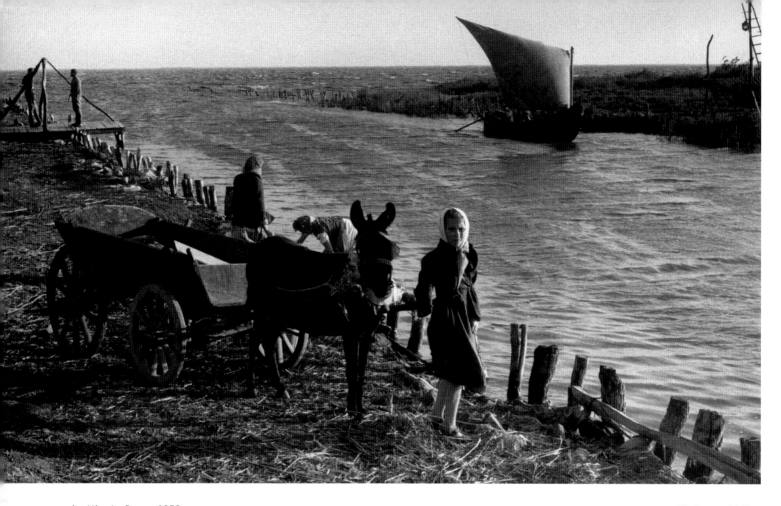

Am Ufer der Donau, 1958.

On the bank of the Danube, 1958.

Die Donau, 1958.

The Danube, 1958.

ÜBERSETZEN ZU ANDEREN UFERN

»Die Mur ist mein Geburtsfluß, sie fließt ja an Graz vorbei«, sagt Inge Morath, während sie sich mit ein paar Tropfen Wassers besprengt, »das ist gut für die Lebensgeister«. – Das sanfte Dahingleiten, die silbergrauen Nebel über der Fluß-landschaft vermitteln Zeitloses – als gäbe es Kein-woher-Kommen-wir, Wohin-Gehen-wir. »Ich hab' die Idee Hölderlins, Flüsse in ihrem umgekehrten Verlauf wahrzunehmen – von der Mündung zum Ursprung –, immer sehr geliebt«, bemerkt die 79jährige –, als ob der Endlichkeit so ein Schnippchen zu schlagen wäre. »Bei der Donau hat man die Länge tatsächlich so berechnet. Da steht der Kilometerstein 0 im Schwarzmeerhafen Sulina.« Dieses Kuriosum, den rückläufigen Blickwinkel, entdeckte Morath 1958 auf einer ihrer ersten großen Flußreisen auf der Donau. Das gefiel den Kollegen bei der legendär gewordenen Photoagentur Magnum, bei der Inge Morath seit Anfang der 50er Jahre in Paris tätig war. Das brachte ungewöhnliches Reportage-Material aus abgeriegelten Teilen Europas, das seit 1945 geteilt war – in West und Ost, Demokraten und Volksgenossen, NATO und COMECON. Tito hatte mit Moskau gebrochen, Jugoslawien block-frei gemacht; in Ungarn hatten die Sowjets 1956 den Aufstand niedergewalzt. Es war die Zeit der Neuorientierung, auch für Inge Morath. »Wie der Krieg aus und die alte Welt für immer verschwunden war, hab ich eine wesentliche Erfahrung gemacht: Meine Sprache war überall, wo ich beruflich zu tun hatte, die Sprache des Feindes. Das war hart und lehrreich. Deshalb hab ich versucht, so viele Sprachen wie nur möglich zu lernen, habe auch viele Übersetzungs-arbeiten gemacht.« – Gegen den Bug schlagen kräftigere Wellen, die Strömung wird stärker. Für Momente blitzen auf der unruhigen Wasseroberfläche bizarre Silberfäden auf. Am linken Murufer kommt schemenhaft eine Schiffsmühle ins Blickfeld. »Es gibt unvermeidliche Reisen«, bemerkt die Photographin, »diese Balkanreise, der 1995 noch eine folgte, als Jugoslawien bereits blutig zerfallen war –, Aufenthalte in der Sowjetunion, in Spanien, im Iran, in China waren solche. Man hat da das Gefühl, zu anderen Ufern überzusetzen. Dieses Gefühl war für mich vor allem die Photographie, meine instante Passion, die mich damals, an einem Regentag in Venedig, ereilt hat. Ich hab abgedrückt und gewußt: Das ist es, was ich machen will, was ich zu sagen habe.«

REGINA STRASSEGGER

CROSSING TO OTHER SHORES

"The Mura is the river of my birth—it flows past Graz," says Inge Morath, and, sprinkling herself with a few drops of water: " ... puts new life into you." The gentle gliding motion and silver-gray mists over the river landscape convey a sense of timelessness, as if there were no "where do we come from," no "where are we going." "I always particularly loved Hölderlin's idea of viewing rivers in reverse flow—from estuary to source," says the 79-year-old, as if it might be a way to outwit life's finitude. "The Danube really is measured like that, the 0 km stone being at the Black Sea port of Sulina." Morath discovered this curiously reversed perspective on one of her first big river trips on the Danube in 1958. Her colleagues at the now legendary Magnum photographers' agency, with which Morath had been working in Paris since the early 1950s, liked that. It brought in unusual reportage material from sealed off areas of Europe that had been divided since 1945—into West and East, democrats and party comrades, Nato and Comecon. Tito had broken with Moscow, and declared Yugoslavia unaligned; in 1956 the Soviet Union had crushed the uprising in Hungary. It was a time of reorientation, for Inge Morath as well. "The war over and the old world gone forever, I made a significant discovery: regardless of where I was working, I found that my language was the language of the enemy. That was tough and instructive. So I tried to learn as many languages as was humanly possible. I also did a lot of translating work."— The waves striking the bow grow stronger, the current becomes more powerful. Bizarre silver threads on the agitated surface of the river flash out for moments. On the left bank the hazy outline of a floating mill comes into view. "Some journeys are inevitable," says the photographer. "That Balkan trip, followed in 1995 by another when Yugoslavia had already fallen bloodily apart, visits to the Soviet Union, to Spain, Iran, and China are examples. One feels as if one were crossing over to other shores. Photography gave me this feeling most of all, an instant passion; it overcame me back then one rainy day in Venice. I pressed the button and knew—that's it, that's what I want to do, what I have to say."

REGINA STRASSEGGER

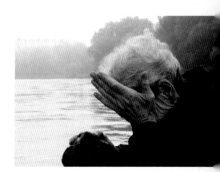

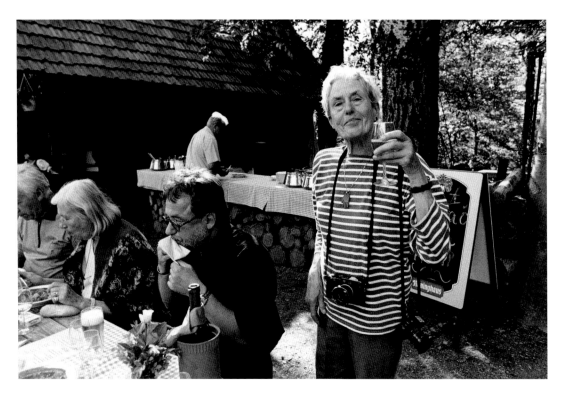

Inge Morath genießt den steirischen Wein.
Inge Morath enjoying the Styrian wine.

Renate Moszkowicz und Freunde lieben den Gesang.
Renate Moszkowicz and friends love singing.

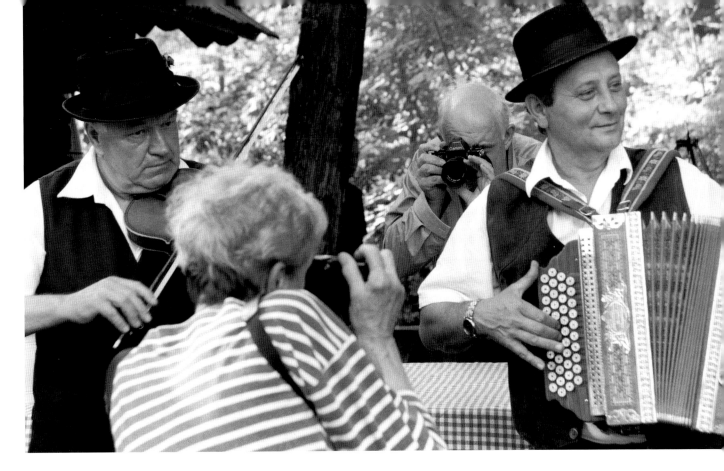

Inge Morath und Stojan Kerbler photographieren um die Wette.

Inge Morath and Stojan Kerbler vying for the best picture.

Steirischer Musikant mit der Teufelsgeige.

Styrian musician with devil fiddle.

Slowenische Musiker hören ihren österreichischen Kollegen zu.

Slovenian musicians listening to their Austrian counterparts.

»Die spätberufene Dichterin Josefa Prelog erzählt, daß sie vor ein paar Jahren bei einer Volkslied-Sendung für das österreichische Radio ein slowenisches Lied gesungen hat. Dabei ist sie ziemlich unflätig behandelt worden, und danach hat sie von national gesinnten Rabauken auch noch Drohanrufe erhalten. Die wollen nichts von einer slowenischen Minderheit wissen, die in der Steiermark nicht anerkannt wird, weil sie zu klein sein soll. Aber neuerdings ist es besser geworden, auch weil eine offenbar vernünftige Landeshauptfrau richtige Zeichen setzt und mit den Leuten gut kann.«

INGE MORATH

"Josefa Prelog, a Slovenian from Austrian Styra and a late-starter among poets, relates how she sang a song for a folk-song broadcast on Austrian radio a few years ago. She was pretty badly treated, and afterwards also received threatening phone-calls from nationalistically-minded roughnecks. They don't want to hear about a Slovenian minority not recognized in the Austrian part of Styria because it is purportedly too small. But things have improved lately, not least because an evidently sensible province governess has set an example and is good with people."

INGE MORATH

Josefa Prelog, eine steirische Slowenin, singt eines ihrer Volkslieder.
Josefa Prelog, a Styrian Slovene, singing one of her folk songs.

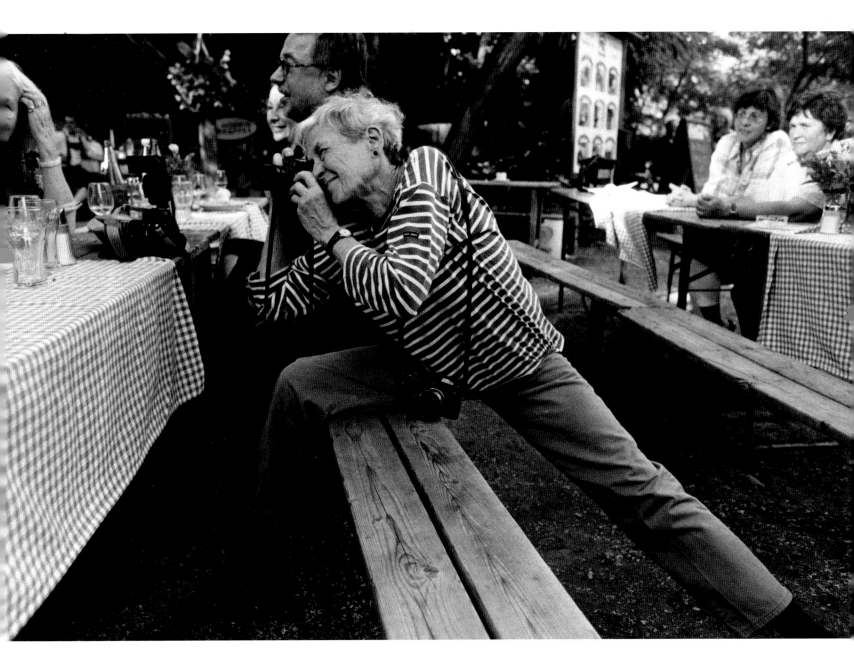

Inge Morath – der richtige Augenblick.

Inge Morath—perfect timing.

BEI DEN LEUTEN IM SÜDSTEIRISCHEN
AMONG THE SOUTHERN STYRIANS

»Am schönsten, am interessantesten sind die Menschen,
wenn sie das tun, was sie am besten können, wo sie sich
zu Hause fühlen – als Rauchfangkehrer, Schnapsbrenner,
Körbeflechter, Bienenzüchter, Winzer, Schriftsteller, Maler.
Kein Wunder, daß die Leute von dieser herrlichen Gegend
inspiriert sind und Meisterliches vollbringen. Allein die
erlesenen Weine sprechen für sich.«

INGE MORATH

"People are best and most interesting when they're
doing what they're good at, where they feel at home—
chimney sweeps, distillers, basket weavers, beekeepers,
vintners, writers, painters. No wonder the people of these
magnificent parts are inspired to masterly achievements.
The choice wines alone say everything."

INGE MORATH

Rauchfangkehrer unterwegs.
Chimney sweep doing his rounds.

Maria Tscheppe vor dem Schuppen des Elternhauses direkt an der Grenze.
Maria Tscheppe and hut belonging to her parents, directly on the border.

Kürbiskernernte für Kernöl.
Harvesting pumpkin seeds for their oil.

Ausgraben alter Weinstöcke.
Digging out old vinestocks.

Beim Schnapsbrennen.
Distilling schnapps.

»Aus dem Alten bricht in seiner überschwenglichen Freude so manches hervor. Er sagt zum Beispiel in unnachahmlichem Steirisch: »Ja Pupperl, Du bist ja fast no was Junges. Wia alt bist Du denn? Do geht vielleicht no was.« Begleitet wird das von einem verschmitzten Bauernlachen und natürlich seinem guten Wein.«

INGE MORATH

"The old fellow's mirth gives rise to a thing or two... In inimitable Styrian he says: "Babe, you're almost a young girl! How old are you then? We might have something going." Accompanied by a farmer's roguish laugh and, of course, his good wine."

INGE MORATH

Vater Gombocz begrüßt mit einem Hecknklescher, sprich Eigenbauwein.
Father Gombocz greeting us with a "Hecknklescher"—homemade wine.

Mutter Gombocz stellt den Hauskater vor.
Mother Gombocz introduces the family tomcat.

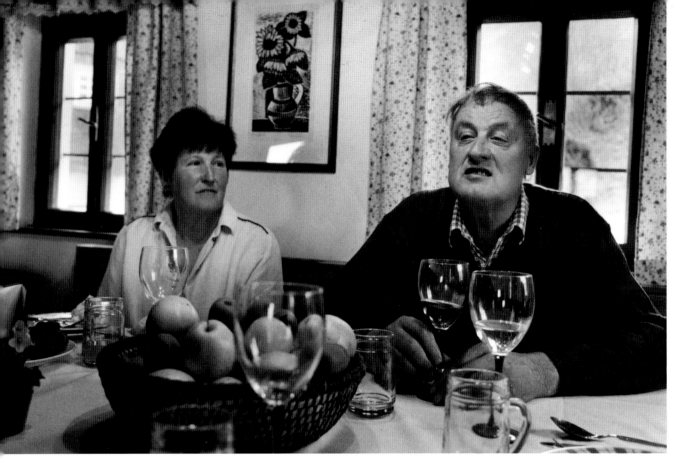

Sepp Loibner, den sie wegen seiner guten Kontakte über die Grenze den Botschafter nennen, mit Ehefrau Margarete.

Sepp Loibner, known as the ambassador for his good contacts to across the border; with wife, Margarete.

Schriftsteller Gerhard Roth mit Ehefrau Senta.
Writer Gerhard Roth and his wife, Senta.

Barbara Loibner, Sepp Loibners 94jährige Mutter.

Barbara Loibner, Sepp Loibner's 94-year-old mother.

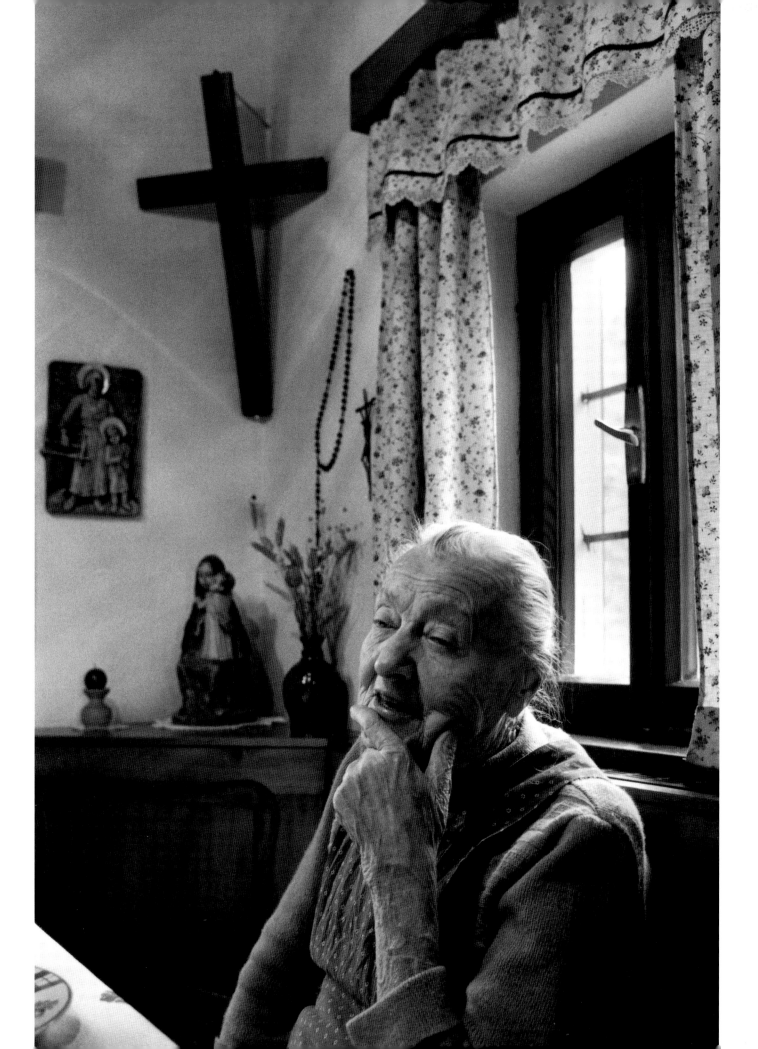

FIKTIVER BRIEF VON GERHARD ROTH AN INGE MORATH

Auch Gerhard Roth lebt
in der Südsteiermark.

Gerhard Roth also lives
in the Austrian part of
Styria.

Auch wenn Sie diese Zeilen auf herkömmliche Weise nicht mehr erreichen, hoffe ich auf Meta-Wege: Ihr wacher Geist, Ihr scharfes Auge, Ihr federsames Wesen nehmen weiterhin wahr – jetzt eben anders. Es war himmlisch, wie Sie Menschen im Beisammensein das Gefühl gegeben haben, besonders zu sein. Ihr »Das ist ja fabelhaft, was Ihnen da mit dem Stillen Ozean geglückt ist. Ich hab das Buch vor unserem untersteirischen Abenteuer gelesen« war hinreißend – wie manches mehr an diesem Abend. Wohl wissend, wie sehr Charme – wie das Trinken auch – Gefühle, Wahrnehmungen vergrößern kann. Aber eines war untrüglich: Auch Sie hat das südsteirische Land, seine archetypischen Menschen in wohligen Schwindel versetzt. Seine winkeligen Straßen im grünen Hügelkarussell, die einem das Gefühl geben, ins Innere einer Pflanze geraten zu sein, die zum Himmel hin offen ist. Seine Menschen, virtuose Bastler, Erzähler, Dulder, Erfinder, Musikanten, Trinker, Streithanseln, Künstler. »Wir haben unglaubliche Originale getroffen«, haben vom »markanten Maler, schnapsbrennenden Jäger, philosophischen Weinbauern, steirisch-weltmännischen Bürgermeister, vom passionierten Privat-Botschafter, schrillen Pfarrer« erzählt. Grenzgänger der Widersprüche, in deren Herzen und Köpfen oft gleichzeitig Gegenteiliges geschieht, denen das Leben eine ständige Zerreißprobe beschert. Zwischen autoritätsgläubig und anarchistisch, katholisch und heidnisch, schweigsam und redselig, fanatisch und wankelmütig, angepaßt und streitsüchtig, fröhlich und traurig. »Ist ja unglaublich! Bei all dem Stoff hätte der alte Freud seine Freude gehabt«, merkten Sie im Bühnenton an, »und vielleicht wäre seine wundersame Diagnose über die Hysterie bei Frauen in der Weingegend etwas anders ausgefallen – wer weiß?« Freud hätte wahrscheinlich bei den Menschen in der steirischen Provinz eine Krankheit des Kopfes diagnostiziert, die den Tod zur Rettung stilisiert. Doch der Tod ist trügerisch, er läßt die Rechnungen nicht aufgehen. Sie erinnern sich an Ihren Ausruf »Na servas, das muß ich dem Arthur erzählen!« – der streute einen Schuß Ironie ins Erzähl-Geschehen, gab für einen kurzen Moment die Rückseite des Charmes frei. Die andere Morath, die mit dem geduldigen Kalkül, die für sich messerscharf taxiert, innere Distanz zwischen sich und anderen setzt. Der kühle Blick der Photographin, der seziert, wartet, den richtigen Augenblick erkennt. – Liege ich hier richtig? Befindet sich der Schriftsteller gegenüber der Fotografin in einem kommunikativen Grenzraum, der schleunigst zu verlassen ist? Wenn ja, verzeihen Sie. Ich erinnere mich jedenfalls, daß dieses Gespräch an diesem Februarabend auch durch Sie einen deutlichen Grenzakzent bekommen hat. Es ist die Frage im Raum gestanden, was diese Grenze mitten durch die Steiermark für das Land, seine Menschen für ein Einschnitt ist. Sie haben erzählt: »Als wir da im Wirtshaus gesessen sind, sagt da ein Steirer in meinem Alter zu seinem Nachbarn aus der slowenischen Steiermark, den er seit Jahrzehnten nicht mehr gesehen hat: "Sag einmal Franc, wieso seid's ihr die vergangenen 50 Jahr nie mehr zu uns herüber kommen. Wir san doch Nachbarn blieb'n, und keine Viertelstund Gehzeit auseinander?" Der Franc hat nichts gesagt, schwer geatmet, starr auf die Tischplatte geschaut. Dann hat einer in der Runde geraunt: "Der hat heut noch Angst! Aber Du Sepp, Du hättest ja zu denen a umi geh'n können!"« – Eine Geschichte vom innersteirischen Graben, der mitten durch Verwandte, Freunde, Nachbarn, Bauernhöfe, Weinberge verläuft. Die längste Zeit ein toter Winkel, überwuchert mit Ängsten, Tragödien, Mißtrauen, aber auch Obskurem, Viehschmuggel, der billige Friseur von ›drüben‹ als Synonym für den illegalen Arbeitskräfte-Verkehr, Verhaftungen und Dramatischeres... Ein aufgerissener Landstrich also. Dort haben die Menschen auf beiden Seiten der Grenze mit diesem amputierten Gefühl gelebt, als wäre eine Gehirnhälfte plötzlich weggesprengt worden – offener Schädel, blutendes Herz. Mir ist Ihr Zwischenruf noch präsent: »Jetzt reicht der Freud aber nicht mehr aus, und die Zunft des Lorenz Böhler ist mein Fall nicht. Ich hasse Blutorgien. Deswegen gab's bei unserer Geschichte auch kein Sauabstechen, Hasenjagen, keinen Leichenschmaus.« Ihre Botschaft war deutlich: Ich habe mit Zerstörungs- und Selbstzerstörungsszenarien, mit Schlachtungen, Selbstmorden, Amokläufen, Formen des Irrsinns nichts am Hut. Insofern war für Sie der ›Stille Ozean‹ vielleicht doch nicht so fabelhaft...

Und doch – das Land, das Ihrer Kindheitssommer, hat Sie trunken gemacht. Das war spürbar in Ihrer weichen Erzählstimme. Wenn Sie von den Marterln, Weingärten, Kastanien, dem Klapotez, Welschriesling geredet haben. – Welch Fügung, daß Ihnen diese mytho-poetische Landschaft zur grandiosen Kulisse einer Vollendungs-Reise geworden ist.

ZUSAMMENGESTELLT AUS ZITATEN VON INGE MORATH UND GERHARD ROTH DURCH REGINA STRASSEGGER

IMAGINARY LETTER FROM GERHARD ROTH TO INGE MORATH

Even though these lines can no longer reach you in the customary way, I hope they may on meta-paths: your alert mind, your keen eye, your buoyant nature continue to perceive, only differently now.

It was marvelous the way you gave those round you the feeling of being something special. Your "It's fabulous what you manage to do in The Calm Ocean; I read the book before our Štajerska adventure," was a delight, as was much else on that evening, although I'm aware how charm—like drink—can amplify feelings and perceptions. But one thing is sure: the land of southern Styria and its archetypal inhabitants had made your head reel pleasantly, too. Its roads winding through a carrousel of hills so you feel as if you'd got inside a plant that's open to the sky. Its people—virtuoso handicraftsfolk, raconteurs and long-sufferers, inventors, musicians, drinkers, wranglers, artists. "We've met incredible types"—you mentioned the "striking painter, the distiller hunter, the philosophical vintner, the cosmopolitan Styrian mayor, the ardent private ambassador, the strident pastor." Borderliners of contradiction, in whose hearts and minds contraries often coexist, and for whom life is one ongoing acid test. Blind faith in authority and anarchy, Catholic and heathen, taciturn and chatty, fanatical and fickle, conformist and cantankerous, cheerful and sad. "It's incredible," you remarked in a stage tone, "old Freud would have had a field day with all this material. And perhaps his singular diagnosis of hysteria in women would have turned out differently in this wine-growing region—who knows?" Freud would likely have diagnosed a disease of the head among the southern Styrians, curable by death alone. Yet death is deceptive, it puts paid to plans. You'll recall how you exclaimed, "Well, whadyouknow! I must tell Arthur about that"—it added a dash of irony to the narrative proceedings, revealing charm's other side for a brief instant. The other Morath, who puts distance between self and others, patient, shrewd, razor-sharp assessor of situations. The photographer's cool gaze that dissects, waits, and grasps the right moment.—Am I on the right track? Is the writer vis-à-vis the photographer in a communicative border space that he is advised to leave instantly? If so, excuse me. At any rate, I recall how the conversation that February evening also received, via you, a definite border slant. In the air was the question what kind of impact this border right through Styria has had on the land and its people. "While we were at the inn," you said, "a Styrian of my age turned to his neighbor from Slovenian Styria, whom he hadn't seen for decades, and said: "Go on, Franc, tell us, why haven't you been over to see us these past fifty years? We're still neighbors less than a quarter-of-an-hour's walk apart." Franc said nothing, heaved a sigh, and stared at the tabletop. Then someone else murmured, "He's still scared today. But Sepp—you could've gone over and visited them as well." "—A tale of inner-Styrian division running between relatives, friends, neighbo's, farms, vineyards. For most of the time it was a dead corner, overrun by fear, tragedies, mistrust, and obscure practices, cattle smuggling, the cheap hairdresser from the "far side," a synonym for the illegal traffic in workers, and events even more dramatic

Call it a ripped up tract of land. People living on both sides of the border had this amputee-feeling, as if one half of their brains had suddenly been blown away: open skull, bleeding heart. I can still hear how you called out, "Joy could not be greater, and the tribe of Lorenz Böhler (a renowned World War I military doctor) is not my cup of tea! I hate orgies of blood. That's why there are no pig killings, hare hunts, or funeral feasts in our story." Your message was clear—with scenarios of destruction and self-destruction, with massacres, suicides, amok killings, and all forms of madness I will have nothing to do. To that extent The Calm Ocean was, after all, perhaps not so fabulous for you....

And yet—the land of your childhood's summer made you drunk. One sensed it in the softness of your voice when you talked about the wayside shrines, vineyards, chestnuts, klapotez, Welsch Riesling.—What providence that this mythopoeic landscape should become the magnificent backdrop for your journey of completion.

COMPILED FROM QUOTATIONS BY INGE MORATH AND GERHARD ROTH, BY REGINA STRASSEGGER

Inge Morath mit Gerhard und Senta Roth.
Inge Morath with Gerhard and Senta Roth.

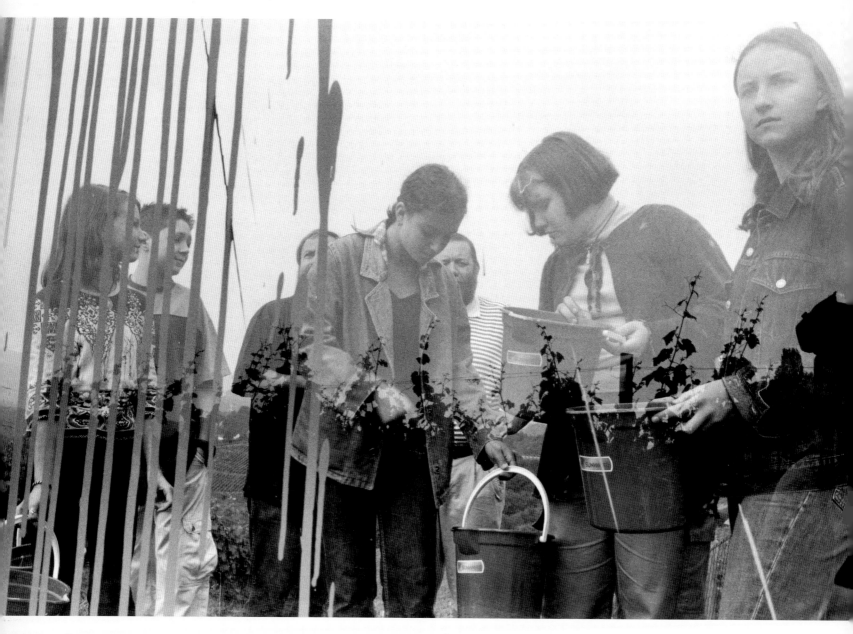

Schüler aus Gamlitz und Kungota stellen Schüttbilder her im Gedenken an die Kriegsereignisse an der Grenze im Juni 1991.

Pupils from Gamlitz and Kungota engaged in action painting to commemorate the border hostilities of June, 1991.

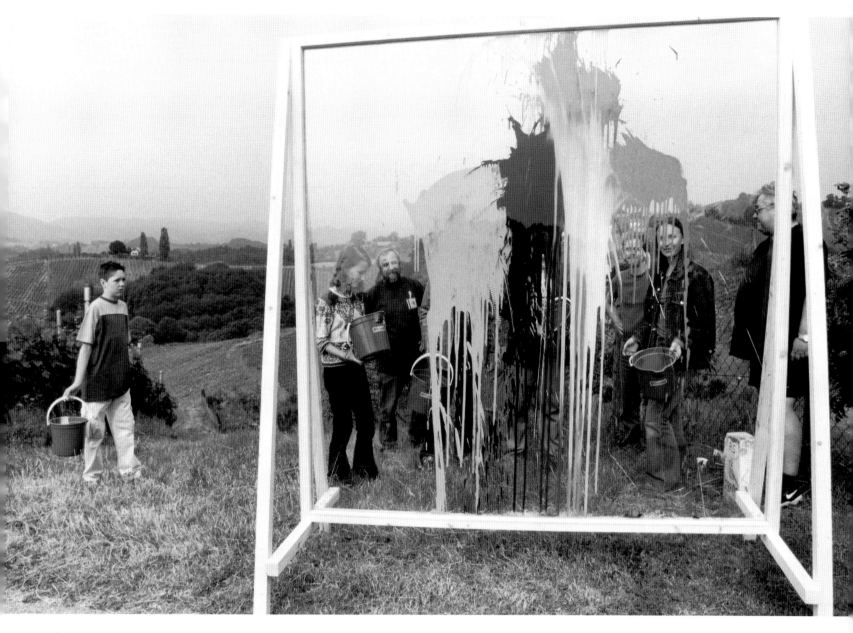

Grenzkunst.

Border art.

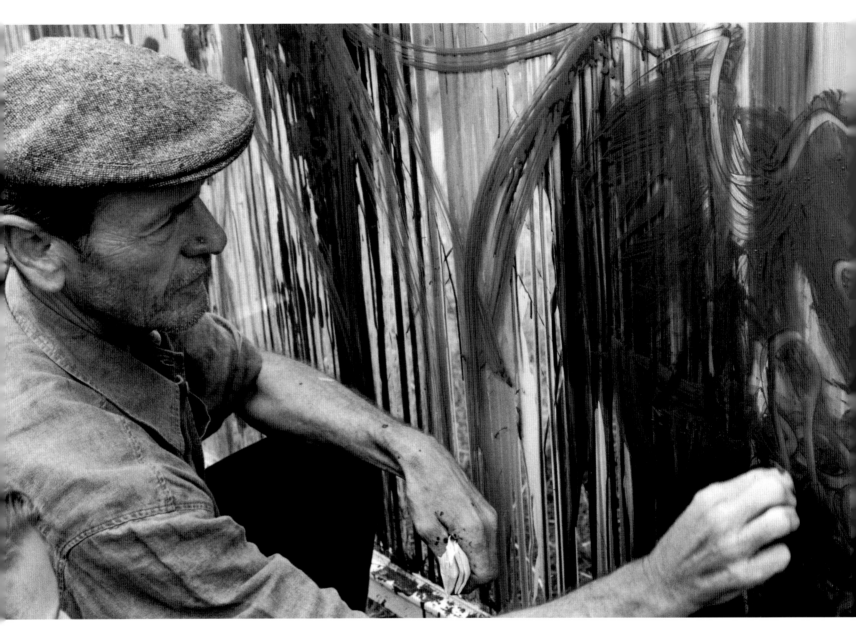

Der Maler Gerald Brettschuh bei der Arbeit.

The painter Gerald Brettschuh at work.

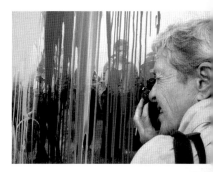

Dnevi, ki so prestrelili Gornjo Radgono

Inge: Juni anno 91, unerträglicher Lärm über unserem Horns. Jugoslawische Überflieger? Draken? Krieg?!

Tage, die Gornja Radgona bewegten

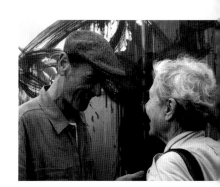

»Kurz nachdem Slowenien unabhängig wurde, war Drago Jančar mit Schriftstellerkollegen bei uns und sagte die denkwürdigen Worte, er wollte seinen slowenischen Paß freiwillig zurückgeben, würde sich der neue Staat fehlentwickeln. Peter Handkes *Neuntem Land* zuliebe aber wollte er nicht Jugoslawe bleiben. Mir war es egal, ob geheime Orte voller Poesie zu diesem oder jenem Staat gehörten, solange ich in diesen verwunschenen Gegenden meine Bilder malen konnte. Sie erzählen besser, als ich Dir beschreiben kann, welche Quelle der Inspiration dort für mich floß.«

GERALD BRETTSCHUH, BRIEF AN INGE MORATH

"Shortly after Slovenia became independent, Drago Jančar was visiting with fellow writers and uttered some memorable words. He said he would voluntarily hand in his Slovenian passport if the state turned out badly. But for the sake of Peter Handke's "ninth land," he did not want to remain a Yugoslav. I didn't care whether secret places full of poetry belonged to this state or that, as long as I could go on painting pictures in these enchanted areas. They testify better than I can to the source of inspiration that flowed for me there."

GERALD BRETTSCHUH, LETTER TO INGE MORATH

WIEDERSEHEN IM HAUS AN DER GRENZE 1992
REUNION IN THE HOUSE AT THE BORDER 1992

»Meine liebe Renate! Vor mir liegen Photos einer selig dreinschauenden Titti beim Geburtstagsfest bei Euch im Weingarten in dieser herrlichen Landschaft. Dieser Besuch war so wunderbar. Leider sehen wir uns viel zu selten. Die Zeit vergeht so rasend. Arthurs neues Stück in New York, London, jetzt Tel Aviv etc. Rebecca schreibt gerade an einem Drehbuch für ihren Film. Meine Ausstellung wandert gerade durch Europa, derzeit Milano. Plane weitere Balkanische Reisen. Dann müssen wir uns öfter sehen! Alles Liebe Deine Inge.«

INGE MORATH, BRIEF AN RENATE MOSZKOWICZ

"My dear Renate,
Spread out in front of me are photos of Titti looking blissful at the birthday party in your garden amid that magnificent countryside. That visit was so wonderful. Unfortunately, we see each other far too seldom. Time simply flies. Arthur's new play in New York, London, and now Tel Aviv, etc. Rebecca is writing a script for her film. My exhibition is touring Europe, in Milan at present. Planning further Balkan trips. Then we must meet more often!
Love, Inge"

INGE MORATH, LETTER TO RENATE MOSZKOWICZ

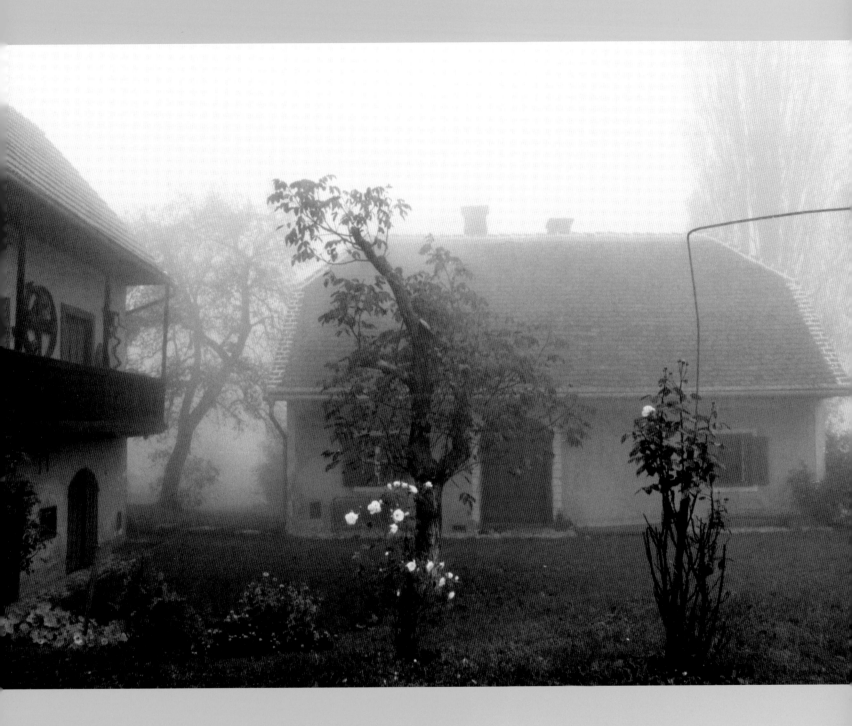

LIEBESGESCHICHTEN UND HEIRATSSACHEN

»Die Inge war eine so berauschende Schönheit, daß ihr alle zu Füßen gelegen sind.
Nach dem Krieg waren wir für eine Weile in einer Kommune in Wien. Die Freunde
waren der Ernst Haas, die Ingeborg Bachmann, der Hans Weigel, der Viktor Frankl
und wie sie alle geheißen haben. Das war nach dem Krieg wie eine Gruppentherapie.
Natürlich gab's da heiße Flirts, flotte Paare. Die Inge hat die Heiratsanträge nur so
gesammelt. Sie ist ja dann nach Paris gegangen.«

RENATE MOSZKOWICZ

»Die Pariser Zeit war unvergeßlich. Der Robert Capa, der Henri Cartier-Bresson
und die anderen, das waren unglaubliche Charaktere. Die hatten einen wunderbaren
Freundeskreis, der sehr kosmopolitisch war – Franzosen, Spanier, Engländer.
Es war amüsant. Durch Freundschaften, auch Liebschaften hat man neue Kulturen
und Sprachen kennengelernt. Mein gutes Spanisch verdanke ich solch einer
Verbindung. Als aber dann Heirat, Hochadel und so fort konkret wurden, war es
vorbei. Dafür hab' ich einen englischen Journalisten in London geheiratet. Das
war unendlich fad und hat nicht lange gedauert. Let's call it a waste.«

INGE MORATH

»Renate ist ihrem Vater gefolgt, der als Nazi nach Argentinien gekommen war, und
ich habe meinen Vater gesucht, der 1938 noch herauskommen konnte. Also – zwei
Flüchtlinge sind sich begegnet, sie haben erkannt: Nach diesem gewaltigen Fiasko
durch die Nazis wird es für uns immer zwei Welten geben. Aber sie haben auch
erkannt: Ein Nebeneinander ist absolut ungenügend, nur ein Miteinander kann
weiterhelfen. Und durch unsere Begegnung hat es sich auf's schönste bestätigt,
daß das Leben nach schlimmen Katastrophen weitergeht und sich auf's glücklichste
erfüllen kann. Wobei natürlich der Wahrheit halber zu sagen ist, alle Männer werden
geheiratet und das ist ja auch in Ordnung so.«

IMO MOSZKOWICZ

»Ich habe den Arthur bei den Dreharbeiten zu Misfits getroffen. Er und Marilyn
hatten eine schwere Zeit. Nach diesem Film war den beiden klar, daß die Ehe kaputt
ist. Der Arthur, der die Marilyn wahnsinnig geliebt hat, war verzweifelt, hat den
Kontakt zu mir gesucht. Aber ich hab' mir damals gedacht: Nichts wie weg, ich will
kein Marilyn-Monroe-Opfer trösten. Ein halbes Jahr später bat Arthur sehr galant
zum Rendezvous. Das war es dann.«

INGE MORATH

»Ich bin noch immer erstaunt über das Glück, das wir vierzig Jahre lang hatten.
Welch Glück! Ich versuche es mir immer wieder zu vergegenwärtigen, auch wie viel
sie mir gegeben hat. Ich kann nur hoffen, daß sie mir gegenüber ähnlich empfunden
hat. Ich glaube, sie tat es. Sie war eine tapfere, feine Frau. Wir waren alle gesegnet,
daß wir so nahe bei ihr waren.«

ARTHUR MILLER, BRIEF AN WERNER MÖRATH

Inge Morath und Arthur Miller im
Februar 1962 in Roxbury, USA.
Inge Morath and Arthur Miller in
Roxbury, USA, February 1962.

Inge Morath mit Großeltern und
Eltern beim Familienbesuch in Graz.
Photo von A. Miller.
Inge Morath visiting grandparents and
parents in Graz; photo, Arthur Miller.

Familienglück. Inge Morath mit
Tochter Rebecca, der stolze Vater
photographiert.
Domestic bliss. Inge Morath, daughter
Rebecca, and the proud father behind
the camera.

ROMANCES AND MARRIAGE TALES

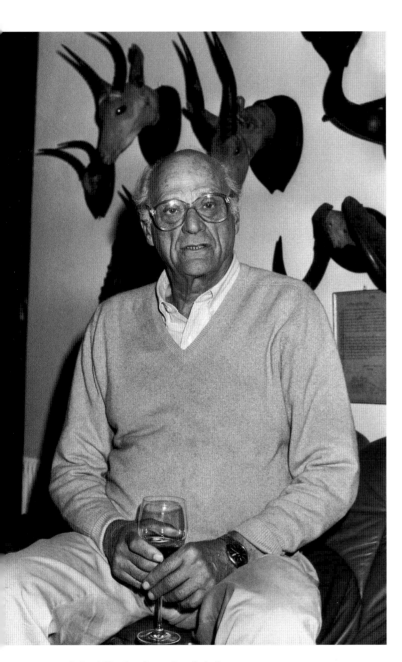

Arthur Miller in seltener Gesellschaft.
Arthur Miller in select company.

"Inge was such a ravishing beauty that she had everyone at her feet. After the war, we lived in a shared apartment for a while in Vienna. Amongst our friends were Ernst Haas, Ingeborg Bachmann, Hans Weigel, Viktor Frankl, and whatever their names were. After the war, it was like group therapy. There were hot flirtations, of course, and smart couples. Inge was just amassing marriage proposals. And then she went to Paris."

RENATE MOSZKOWICZ

"My time in Paris was unforgettable. Robert Capa, Henri Cartier-Bresson and the others were unbelievable characters. They had a fantastic, very cosmopolitan circle of friends—French, Spanish, English. It was entertaining. Through friendships, and also affairs, one got to know new cultures and languages. I owe my good Spanish to one such liaison. But when marriage, high nobility and so on were in the offing it was all over. I married an English journalist in London instead. It was infinitely dull and didn't last long. Let's call it a waste."

INGE MORATH

"Renate followed her father, who, as a Nazi, had reached Argentina, and I was looking for my father, who had managed to get out in 1938. So, two refugees met, and they realized, after this almighty fiasco of the Nazis there would always be two worlds for them. But they also realized that mere coexistence was utterly inadequate, that the only way was cooperation. Ultimately our meeting became the beautiful proof that, after terrible catastrophes, life goes on and can lead to great happiness and fulfilment. Of course, for truth's sake one must add that all men go into marriage and that's just how it should be."

IMO MOSZKOWICZ

"I met Arthur when *The Misfits* was being filmed. He and Marilyn were going through a hard time. After the film, it was clear to both that the marriage was finished. Arthur, who loved Marilyn madly, was in despair, and sought my company. But at the time I just wanted to get away—I had no desire to console a Marilyn Monroe victim. Six months later Arthur very gallantly asked for a rendezvous. That was it."

INGE MORATH

"I'm still astonished by the happiness that was ours for forty years. And what happiness! I try to keep reminding myself of it, also how much she gave me. I can only hope she experienced something similar regarding me. I think she did. She was a courageous, fine woman. We were all blessed in being so close to her."

ARTHUR MILLER, LETTER TO WERNER MÖRATH

Die 95jährigen Jubilarinnen Titti, Else und die jüngere Schwester Grete.

Titti and Else on their 95th birthday, with their younger sister Grete.

»Mein Ingelein! Ist es nicht wunderbar und beglückend, daß Imo unser Paradies auch so liebt wie wir beide und daß Arthur auch den Zugang zu diesem so wehmütigen herrlichen Land gefunden hat?

Oft denke ich an Tittis 95. Geburtstag, an ihren Tod, an die Katze in ihrem Grab, als wir beide ganz allein vor diesem winzigen Loch standen, in das die Urne kommen sollte, und eine streunende Katze sich in dieses winzige Loch setzte und uns anschaute. – Das war schon mystisch. Du hast in Deiner unnachahmlichen Art gesagt: »Die Titti kann's nicht lassen. Vielleicht betört sie ja auch noch den lieben Herrgott, falls es ihn gibt!«

Ich danke Dir, daß Du mich an vielem hast teilhaben lassen. Es ist so wichtig, daß man gemeinsame Erinnerungen hat, auch daß man im ›hohen‹ Alter an all das denken kann.

Ich umarme Dich! – Renate«

RENATE MOSZKOWICZ, BRIEF AN INGE MORATH

"My little Inge,

Isn't it wonderful that Imo shares our love for this paradise, and that Arthur can also relate to this magnificent and melancholy land?

I often think of Titti's ninety-fifth birthday, of her death, of the cat at her grave as the two of us stood in front of this tiny hole that was to receive her urn. A cat came along, sat in the tiny hole, and stared at us.—It really was mystical. In your inimitable way you said: "Titti just can't stop it—she'll likely beguile God, if he happens to exist!"

Thank you for sharing so many things with me. It's so important for there to be joint memories, also so one can look back on it all in old age.

I embrace you.

Renate"

RENATE MOSZKOWICZ, LETTER TO INGE MORATH

Katze besetzt das Urnengrab bei Tittis Beisetzung in Graz.
Cat occupying Titti's urn grave at her funeral in Graz.

»IHR BESUCH EHRT UNSEREN KUNSTSINN!«
"YOUR VISIT HONORS OUR ARTISTIC SENSIBILITY"

»Daß wir die große Dame der Photographie bei uns begrüßen
dürfen, ist erstklassig und ehrt uns. Wir wissen, daß wir Ihr Kommen
Ihrer Familiengeschichte verdanken, aber wir wissen auch, daß Sie
mittlerweile erstaunt erkannt haben, daß unsere Stadt Slovenj Gradec
so etwas wie eine heimliche Hauptstadt der Künste ist, und so ehrt
Ihr Besuch auch unseren Kunstsinn! Wir freuen uns sehr!«

KAREL PEČKO

"It is a delight and an honor to be able to welcome photography's
great lady in our midst. As we know, we owe her visit to her family
past. But we also know that meanwhile she has discovered to her own
surprise that our city Slovenj Gradec is something like a secret capital
of the arts, and so her visit honors our artistic sensibility. We are highly
delighted."

KAREL PEČKO

Karel Pečko, der Meister erotischer Landschaften.
Karel Pečko, master of erotic landscapes.

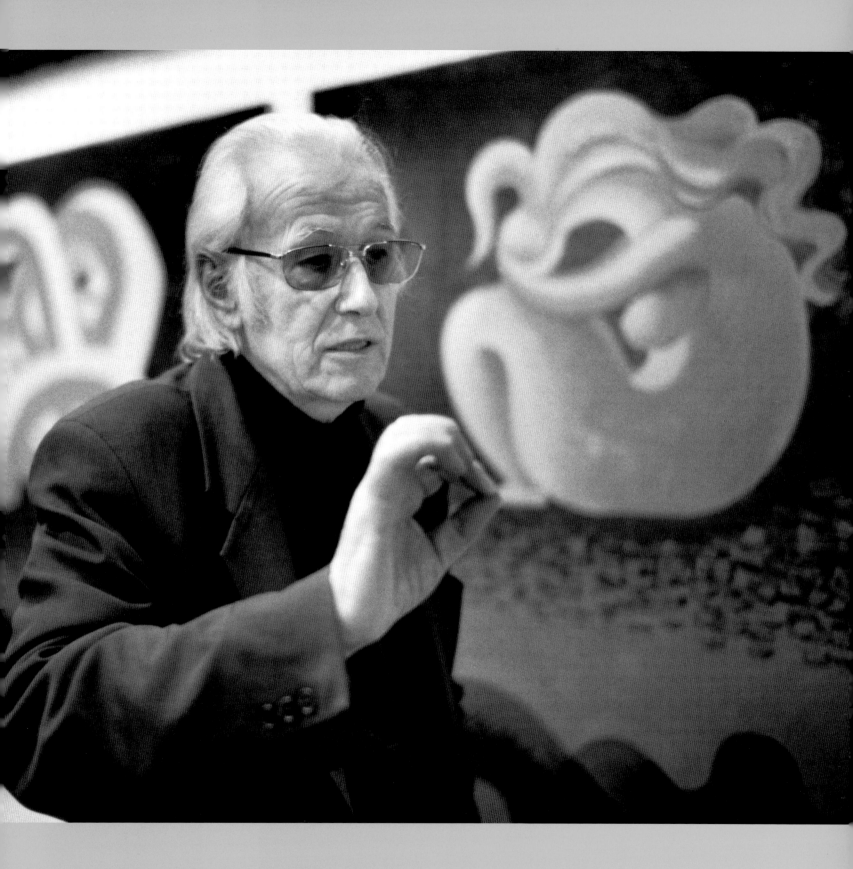

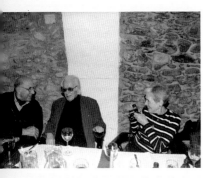

Werner Mörath, Karel Pečko,
Inge Morath – »Schön – uns
verbindet auch Gemeinsames«.
Werner Mörath, Karel Pečko,
Inge Morath.—"Good—we have
common interests, too."

Inge Morath, Karel Pečko –
»Génie local« und berühmte Dame.
Inge Morath, Karel Pečko—
génie local and famed lady.

Karel Pečko, Inge Morath –
»Entschuldigen Sie, das ist
kein Spaß, Madame«.
Karel Pečko, Inge Morath—"Begging
your pardon, it's no joke, Madame."

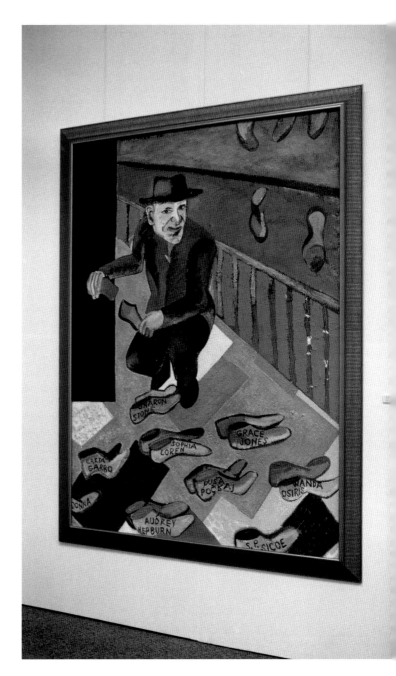

Silvester Plotajs Sicoe, *Wild at Heart*, 1998.

Karel Pečko führt durch die Galerie von Slovenj Gradec.

Karel Pečko guides visitors round the gallery in Slovenj Gradec.

Der Leichenbeschauer,
Gemälde von Jože Tisnikar.

The Coroner, painting by
Jože Tisnikar.

Hugo Wolf von Jože Tisnikar.

Hugo Wolf, by Jože Tisnikar.

Karel Pečko und Inge Morath in
Gesellschaft des Tisnikar-Raben.

Karel Pečko, Inge Morath, and
Tisnikar raven.

Avgust Lavrenčič, *Schweigen ist Tod*, Detail des Gemäldes.
Avgust Lavrenčič, *Silence is Deadly*, detail.

»Im Laufe meines Lebens hat sich mein Gefühl aus dem Elternhaus, daß Künstler im Leben wahnsinnig wichtig sind, immer klarer bestätigt. Sie sind die Seismographen der Gesellschaft, sie spüren voraus, sie können uns etwas in den Sinn bringen, bevor es wirklich passiert. Nicht umsonst sind die Nazis mit der ›Entarteten Kunst‹ so verfahren. Die haben sich von deren Wahrheit bedroht gefühlt. – Wenn ich wohin fahre, sehe ich immer zuerst die Schriftsteller, Maler, die weisen mir dann in gewisser Weise den Weg. Darum habe ich auch hier ein spezielles Gefühl. Da ist die Geschichte meiner Familie, die ja viel mit Künstlern zu tun hatte – Hugo Wolf und so, und da ist jetzt dieses Gefühl, daß Slovenj Gradec bis heute Künstler anzieht, ein besonderes Sensorium für sie hat. That makes me feel at home.«

INGE MORATH

"In the course of my life, the feeling I acquired from home that artists are fantastically important has proved increasingly true. They are society's seismographs, they sense things in advance, they can make us sense things before they actually happen. It was not for nothing that the Nazis dealt with so-called degenerate art as they did— they felt threatened by its truth.—Wherever I go I look at the writers and artists first; in a certain sense they point out the way. Which is why I have a special feeling here. There is my family history and its close involvement with artists—Hugo Wolf and so on—and now there's this feeling I have that even today Slovenj Gradec attracts artists, that it has a special sensorium for them. That makes me feel at home."

INGE MORATH

Die Witwe des bekannten slowenischen Malers Jože Tisnikar.
The widow of well-known Slovenian painter Jože Tisnikar.

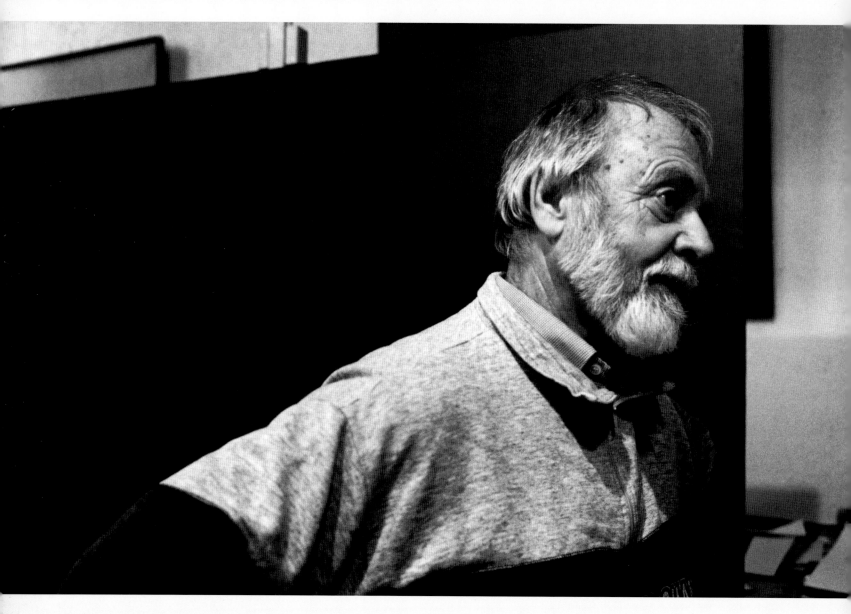

Der international bekannte Grafiker Bogdan Borčič.

Bogdan Borčič, graphic artist of international repute.

Bogdan Borčič spricht klangvolles Französisch.
Bogdan Borčič, a sonorous speaker of French.

Bogdan Borčič überlebte als Siebzehnjähriger Dachau.
At the age of seventeen Bogdan Borčič survived Dachau.

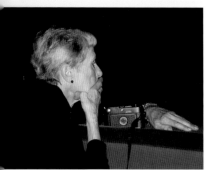

DRAGO JANČAR

INNEHALTEN. EINE BEGEGNUNG MIT INGE MORATH, HEUER IM FRÜHJAHR

Inge Morath hätte ich letztes Frühjahr treffen sollen. Ich war in Bohinj, im letzten Winkel dieses Alpentales, am Talschluß, wo zu Anbeginn der Welt ein großer Gletscher die dunkel schimmernde Fläche eines schweigenden Sees zurückgelassen hat. Sein Spiegel ist dunkel, denn das Wasser in ihm ist tief und still, so still wie die reglose Gegenwärtigkeit alles Uralten, vielleicht aber auch nur deshalb, weil seine Ufer zu dieser Zeit, im kühlen Vorfrühling, keine Touristen kennen, die unter lauten Zurufen ihre Familien, ihre Großmütter und Kinder vor dem Photoapparat gruppieren, um sie im Bild, im Rahmen, in der Erinnerung festzuhalten, vor dem Hintergrund jener dunklen, blaugrünen Schönheit, die auch ihre Augen ahnen, die auch ihre rastlosen, nach immer neuen Landschaften und optischen Reizen ausgreifenden Touristenseelen für Momente wahrnehmen. Wenn ich jetzt, ein Jahr danach, am selben Ort, wieder im Vorfrühling, in einem Buch mit den Photographien Inge Moraths blättere, wenn ich an ihrer Seite in Preßburg eine regennasse Straße mit bröckelnden Fassaden alter Häuser durchschreite, wenn ich mit ihren Augen die dunklen Gestalten des abendlichen Corso von Jerez de la Frontera sehe und dann wieder das Paar müder Damenschuhe (ihre?) auf dem Pflaster von Venedig, wenn ich die vielen anderen Bilder des für einen Augenblick angehaltenen Lebens sehe, muß ich an dieses Innehalten denken, daran, daß Inge Morath vielleicht gesagt hätte, es bedürfe des Innehaltens im Leben, in der Landschaft, auf der Straße, im Hof eines Frauenklosters, am Ufer des Bodensees, in Peking oder in St. Petersburg, wenn man sehen wolle. Und zu sehen, wenn man verstehen wolle. Das hat sie nicht gesagt, weil wir uns nicht getroffen haben, das sagen mir jetzt ihre Photographien.

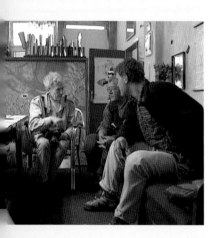

Damals, im vergangenen Frühjahr, sie bereiste gerade Slowenien, rief mich ihr Begleiter auf dieser Reise an, Ludwig Hartinger, Bilddeuter dieses Landes und Aufdecker seiner Wortgeheimnisse. Er sagte, Inge Morath habe den Wunsch geäußert, mich zu treffen, wir sollten uns in Ljubljana treffen, sie wolle mit mir über das Land sprechen, das sie bereise, über seine Kunst, über die politischen und kulturellen Turbulenzen des letzten Jahrzehnts, auch über die Literatur, die hier entstehe. Daß Inge Morath auch verstehen wollte, um sehen zu können, davon erzählen ihre Photographien, die Menschen auf ihnen. Man könnte sie Stimmungsphotos nennen, auf denen der uralte Friede der Donau hörbar, die Verzweiflung eines osteuropäischen Landes erahnbar, das vitale Pulsieren Pamplonas, der Esprit von Paris und die Dynamik New Yorks spürbar werden, aber jede einzelne Photographie spricht zu uns auch davon, daß Inge Morath über die Dinge, die sie sah, auch nachdachte. Das können wir an einer einzigen Szene vor einem irischen Pub erkennen, an der Photographie sich bückender Gestalten, die durch die Berliner Mauer spähen, überall läßt sich der Geist des geschichtlichen und sozialen Augenblicks nicht nur erahnen, sondern auch verstehen; aus dem Anblick einer Pariser Kellnerin hinter der Theke, aus einem Kuß in einer Straße New Yorks. Aus jedem angehaltenen Lebensmoment aber atmet zugleich der zielsichere Sog des Lebens. In den unaufhaltsamen Szenen ist Bewegung, ein Lebensstrom, der sie alle mit sich trägt, Bauern und Modistinnen, rumänische Eisenbahner und Beduinentänzerinnen, entrückte Gläubige und kühle Geschäftsleute, New Yorker Prostituierte und Londoner Aristokratinnen, alle Spielarten gesellschaftlicher Randexistenz und die künstlerischen und kommerziellen Säulen der Gesellschaft im Pulsschlag der historischen Zeit und ihres eigenen Lebens.

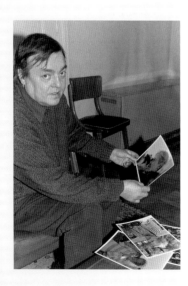

Ich weiß nicht, über was Inge Morath mit mir sprechen wollte, wohl über die Menschen und über dieses Land, aus dem ihre Eltern stammten, Angehörige jener deutschsprachigen Volksgruppe, die sich nach dem Ersten Weltkrieg über Österreich und Deutschland zerstreut hat und die nach dem Zweiten Weltkrieg aus den krainischen und steirischen Städten und Märkten Sloweniens ganz verschwunden ist. Hinter ihnen sind nur die Grabsteine zurückgeblieben, verstreute Hinweise in den Museen, Bücher in den Bibliotheken, Spuren der deutschen Sprache in der slowenischen, unsichtbare Geister der Vergangenheit aus meiner Marburger Jugend. Vielleicht suchte sie die Nähe dieser unsichtbaren und untergegangenen Welt, in der ihre Vorfahren gelebt haben und die von Kriegen und Revolutionen verheert worden ist, vielleicht wollte Inge Morath, die die Welt durchreist und im Sog ihrer künstlerischen und intellektuellen Zentren lebte, in die Tiefe ihrer Erinnerung sehen, jener Erinnerung, die jenseits unserer Erfahrung lebt, die in jenen gelebt hat, die nicht mehr sind. Mit ein wenig schriftstellerischer

Eitelkeit stelle ich mir vor, daß sie vielleicht auch ein Wort zu meinen in deutscher Übersetzung erschienenen Büchern sagen wollte, die sie angeblich in der Reisetasche auf diesem Weg begleiteten. Alles das weiß ich nicht, weil wir uns nicht begegnet sind.

Ich steckte damals in den Wahnbildern meiner Sätze und Figuren, am Rande der Welt, im hintersten Winkel dieses uralten Gletschertales, an seinem dunklen, schweigenden See und durfte es nicht zulassen, daß mit meinem Besuch in Ljubljana, mit meiner Begegnung mit der berühmten und weltläufigen Photographin in einem verrauchten Intellektuellenclub, wo die Begegnung hätte stattfinden sollen, der Schwall der Großen Welt in meine mönchische Einsamkeit hereinbrach, ihr Paris oder New York, die berühmte Photoagentur Magnum und die noch berühmtere Marilyn Monroe, der ganze Glamour, aber auch die große Kunst der Prominenten, mit denen sie verkehrte und von denen auch ihre photographische Karriere ihren Glanz bekommen hatte, Robert Capa, Jean Arp, Jean Cocteau, Henry Moore, Alberto Giacometti, um nicht von Arthur Miller zu reden. Also sagte ich zu Ludwig Hartinger, wir sollten die Begegnung um ein, zwei Monate verschieben. Ludwig meinte, das sei kein Problem, denn der Photozyklus sei noch nicht abgeschlossen. Und doch war er abgeschlossen.

AUS DEM SLOWENISCHEN VON KLAUS DETLEF OLOF

DRAGO JANČAR

PAUSING. AN ENCOUNTER WITH INGE MORATH, THIS YEAR IN SPRING

I should have met Inge Morath last spring. I was in Bohinj, in the remotest corner of this alpine valley, at the end of it, where, at the beginning of time, a big glacier left behind the dark-shimmering surface of a silent lake. This surface appears dark, because the water in the lake is deep, and still, as still as the motionless existence of everything primeval, but perhaps also simply because at this time of year, in the cool pre-spring, its banks are free of tourists loudly marshaling their families, their grandmothers and children into groups in front of cameras in order to photograph them, frame them, record them in memory against the backdrop of that dark, blue-green beauty that even their eyes sense, that even their restless tourists' souls that are always reaching out for new landscapes and visual stimulation experience for moments. When, now, a year later, at the same place, in pre-spring, I leaf through a volume of Inge Morath's photographs; when I walk at her side down a street wet with rain in Bratislava, past the crumbling façades of old houses; when I see the dark figures on their evening promenade in Jerez de la Frontera through her eyes and then again that pair of tired lady's shoes (hers?) on Venice's paving stones; when I view the many other photographs of life that has been stopped for an instant; then I cannot but think of this act of pausing, of the fact that Inge Morath might have said that it is necessary to pause in life, in the landscape, on the street, in a convent courtyard, on the shore of Lake Constance, in Peking, or St. Petersburg, if one wants to see. And to see, if one wants to understand. She never said that, because we never met; her photographs tell me that now.

Back then, last spring, she was traveling in Slovenia, and her escort on this journey, Ludwig Hartinger, picture-interpreter of this land and revealer of its word-secrets, called me up. Inge Morath, he said, had expressed a wish to meet me, that we should meet in Ljubljana, she wanted to speak with me about the country she was traveling in, about its art, about the political and cultural upheavals of the past decade, also about the literature arising here. Inge Morath's photographs, the people in them, speak also of the fact that she wanted to understand in order to see. One might term them mood photos, in which we can hear the Danube's age-old peace, divine the despair in an eastern European land, sense Pamplona's vital, pulsing life, the spirit of Paris, and the dynamism of New York; but each individual photograph also speaks to us of the fact that Inge Morath thought about the things she saw. We can see this in a single scene outside an Irish pub, in the photograph of people stooping to

Drago Jančar ist einer der bekanntesten slowenischen Schriftsteller, der sich auch sehr kritisch mit der politischen Vergangenheit Jugoslawiens auseinandersetzt.

Drago Jančar, one of Slovenia's best-known writers, has also subjected Yugoslavia's political past to highly critical scrutiny.

peer through the Berlin wall; not only can one sense the spirit of the historical and social moment everywhere, one can understand it: in the look of a Paris waitress behind the bar, or a kiss on a New York street. But, at the same time, each frozen moment of life breathes life's unerring undertow. Movement is in all the unstoppable scenes, a life-current that bears everything along with it. Farmers and milliners, Romanian railwaymen and Bedouin dancers, enraptured religious and cool business people, New York prostitutes and London's women aristocrats, all varieties of life on the edge of society and society's artistic and commercial pillars in the pulse of historical time and of their own lives.

I don't know what Inge Morath wanted to talk with me about, about the people and the country presumably from which her parents came, members of that German-speaking ethnic group that scattered over Austria and Germany after World War I and, after World War II, disappeared entirely from the Carniolan and Styrian cities and market towns of Slovenia. Only gravestones remain, scattered clues in museums, books in libraries, traces of the German language in the Slovenian language, invisible ghosts of the past from my youth in Maribor. Perhaps she sought the proximity of this invisible and extinct world inhabited by her ancestors and devastated by wars and revolutions; perhaps Inge Morath, who toured the world and lived in the maelstrom of its artistic and cultural centers, wished to see into the depth of its memory, the memory that lives beyond our experience, which lived in those who are no more. Not without something of the writer's typical vanity, I flatter myself she might also have wanted to say something about my writings that have appeared in German translation, which apparently were in her traveling bags on this trip. I don't know whether all this is true, because we never met.

At the time, I was immersed in the chimeras of my sentences and characters, on the edge of the world, in the farthermost corner of this primeval glacier valley by its dark, silent lake, and I could not afford, with a visit to Ljubljana and my meeting the world-famous, world-traveled photographer in some smoky intellectual club as was planned, to let the surging world break in on my monastic isolation, her Paris or New York, the famous Magnum photographers' agency and the yet more famous Marilyn Monroe, all the glamor, but all the great art of the celebrities she moved among as well, and from whom her photographic career derived its splendor, Robert Capa, Jean Arp, Jean Cocteau, Henry Moore, Alberto Giacometti, to say nothing of Arthur Miller. So I told Ludwig Hartinger we should postpone the meeting for a month or two. Ludwig said it would be no problem since the photographic cycle had not yet been completed. And yet it had been completed.

TRANSLATED FROM SLOVENIAN BY KLAUS DETLEF OLOF

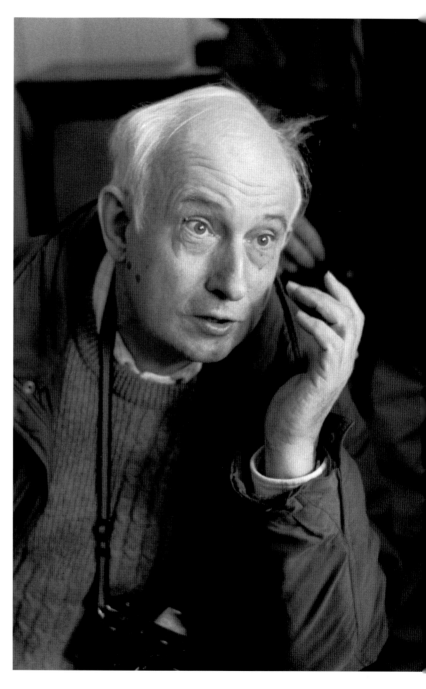

Der vielfach prämierte Photograph Stojan Kerbler.
Multiple award-winning photographer Stojan Kerbler.

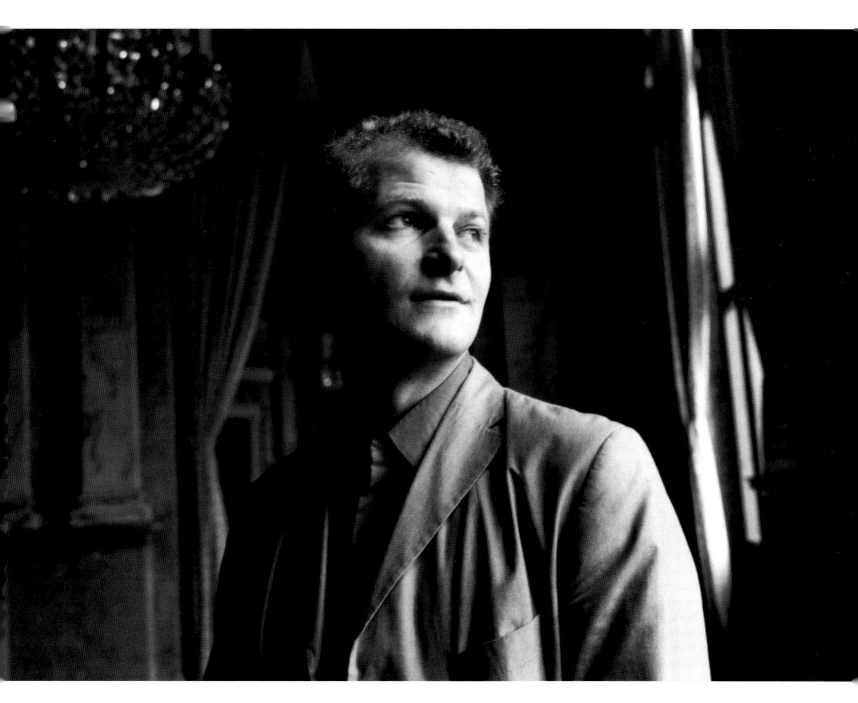

Der austro-slowenische Regisseur Martin Kušej gilt als der Grenzgänger unter den Theatermachern.

Austro-Slovenian Martin Kušej is seen as the border-walker among stage directors.

GRENZÜBERSCHREITUNGEN
BORDER CROSSINGS

»Der Grenzstein vor der Kirche von Sankt Pongratzen/Sveti Pankrac, der
früher einmal die Grenze mitten durch die Kirche angezeigt hat, bekommt
erfreulicherweise immer mehr Museumscharakter. Jeden Pfingstmontag feiern
die österreichischen Steirer und die slowenischen Steirer gemeinsam ihr
Kirchen-Grenzfest. Mit Musikkapellen, Feuerwehr, Jägern, Prozession,
›Himmel-Tragen‹. Da spürt man, wie sehr die Grenze sich hier zum Guten
verändert hat. Hoffentlich geht's weiter so.«

INGE MORATH

"The boundary stone outside the church of Sankt Pongratzen/Sveti Pankrac
used to show the border as running right through the church. Fortunately it is
becoming more and more of a museum exhibit. Every Monday after Pentecost,
Austrian Styrians and Slovenian Styrians celebrate their church border-festival
together, with bands, fire services, hunters, parade, baldachin-carriers. One can
feel that the border has changed for the good here. Hopefully it will continue."

INGE MORATH

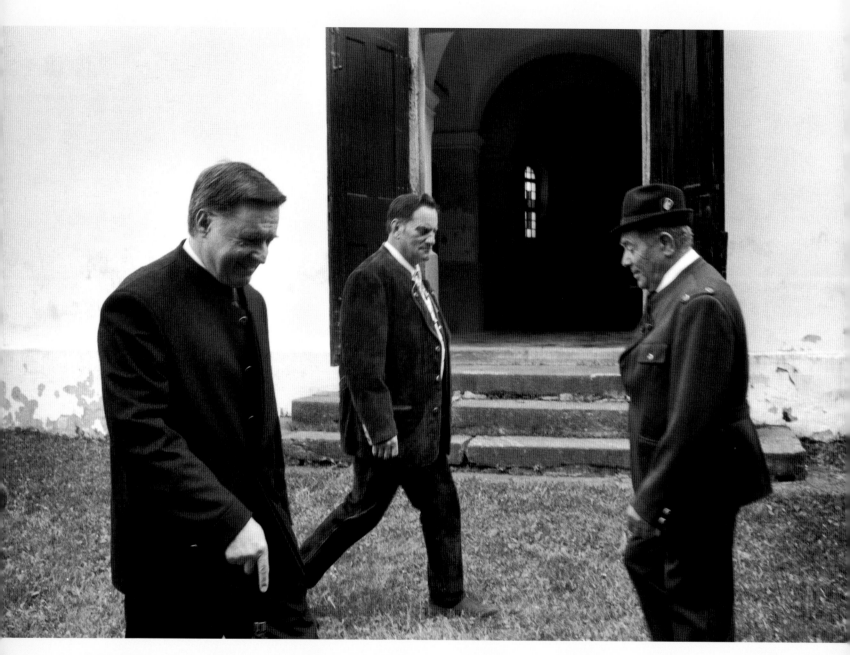

Grenzszene: Drei Bürgermeister – zwei slowenische und ein Österreicher –
überschreiten den Grenzstein vor der Kirche von Sankt Pongratzen/Sveti Pankrac.

Border scene: three mayors—two Slovenian and one Austrian
—cross the boundary stone at the church of Sankt Pongratzen/Sveti Pankrac.

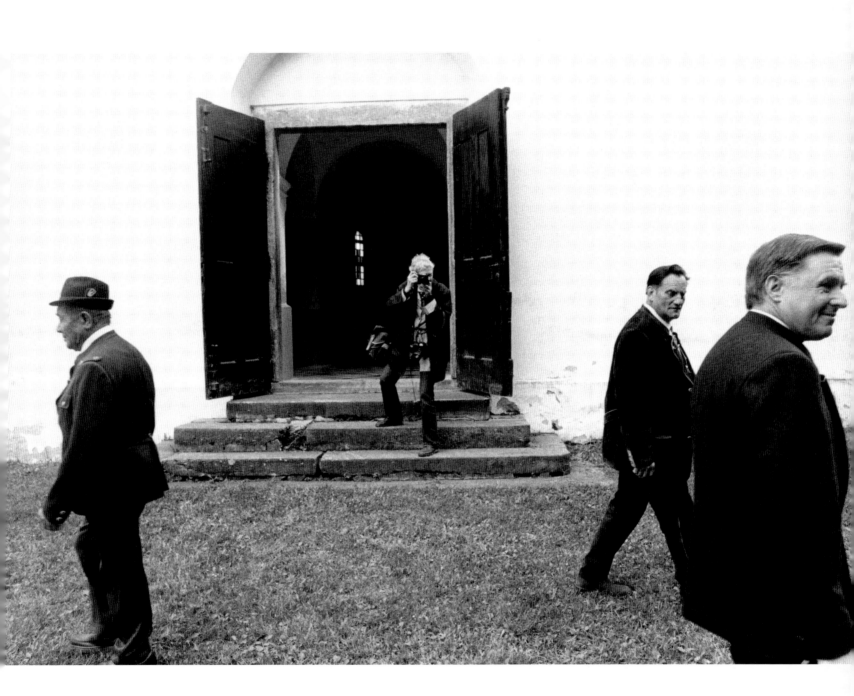

Das Kreuz mit der Grenze wird leichter.

The cross to be borne at the border is growing lighter.

Die Musikanten spielen einen Grenzüberschreitungs-Marsch.

Musicians playing a border-crossing march.

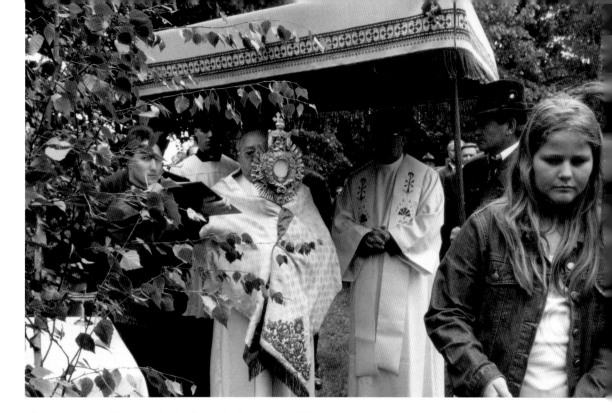

Pfingstprozession – Priester von beiden Seiten der Grenze beim Zelebrieren.
Pentecost parade, with priests from both sides of the border officiating.

Inge Morath, Branko Lenart.

Liebe Inge Morath!

Als Du vor kurzem in unserem Haus warst, klang auch das Thema der Grenznähe, unser Verhältnis dazu, an.
Vom Atelierfenster schaust Du hinauf zum Bauern Isak, hinter dessen Stall Slowenien beginnt. Meine Beziehung
zum Nachbarland und seinen Menschen hängt eng mit dem Bauernhof meiner Großmutter vulgo Magligga zusammen.
Die südliche Grundgrenze verlief ein paar hundert Meter entlang der jugoslawischen Staatsgrenze. Wenn wir unser
Vieh auf dieser Hutweide hatten, kam es immer wieder vor, daß es über die Grenze graste, die weder markiert noch
abgezäunt war. In der nahegelegenen Karaula – der Name stammt aus der osmanischen Zeit und bezeichnet die
Soldatenunterkünfte – waren Soldaten der damaligen jugoslawischen Volksarmee stationiert. Burschen aus Bosnien,
Montenegro, Kroatien, niemals slowenische, die heute, lebten sie noch, in ihren Achtzigern wären. Nur uns Kindern
erlaubten sie, die Grenze zu übertreten, Schafe und Rinder zurückzutreiben. Das war in den späten 40er Jahren.
Da waren die politischen Beziehungen noch schwer belastet. Heute ist diese Waldlichtung halb zugewachsen, eine
Kapelle aus Monarchiezeiten steht um Fußbreit auf – slowenischem Boden. Österreichische Zöllner, die ein paar
Schritte gegenüber ihr Wachhäuschen haben, organisierten die Renovierung der Michaelskapelle und holten mich
als Maler dazu. So sieht man jetzt im westlichen Giebeldreieck eine Hirtenszene mit Knaben. Sobald Du wieder
bei uns in Arnfels vorbeikommst, wandern wir hin und besuchen auch den Besitzer der Kapelle, den slowenischen
Bauern vulgo Langfried. Dort wird Dir Most, Brot, Schmalz – wie es immer Brauch war – aufgetischt.
Von uns weg liegt eine dreiviertel Stunde bergauf eine mehrhundertjährige, dem hl. Pankratius geweihte Wallfahrts-
kirche, die bald nach der Unabhängigkeit Sloweniens 1991 wieder in Stand gesetzt wurde. – Soweit ich mich erinnere,
wolltest Du dort ja auch photographieren. – Wir gehen seit über zwanzig Jahren am Pfingstmontag mit Freunden
von Arnfels aus denselben Weg wie seinerzeit mit Eltern und Geschwistern zum Pongratzenkirchtag der Offenen
Grenze. Um die Kirche, die keine fünf Meter ›drüben‹ steht, sind Kramerstände aufgebaut. Wein,
Bier und Schnaps wird ausgeschenkt. Steirer von hüben und drüben braten Würste, kaufen slowenische Holzrechen,
Werkzeugstiele, Birkenbesen, hölzernes Kinderspielzeug. Steirisch, Windisch, Slowenisch und ›Daitsch‹ wird
geredet und gesungen. Ich hoffe, Du kannst das alles bei schönem Sommerwetter photographieren und eine echte
steirische Grenzgaudi!
Auf Wiedersehen hoffentlich bald!
Dein Gerald Brettschuh

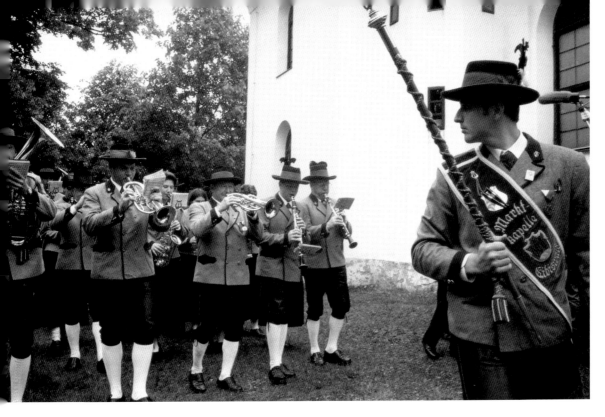

Waldhornbläser beim musikalischen Grenzgang.
Wind band at ceremonial border crossing.

Dear Inge Morath,

When you were at our house recently, the subject of the nearness of the border and of our relation to it also came up. From the studio window you see uphill to farmer Isak, behind whose cowshed Slovenia begins. My relationship to the neighboring country and its people is closely linked to my grandmother Vulgo Magligga's farm. For a few hundred meters, the southern border of the property ran along the Yugoslavian state border. When our cattle were on this pastureland, it kept happening that they would graze over the border, which was neither marked nor fenced off. In the nearby *karaula*—the name goes back to Ottoman times and means soldiers' living quarters—soldiers of the then Yugoslavian People's Army were stationed—lads from Bosnia, Montenegro, Croatia, but never Slovenia, who, if they were still alive today, would be in their eighties. We children alone were permitted to cross the border to drive back sheep and cows. That was in the late 1940s. Political relations were still badly strained. Today, this forest clearing is half overgrown; a chapel from Habsburg times stands there, on Slovenian ground, but only just. Austrian customs officials, whose little guard house is but a few paces off, and who arranged for the chapel of St. Michael to be renovated, brought me in as a painter—a pastoral scene with a boy now adorns the western pediment. As soon as you visit us again in Arnfels we can go up there and visit the chapel's owner as well, the Slovenian farmer vulgo Langfried. He'll serve new wine, bread, drippings, as is the age-old custom.

Three-quarters-of-an-hour's uphill walk from us is a pilgrimage chapel dedicated to St. Pancras; several centuries old, it was restored shortly after Slovenia declared independence in 1991.—As far as I recall, you also wanted to photograph there.—On the Monday after Pentecost for over twenty years now, together with friends from Arnfels, we have gone the same way we used to with parents and brothers and sisters for the Pongratzen church open-border day. Stalls are erected round the church—which is scarcely five meters on the "far side." Wine, beer, and schnapps are served. Styrians from both sides of the border grill sausages, sell Slovenian wooden rakes, tool handles, birch brooms, toys made of wood. Styrian, Windisch, Slovenian, and "Daitsch" (German) are spoken and sung.

I hope you'll be able to photograph all that and a good deal of Styrian border fun in fine weather.

Hopefully until soon,

Gerald Brettschuh

»Viele Lieder habe ich gelernt im Laufe der Zeit. Das folgende ist für uns Südprovinzler so etwas wie die heimliche Landeshymne. Es geht so: Pojdem na Štajersko – Ich geh auf Steiermark – gledat, kaj delajo – Schauen was sie machen – ljubice tri – Die drei Liebchen. Davon gibt's drei Strophen. Die haben mein Freund Hasewend, den Du ja als ›Efendic‹ kennengelernt hast, so manchem Unbedarften bei Welsch- oder laški Riesling eingetrichtert.«

GERALD BRETTSCHUH, BRIEF AN INGE MORATH

"I've learnt many songs over the years. This one is something like a secret national anthem for us southern provincials. It goes: Pojdem na Štajersko—I'm going to Styria—gledat, kaj delajo— See what they're up to—ljubice tri—My three loves. It has three stanzas. My friend Hasewend, who you know as "Efendic", has funneled it into various inexperienced souls with Welsch or *laški* Riesling."

GERALD BRETTSCHUH, LETTER TO INGE MORATH

Inge Morath freut sich über neue Kochlöffel-›Botschaften‹.
Inge Morath, pleased at new wooden-spoon "tidings."

Sepp Loibner im Gespräch mit Regina Strassegger.
Sepp Loibner and Regina Strassegger converse.

Gerald Brettschuh und sein Freund Gunther Hasewend beim Gesang.

Gerald Brettschuh and friend Gunther Hasewend singing.

Der selbstgemachte Milchstritzl ist eine gefragte Spezialität.

Homemade plaited yeast loaf is a popular specialty.

GESPRÄCH ZWISCHEN INGE MORATH UND JOSEF LOIBNER JUNIOR

I.M.: Für mich waren Grenzen immer lästig. Sie halten einen auf, haben etwas Schikanöses. Das hab ich auf meinen frühen Reisen in Osteuropa und in der Sowjetunion zu spüren bekommen. Bis da alle Papierln zusammen waren, konnte das unglaublich lange dauern. Wie war das bei Euch hier, bevor es mit der Grenze leichter geworden ist?

J.L.: Den Eisernen Vorhang hat es an dieser Grenze so wie an der zu Ungarn oder zur damaligen Tschechoslowakei eigentlich keinen gegeben. Es gab zwar Wachtürme, Grenzposten und so. Es gibt natürlich schon Geschichten, wo früher Leut von den jugoslawischen Grenzern geschnappt worden sind. Oft waren das natürlich auch Schmuggelgeschichten. Die mußten dann in Mahrenberg oder in Marburg ausgelöst werden. So viel uns erzählt worden ist, hat es nur ganz selten Tote gegeben. Von der Partisanenzeit natürlich abgesehen.

I.M.: Wie wir im vergangenen Februar hier waren, hat uns Ihr Vater diese skurrile Geschichte mit der Straße erklärt. Es fehlen eigentlich nur ein paar hundert Meter, daß die hiesige Seite mit der slowenischen verbunden wäre. Dann wären die beiden Dörfer mit dem Auto innerhalb von zehn Minuten erreichbar, so muß man eine dreiviertel Stunde herumfahren. Die einfache Lösung kommt seit Jahren nicht zustande, weil da das Getue mit der Schengen-Außengrenze ist und die umständlichen Bürokraten sowieso nicht die schnellsten sind. Hoffentlich tut sich da jetzt was!

J.L.: Ja, die tun da schon so lange herum. Aber wir hoffen halt auf bessere Zeiten. Vor allem wenn Slowenien in ein paar Jahren zur EU kommt, wird sich da schon einiges ändern.

I.M.: Die entscheidende Frage bei diesen ganzen Grenzgeschichten ist natürlich, wie sehr die Menschen die Grenze im Kopf loswerden. Let's hope for the best!

TALK BETWEEN INGE MORATH AND JOSEF LOIBNER JR.

I.M.: I've always found borders a nuisance—a delay, and then often an excuse for chicanery. I experienced that on my early trips in Eastern Europe and the Soviet Union. It could take ages to get all the necessary bits and pieces of paper together. What was it like for you here before things eased up at the border?

J.L.: There was never really an iron curtain at this border as there used to be at those to Hungary or former Yugoslavia. There were watchtowers, border guards, and so on. Of course, there are stories of people being caught by Yugoslavian border patrolmen; often these stories have to do with smuggling. They had to be bailed out in Mahrenberg or Maribor. Deaths at the border, as far as we were informed, were very rare. Apart from the partisan era, of course.

I.M.: When we were here last February your father told us this absurd story about the road. Only a few hundred meters are missing to link this and the Slovenian side. Then the two villages would be ten minutes' automobile ride apart; as it is, one has to take the long way round, a drive of forty-five minutes.

J.L.: Yes. They've been fooling about for so long. But we're hoping for better times. Especially when Slovenia joins the European Union in a couple of years' time, a good deal should change.

I.M.: The decisive question with all these border issues, of course, is to what extent people manage to rid themselves of the border in their heads. Let's hope for the best!

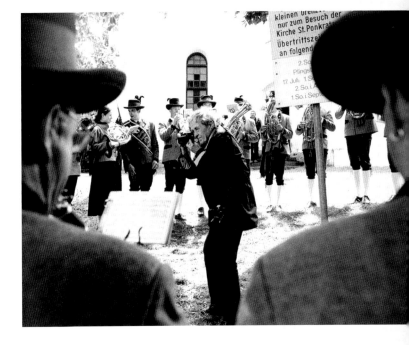

GRENZSITUATION HERBST 2001
BORDER SITUATION, FALL 2001

In der Nacht vom 10. auf den 11. September 2001 besteigen Inge Morath und Arthur Miller in New York JFK ein Flugzeug nach Paris Charles de Gaulle. Eine Preisverleihung in Versailles und Fernsehaufnahmen für die ›Grenz.räume‹ stehen auf dem Programm. Stunden später: Islamistische Extremisten kapern Passagierjets, verwandeln sie in Selbstmord-Geschoße. Terror-Horror live. ›America under attack!‹ Allein in New York über 3000 Tote! Aus den WTC-Türmen der Finanz-Metropole wird ›ground zero‹.
Um 16 Uhr 27 MEZ läutet im Pariser Hotel Maurice bei Miller / Morath das Telephon. Ein Anruf aus Wien. Inge Morath hebt ab, sagt: »Hallo, ja wir sind gut angekommen, alles in Ordnung. Wir sehen uns ja morgen… Was ist da auf CNN? Arthur, schalt einmal den Fernseher ein, CNN…«

On the night of September 10/11, 2001, Inge Morath and Arthur Miller board a plane at JFK, New York, bound for Charles de Gaulle, Paris. A prize-giving ceremony in Versailles and television recordings for *Border.Spaces* are on the program. Hours later, Islamic extremists seize passenger airliners and turn them into *kamikaze*-missiles. Horror, live. "America under attack!" Over three thousand dead in New York alone! The World Trade Center towers are transformed into "ground zero."
 At 16.27 CET the telephone rings for Miller/Morath at Hotel Maurice, Paris. A call from Vienna. Inge Morath answers the phone: "Hallo, yes, we've arrived safely, everything's okay. We'll be seeing each other tomorrow… What's on CNN? Arthur, switch the television on, CNN…"

Inge Morath im Grenzraum.
Inge Morath in border space.

»New York 11. September 2001 via CNN in einem Pariser Hotel. Wir versuchen mit unserer Tochter in New York zu telefonieren. Dead lines.«

"New York, September 11, 2001, via CNN in a Paris hotel. We try phoning our daughter in New York. Dead lines."

ZWEITES TELEFONAT WIEN–PARIS AM 11. 9. 2001, 18 UHR 43 MEZ

R.ST.: Habt ihr Nachricht von Rebecca?

I.M.: Nein, seit Stunden kein Durchkommen. Hoffentlich hat der Ronan dieses Desaster nicht mit anschauen müssen. Der ist zwar tough, aber das ist doch ein bisserl viel.

R.ST.: Wir werden uns morgen unter diesen Umständen wohl nicht sehen...

I.M.: Wenn wir schon einmal hier sind und eh nichts tun können, laß uns doch das machen. Der Arthur hat die Geschichte in Versailles am Donnerstag abgesagt, was den Chirac wahrscheinlich nicht so freuen wird. Aber zum Feiern gibt's ja jetzt wirklich nichts.

R.ST.: Der Al Gore ist gerade zu Besuch in Wien. Der versucht über Kanada zurückzukommen. Offizielle Statements hat er keine abgegeben.

I.M.: Uns wird wahrscheinlich auch nichts anderes übrig bleiben, als über Kanada zurückzufliegen. Aber jetzt versuchen wir alles, um mit Rebecca in Kontakt zu kommen. Das ist ja wirklich unangenehm. Aber die werden schon in Ordnung sein. Wir müssen jetzt ja trotzdem alle irgendwie weitermachen.

INGE MORATH, TELEFONAT MIT REGINA STRASSEGGER

SECOND PHONE CALL VIENNA / PARIS SEPTEMBER 11, 2001 18.43 CET

R.S.: Have you heard from Rebecca?

I.M.: No, the lines have been dead for hours. Hopefully Ronan didn't have to witness this disaster. He's tough. But this is a bit much.

R.S. Under the circumstances we won't be seeing each other tomorrow....

I.M.: Now that we're here and there's anyway nothing we can do, let's stick to our plan. Arthur has canceled the Versailles engagement, which likely won't please Chirac. But there's really nothing to celebrate now.

R.S.: Al Gore's in Vienna at the moment. He's going to try to get back via Canada. He's issued no official statements as yet.

I.M.: Likely we'll have no alternative but to fly back via Canada, too. At the moment we're doing all we can to contact Rebecca. It's really most unpleasant. But they'll be alright. We all have to try and get on with life despite this.

INGE MORATH AND REGINA STRASSEGGER ON THE PHONE

»Der zweite WTC-Turm kollabiert. Unsere Tochter Rebecca lebt nur ein paar Straßen von dort.
Sie bringt um diese Zeit unseren Enkel Ronan zum Kindergarten.«

"The second WTC tower collapses. Our daughter Rebecca lives only a few streets away.
At this time she is usually taking our grandson Ronan to kindergarten."

Arthur Miller – Extreme Zeiten.
Arthur Miller—extreme times.

AUS DEM PARISER GESPRÄCH, 13.9.2001

»Zum Glück wissen wir jetzt, daß Rebecca und Ronan heil davongekommen sind. Sie waren tatsächlich gerade unterwegs zum Kindergarten, als das alles im Gange war. Es muß die Hölle gewesen sein. Aber scheinbar hat es der Vierjährige ganz gut verkraftet. Rebecca ist nach wie vor außer sich.«

INGE MORATH

»Ich hab keine Ahnung, was ich unserem Enkel auf seine unzähligen Fragen antworten soll. Ich kann ihm ja nicht sagen, daß sich hier womöglich etwas fortsetzt, was im vergangenen Jahrhundert mit 200 Millionen Kriegstoten aufgehört hat. / Ich fühle mich persönlich angegriffen, nicht als Jude, sondern als Angehöriger der menschlichen Rasse. In New York leben so viele Moslems. Eben erst haben sie in der 96. Straße in Manhattan eine riesige Moschee gebaut. Diese wahnsinnigen Todesanbeter haben bei diesen Anschlägen auch unzählige Moslems in den Tod gerissen. / Ich hoffe, unserem Präsidenten fällt mehr ein als Gewalt, und ich hoffe, daß er angesichts dieser Ereignisse über sich hinauswachsen kann.«

ARTHUR MILLER

»Weil wir in unserer gemeinsamen Arbeit so viel über Grenze reden: Das hier ist für Amerika seit Pearl Harbour eine der extremsten Grenzsituationen überhaupt. Die Angreifer haben ja sämtliche Grenzen menschlichen Handelns überschritten. Das ist alles sehr bedrückend.«

INGE MORATH

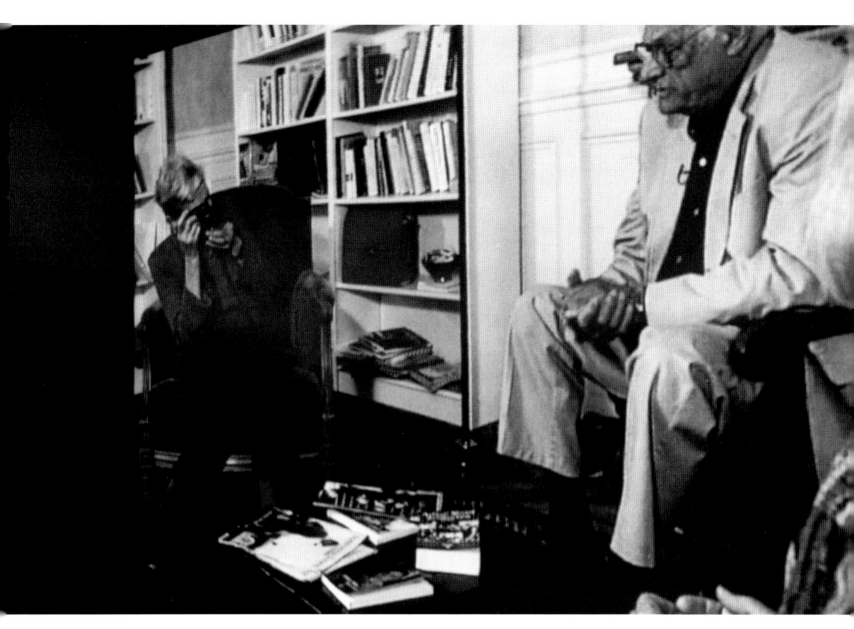

Inge Morath photographiert Arthur Miller.
Inge Morath photographs Arthur Miller.

PARIS CONVERSATION SEPTEMBER 13, 2001

"Fortunately we know now that Rebecca and Ronan are safe. They really were on their way to the kindergarten at the time it was all happening. It must have been hell. The four-year-old seems to have taken the strain well. Rebecca is still beside herself." INGE MORATH

"I have no idea how to answer our grandson's countless questions. After all, I can't tell him that the process that ended in the past century with 200 million war dead is possibly continuing. / I feel personally assaulted, not as a Jew, but as a member of the human race. There are so many Muslims living in New York. Just recently a huge new mosque was built on 96th Street in Manhattan. Through their attack these insane death-worshipers killed untold Muslims as well. / I hope our President thinks of more than just violence, and I hope these events enable him to rise above himself." ARTHUR MILLER

"Since the theme of borders has been central to our project—this is one of the most extreme borderline situations for America since Pearl Harbor. The aggressors have transgressed every known limit of human action. It is all very distressing." INGE MORATH

RÜCKKEHR – EIN LETZTES MAL

Die Arbeit an den ›Grenz.Räumen‹ geht weiter. Inge Morath verschiebt ihre Ankunft für die Herbst-Session um zwei Tage. Es hat sich in den USA noch ein unverschiebbarer Termin für ›Westpoint's Women‹ – ein Projekt über Soldatinnen in der militärischen Kaderschmiede – ergeben. Als Morath am 30. September aus dem Flugzeug steigt, sagt sie beiläufig: »Ich hab mir beim Spielen mit dem Ronan das Kreuz verrissen. Tut ein bissl weh. Aber mit meinem Yoga werde ich das schon wieder hinkriegen.« Allgemeiner Tenor: schmerzhaft, aber nicht weiter schlimm. Wir werden die ersten Tage leiser treten. Außerdem ist für Inge Morath ein Ruhetag mit ihren Freunden im Weingarten eingeplant. Sie freut sich darauf – Weinlese, ›Sturm‹ trinken, frisch gebratene Kastanien essen und natürlich auch Schwammerl, mit Salat und viel Kernöl. Zuerst soll aber der Stimmungslage der slowenischen Jugend in Maribor nachgespürt werden. Hoffnungen, Ängste, Träume, Zukunft – auch nach dem 11. September.

»Welcome to Bukvarna«, sagt ein junger Experimental-Photograph zu seiner weltberühmten Kollegin, die neugierig ist auf den Jugend-Treff in einer ehemaligen Kaserne der jugoslawischen Volksarmee. Der Ort hat Flair: Grafitti-Kunst, Tito-Büsten, vermodernde Grenzbalken, futuristisches Klimbim, Rockcafé, Open Air-Bühne… Ein Paradies an Motiven. Nur: Inge Morath quält sich. Sieht schlecht aus, legt häufig gymnastische Übungen ein, macht mit eiserner Selbstdisziplin weiter, will von einem Arztbesuch nichts wissen. Als ihr Matjaž Wenzel eine geometrische Licht-Schatten-Photographie schenkt, sagt er: »We all need solidarity in hard times…« Künstler als Seismographen – so ähnlich hatte es Inge Morath an anderer Stelle formuliert. Sie spüren, was kommt. Die 79Jährige drückt ihre rechte Hand in den Rücken, sieht dem jungen Mann kurz in die Augen, antwortet: »Yes, this is true. Thank you!« Die Wahrheit ist konkret. Plötzlich wird klar: Inge Morath, die sonst im Umgang mit Menschen – besonders mit jungen Männern – so sprühend, charmant, jugendlich, ab und zu sogar neckisch sein kann, ist am Limit. Und trotzdem: Die Frau macht weiter. Will sich die nächsten Sessions – Rockcafé, Video-Konzert, Jazz-Keller – nicht entgehen lassen. Sie will – noch einmal – die Welt der Jungen spüren.

REGINA STRASSEGGER

RETURN—ONE LAST TIME

Work on *Border.Spaces* continues. Inge Morath postpones her arrival for the fall session by two days. An engagement has come up in the United States in connection with *Westpoint's Women*—a project about women soldiers in the Military Academy—and cannot be put off. Getting off the plane on September 30, Morath remarks casually, "I strained my back playing with Ronan. Hurts a bit. Nothing a few yoga exercises won't set right though." General tenor: painful; otherwise no cause for worry. We can take it easier for the first few days. In addition, a day of rest with Inge Morath's friends in the vineyard garden is on the program, which she is looking forward to—grape harvest, "Sturm" (new wine), fresh-roasted chestnuts, and mushrooms of course, and salad with plenty of pumpkin-seed oil. But first the mood among young Slovenians in Maribor is to be checked out—hopes, fears, dreams, the future; after September 11, too.

"Welcome to Bukvarna," says a young experimental photographer to his world-renowned colleague, who is curious about meeting these young people in a former barracks of the Yugoslavian People's Army. The place has flair: graffiti art, Tito busts, rotting border barriers, futuristic paraphernalia, rock café, open-air stage…. A paradise of motifs. Only: Inge Morath is suffering. She looks unwell, stops frequently to do yoga exercises, goes on then with iron discipline, refuses to see a doctor. Giving her a photograph—a geometrical pattern of light and shadows—Matjaž Wenzel says, "We all need solidarity in hard times…." Artists as seismographs; Inge Morath put it similarly on another occasion. They sense what is coming. The 79-year-old presses her right hand against her back, looks into the young man's eyes briefly, says, "Yes. That's true. Thank you." Truth is clear-cut. Suddenly it is clear that Inge Morath, who otherwise in dealing with people, especially young men, can be so exuberant, charming, youthful, even a tease, has reached her limit. Despite which, she goes on, not wanting to miss the next sessions—rock café, video-concert, jazz cellar. She wants to experience the world of young people one more time.

REGINA STRASSEGGER

Hard times, Photographie. Geschenk des slowenischen Photographen Matjaž Wenzel für Inge Morath in memoriam (11.9.2001).

Hard Times, photograph. Gift of the Slovenian photographer Matjaž Wenzel for Inge Morath in memoriam (September 11, 2001)

Leadsänger der Rockgruppe Laibach.

Lead singer of the rock band Laibach.

Provokanter Song *Alle gegen Alle!*.
Song as provocation: All against All.

Cry, river, cry.

Inge Morath – scharfes Auge,
wacher Geist.
Inge Morath—keen eye,
alert mind.

Fatalismus bei den Jungen.
Fatalism among the young.

No luck.

TODESNÄHE DEATH'S NEARNESS

Grenzräume. Raum bedingt Grenzen. Räume und Gedächtnis gehören zusammen.
Gedächtnisräume... Die Sehnsucht zu bleiben, zumindest in der Erinnerung.
Der Himmel hat keine Grenze... endlose Räume.
Und die Grenzenlosigkeit, die Seligkeit – nach dem Tod.
Mag sein.

Border spaces. Space presupposes borders. Spaces and memory belong together.
Memory-spaces.... The longing to remain, at least in memory.
The sky is without limits... infinite space.
And limitlessness, blessedness—after death.
Perhaps.

Kreuze an der Tür.
Crosses on the door.

Eintritt ins Schattenreich – Verlust des Sohnes.

Entry into a shadow realm—loss of a son.

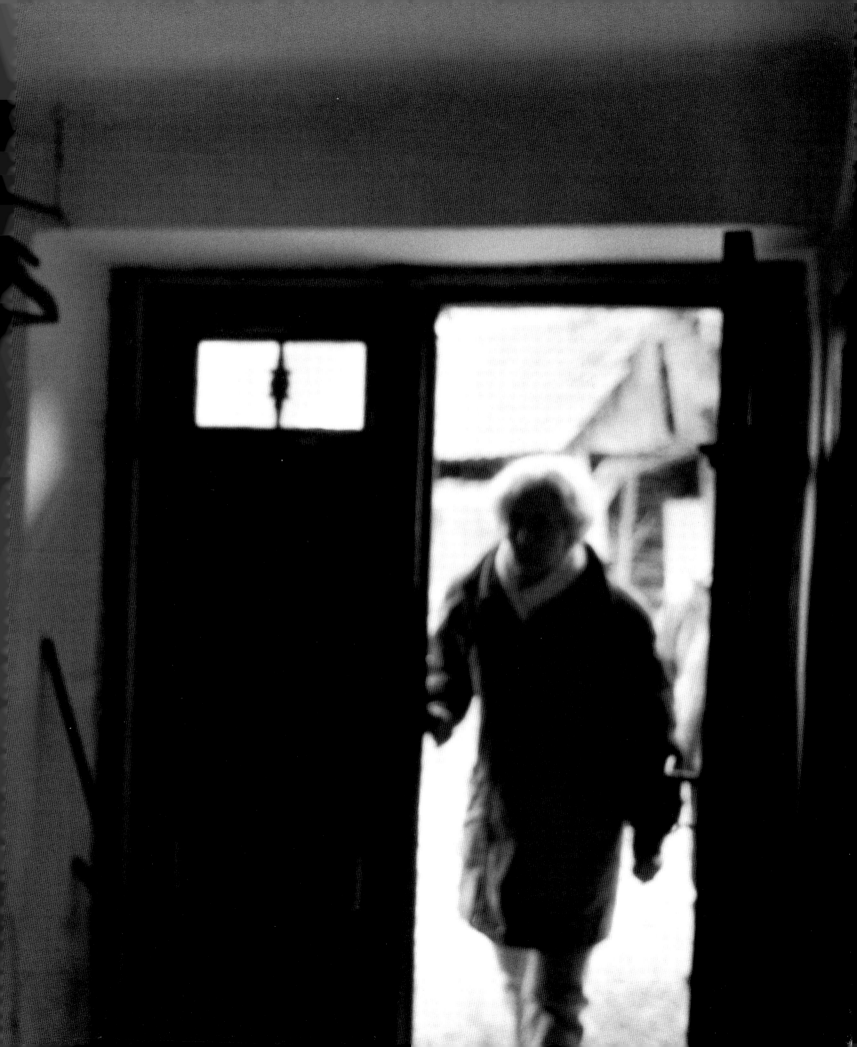

Inge Morath – stilles Zuhören.
Inge Morath—listening in silence.

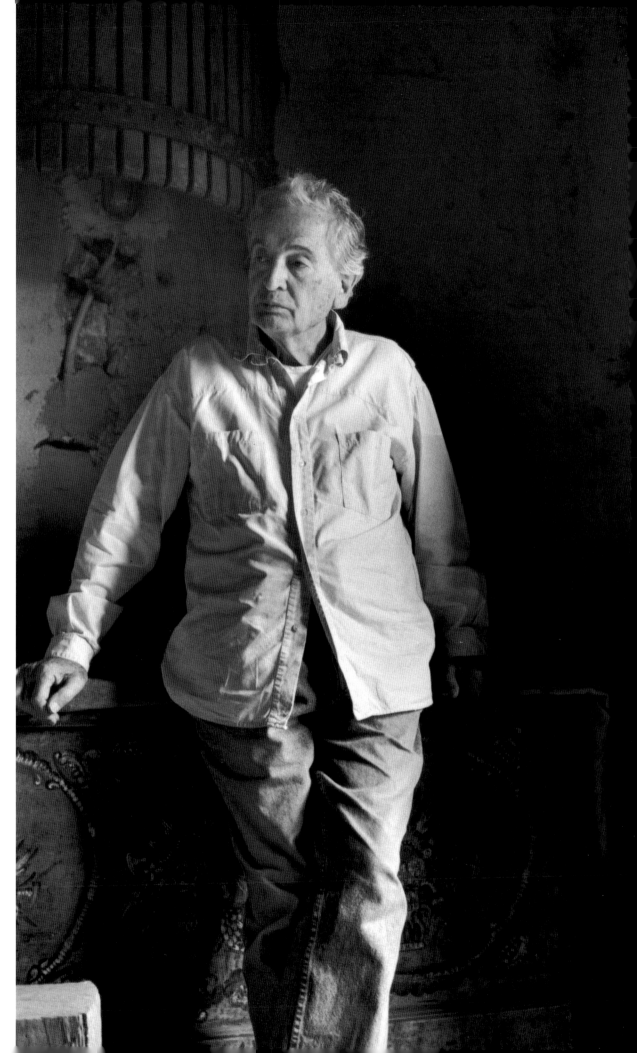

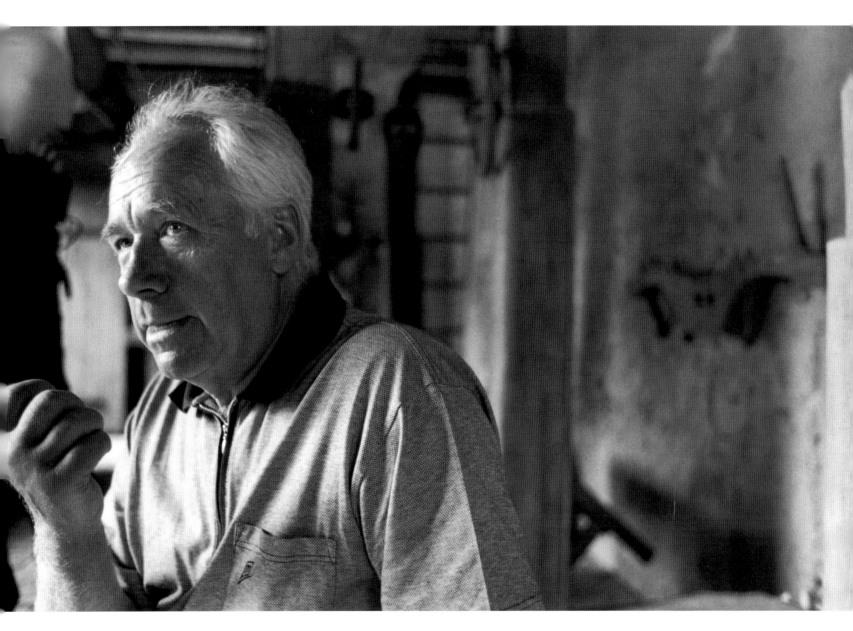

Andreas Tscheppe sucht im Tod seines Sohnes einen höheren Sinn zu sehen.

Andreas Tscheppe tries to see a deeper meaning in the loss of his son.

Links: Imo Moszkowicz zürnt dem Schicksal.

Left: Imo Moszkowicz harbors resentment against his fate.

»NICHTS IST VERLOREN...«

»Manch einer, der hier nicht lebt, redet gern von den sanften, paradiesischen Hügeln der Südsteiermark«, sagt der mit Inge Morath und Imo Moszkowicz im alten Preßhaus sitzende Winzer Andreas Tscheppe, »sie wissen wenig über die Arbeit, die Opfer am Weinberg. Dieses Biblische ›im Schweiße deines Angesichts...‹ oder gar die Geschichte des Hiob passen hier gut her.« Erst kürzlich wieder ist ganz in der Nähe ein Weinbauer im steilen Gelände mit dem Traktor tödlich verunglückt – so wie vor Jahren im Mai der 23jährige Sohn der Familie Tscheppe. Inge Morath fährt mit einer Hand die Kante einer Bauerntruhe entlang. Für Momente umklammert sie das alte Holz.

»Es mag vielleicht unverständlich klingen. Aber es gibt nur eine Erkenntnis aus diesem Ereignis«, sagt der für seine ungewöhnliche Lebensphilosophie weithin bekannte Weinbauer, »es ist zu unserem Besten. Meine Tochter hat mir zum Beispiel klar gemacht, daß der Michael ein Frühvollendeter war. Er hat kurz vor seinem Tod noch zu ihr gesagt, er möchte nicht wiedergeboren, sondern geistig weitergetragen werden.« Inge Morath und Imo Moszkowicz schauen ihren Bekannten staunend an. Der zürnt seinem Gott nicht; er ist ihm näher denn je. »Ich bewundere das. Ich selbst kann das nicht«, bekennt Moszkowicz, der seine Mutter und sechs Geschwister in den Gaskammern verloren hat, »ich habe in Auschwitz aufgehört, meinen bis dahin so geliebten Gott zu lieben. Dieser Gott hat mich um die Hoffnung betrogen. Mein Gott ist jetzt irdischer Natur: meine Frau, meine Kinder, meine Enkel. Und ich fühle mich nicht verloren.« Moszkowicz wendet seinen Blick hinaus, verweilt bei der herbstlichen Heckenrose. »Nichts ist verloren«, sagt der Weinbauer in die Stille hinein, »auch Hoffnung und Verheißung nicht – diese vagen Begriffe haben sich für mich, den ewigen Zweifler, seit dem Tod von Michi erhärtet. Ich wünschte, wir könnten davon etwas gemeinsam spüren.«

Wenige Wochen später wird Imo Moszkowicz einen Herzinfarkt erleiden und nach seiner Genesung sagen: »Es war erstaunlich, wie ruhig ich meinem Tod entgegen-gesehen habe. Er war sehr nah, das konnte ich spüren.« – Helldunkel-Kontraste durchfluten den Raum. Die Photographin bleibt in diesem Gespräch über den Tod und das Danach bewußt – oder auch unbewußt – stille Zuhörerin. Sie macht Porträts. Zwischendurch drückt sie immer wieder ihre Hand in den Rücken. Niemand weiß, daß ihre Schmerzen eine Krankheit zum Tod signalisieren. Metastasen eines Lymphoms...

REGINA STRASSEGGER

"Some people who don't live here like to talk of the gently rolling, paradisial hills of southern Styria," says Andreas Tscheppe, vintner, sitting in the old winepress hut with Inge Morath and Imo Moszkowicz. "They know little about the hard work and sacrifice of the vineyard. The biblical saying "by the sweat of one's brow," or the story of Job, fit well here." Only the other day another vintner was killed nearby in a tractor accident on steep ground, as happened years ago one May to the Tscheppes' 23-year-old son. Inge Morath runs a hand along the edge of a wooden farm chest. Her hand clasps the old wood for a moment.

"It may sound mysterious. But there's only one way of understanding the event," says the wine farmer, well known in the wider vicinity for his unusual outlook on life," it was for our best. It was my daughter who helped me to realize that Michael was one of those people whose life is accomplished at an early age. Shortly before his death, he'd told her he wouldn't want to be born again, but to be remembered." Inge Morath and Imo Moszkowicz look at their acquaintance in astonishment. He harbors no resentment against his God; he's closer to him than ever. "I admire that," admits Imo Moszkowicz, who lost his mother and six brothers and sisters in the gas chambers, "I'm not up to it myself. In Auschwitz I stopped loving the God I'd loved so much till then. This God cheated me out of hope. My god is of an earthly kind now—my wife, children, grandchildren. And I don't feel lost." Moszkowicz's gaze turns to the fall dog rose outside, lingering there. "Nothing is lost," the wine farmer says into the silence, "not hope, and not promises. Those ideas have become reality for me, the eternal doubter, since Michael's death. I wish we could share something of that."

A few weeks later Imo Moszkowicz will suffer a heart attack, and, after recovering, say: "It was astonishing how calmly I viewed my death. I felt it very close." The room is flooded with light and shadow. Throughout this conversation on death and the thereafter, Inge Morath remains consciously—or perhaps unconsciously—a silent listener. She shoots portraits, and keeps pressing a hand against her back as she works. No one knows that the pains she is experiencing are symptoms of a metastasizing lymphoma that will prove fatal....

REGINA STRASSEGGER

LETZTER TANZ LAST DANCE

»Was für ein prachtvoller Herbsttag, was für ein schönes Fest – nur
ich, der von Euch so verwöhnte Gast, ich bin ziemlich zerlempert...«

INGE MORATH, 6. 10. 2001

"What a splendid fall day, what a beautiful festival—only I,
your spoiled guest, am pretty badly out of shape..."

INGE MORATH, OCTOBER 6, 2001

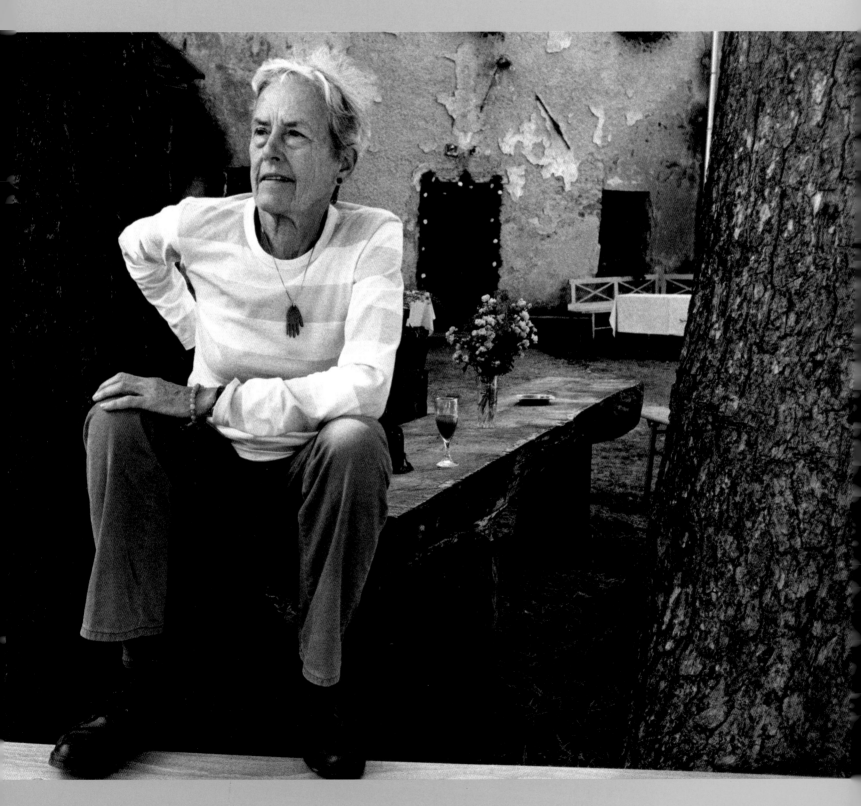

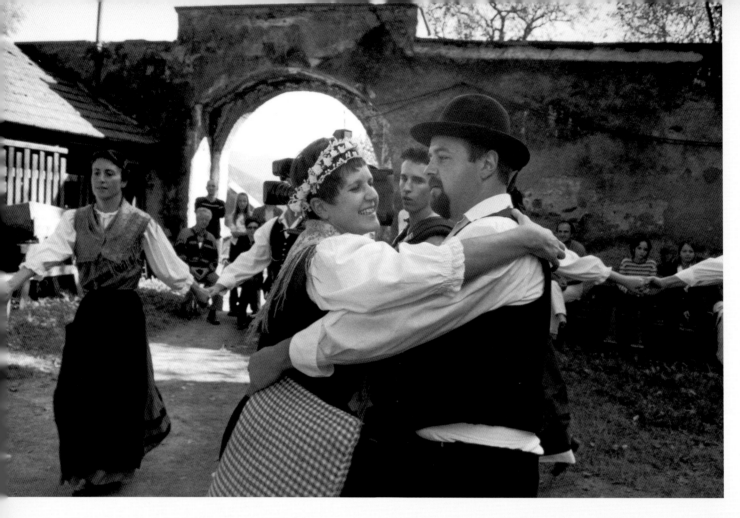

Der Tanz geht weiter. The dance goes on.

Trost von den Freunden. Comfort from friends.

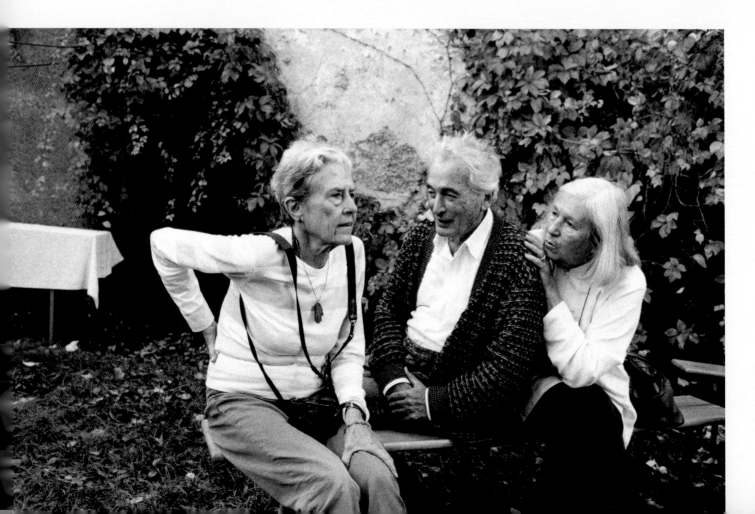

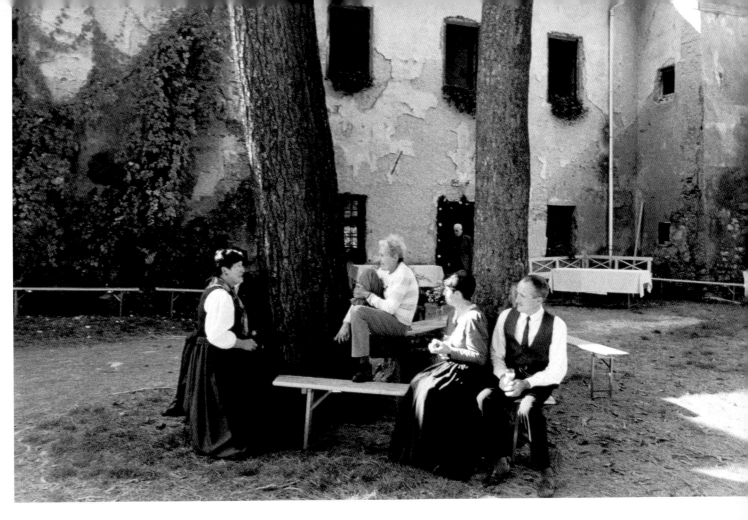

Die Schmerzen sind unerträglich. Unbearable pain.

Der Tanz geht dem Ende zu. The dance nears its close.

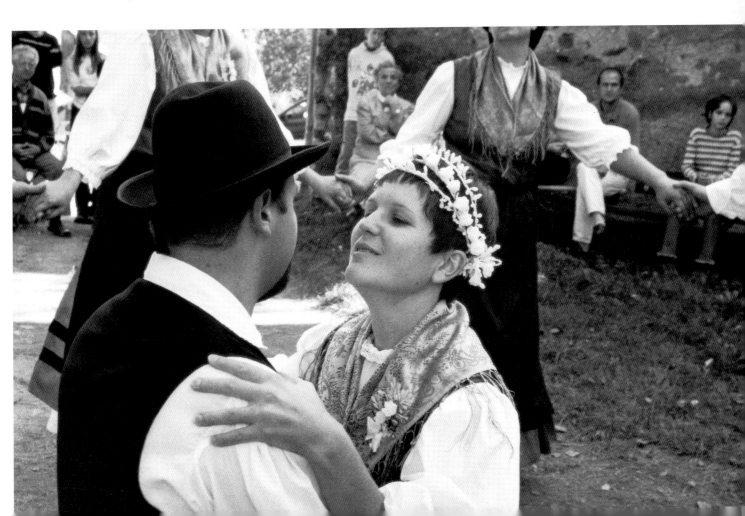

Liebe Inge.

Wie geht es Dir? Konnten Sie Dir in der Klinik diese elenden Schmerzen nehmen? War es tatsächlich ein eingeklemmter Nerv? Hoffentlich!!!

Inge, daß Du diese Herbst-Session mit uns bis zum Schluß durchgestanden hast, war heroinenhaft. Deine toughness – dieses, wie Du öfters gesagt hast, von der Titti geerbte »Trotzdem-Weitermachen« war unglaublich. Unheimlich wurdest Du mir aber, als Du trotz höllischer Schmerzen den jungen Arzt im Krankenhaus mit Deinen akrobatischen Turnübungen total verwirrt hast. Der sagte: »Wo ist das Problem, die Patientin ist voll bewegungs-fähig.« Du drauf: »Ich sag's ja.« Diese Szene war zu komisch. Wärst Du nicht so bedient gewesen, hätten wir einmal mehr über Dein komödiantisches Talent Tränen gelacht. Erinnere nur an die Stichworte: »Amoröse Turnübungen der Madame soundso auf der Waschmaschine...«; »der falsche Fuchziger gehört in den Beichtstuhl«; oder Dein Sager: »Die Chance mit der alten Schloßdame noch einmal eine so phantastische Begegnung zu haben, ist gering, she might have expired...« Inge, Inge!!! Sie ist übrigens noch putzmunter. So, there is hope for more. Aber laß Dir Zeit beim Genesen; der Rollstuhl – wie beim Abschied – steht Dir nicht gut. Deine unzähligen Projekte können ja auch einmal auf Dich warten. Die ›Grenz.Räume‹ jedenfalls drängen nicht.

Auch das aufgeschobene lange Interview holen wir nach. Wir haben ja Zeit.

Inge, vielen, vielen Dank so far, und alles, alles Gute!!!

Denke viel an Dich,

Regina

REGINA STRASSEGGER, BRIEF AN INGE MORATH

Liebe Regina.

Ich befinde mich endlich wirklich auf dem Weg der Besserung. Laufe wieder herum, mache Yoga, fahre Auto. Etwas von der alten Energie fehlt noch, wird jedoch täglich besser. Noch drei Therapien (leider auch etwas Chemo), kann jedoch Mitte Jänner anfangen zu arbeiten. Aufnahmen der Broadway Production von *Hexenjagd*.

Endlich bin ich auch dabei, die Photos der letzten gemeinsamen Reise einzuscannen. Ich hoffe, in zwei Tagen damit fertig zu sein, Dir das printout schicken zu können. Nachdem ich in dieser ›Grenz-Woche‹ zu viel Schmerzen hatte, habe ich abends keine sehr guten oder genauen captions geschrieben. Da werdet Ihr mir helfen müssen. Ich habe eine eher strenge Bildauswahl getroffen, vor allem von Sachen, die nicht in den ersten beiden Takes waren. Hoffentlich gefällt Euch Einiges.

Viel Glück bei Deinen unzähligen Unternehmungen. Ich bin schon riesig gespannt, welche Gestalt unsere Arbeit in Deinen Händen annehmen wird.

Laß mich hören, wie's geht. Ich bin am Platz, Reisen in Flugzeugen noch verboten. Aber irre zu tun hier. Rebeccas Film wurde im Sundance Festival der Robert Redford Stiftung angenommen, was prima ist. Ich habe die Standaufnahmen gemacht und kämpfe nun, mit allen Magazinen etc. fertig zu werden. Die Kaindls waren hier, New York Ausstellung für Passau Festival im Sommer zusammengestellt, auch Venedigbuch ist am fertigwerden. Ich wünsche Dir ein wenig Ruhe und viel Freude über die Festtage. Bitte grüße Eva und Viktor von mir.

Liebe Grüße,

Deine Inge

INGE MORATH, BRIEF AN REGINA STRASSEGGER, 6 WOCHEN VOR IHREM TOD AM 30. 1. 2002 IN NEW YORK

Dear Inge,

How are you? Were they able to help you in the clinic and stop the dreadful pain? Was it really a pinched nerve? Hopefully!!!

Inge, your seeing the fall session through to the end with us was worthy of a heroine. Your toughness was incredible—this "keep going, despite everything," which you often said you inherited from Titti. But the way you totally perplexed that young hospital doctor with your gymnastic exercises, despite being in such pain, was almost too much for me. "Where's the problem," he said, "the patient is one hundred percent mobile." "That's what I'm saying," you retorted. It was just too funny. Had your situation been otherwise, we would have wept tears of laughter again at your comedian's talents. Your "Amorous exercises of Madame What's-her-name on the washing machine," for example, and "That false foxy-year-old should be in the confessional," come to mind. Or the way you said, "The chances of repeating such a fantastic encounter with the old château lady are slim— she might have expired...." Inge, Inge!!! She's still as merry as a lark. So there's hope for more. But take your time convalescing; the wheelchair—as when we parted—doesn't suit you. Your countless projects can also wait for you for once. *Border.Spaces* is not pressing just now, and we can do the long interview we postponed later on. There's plenty of time.

Many, many thanks for everything so far, Inge, and all—all the best!!!
Thinking of you a lot.
Regina

Dear Regina,

At last I'm really on the mend. I'm on my feet again, doing yoga, driving. I still lack something of my old energy, but each day a bit more comes back. Three more therapy sessions (chemo unfortunately as well), but I can begin work again mid-January—shooting the Broadway production of *The Crucible*.

I've at last got round to scanning the photos from our last joint trip. I hope to be finished in two days and to be able to send you a printout. Because of the pain I was having in our last "Border-Week," I didn't write very good or precise captions in the evenings. You'll have to help me. I've been more severe than lax in my selection of pictures, especially things that weren't in the first two takes. I hope you like some of them.

I wish you luck with your many projects. I can't wait to see what shape our work will take in your hands. Let me know how things are going. I'm here, air travel is still forbidden. Incredible amount to do. Rebecca's film was accepted for the Robert Redford Foundation's Sundance Festival, which is super. I did the stills and now I'm battling to cope with all the magazines, etc. The Kaindls were here, putting together the New York exhibition for the Passau Festival in summer. The Venice book is also getting itself finished.
I wish you some quiet and much joy over the holidays. My greetings to Eva and Viktor, please.
Love,

Inge

Dieses Buch erschien anläßlich des Projekts ›Graz 2003 – Kulturhauptstadt Europas‹
This book has been published in conjunction with the project "Graz 2003—Cultural Capital of Europe"

KÜNSTLERHAUS GRAZ (02.2003)

KOROŠKA-GALERIE DER BILDENDEN KÜNSTE, SLOVENJ GRADEC (04.2003)

LEICA-GALERIE, NEW YORK (07.2003)

STADTGALERIE LJUBLJANA (08.2003)

HAUS DER PHOTOGRAPHIE, BUDAPEST (10.2003)

Auf dem Schutzumschlag / Front cover Schaffner, Zug – Dravograd – Maribor, 2001
Conductor on train from Dravograd—Maribor, 2001 (Photo Inge Morath)

Umschlagrückseite / Backcover Inge Morath auf der Mur, 2001
Inge Morath on the Mura River, 2001 (Photo Regina Strassegger)

Die historischen Photographien wurden freundlicherweise vom Inge Morath Estate, New York, von
Werner Mörath, Düsseldorf, Renate und Imo Moszkowicz, München, dem Landesmuseum Joanneum,
Bild- und Tonarchiv, Graz, sowie dem Regionalmuseum Koroška, Slovenj Gradec, zur Verfügung gestellt /
Historical photographs kindly lent by the Inge Morath Estate, New York, by Werner Mörath, Düsseldorf,
Renate und Imo Moszkowicz, Munich, Landesmuseum Joanneum, Bild- und Tonarchiv, Graz, and
Regionalmuseum Koroška, Slovenj Gradec

CIP-Kurztitelaufnahme der Deutschen Bibliothek
Ein Titeldatensatz für diese Publikation ist bei der Deutschen Bibliothek erhältlich

Die Deutsche Bibliothek CIP-Einheitsaufnahme data and the Library of Congress
Cataloguing-in-Publication data is available

Prestel Verlag Königinstraße 9 80539 Munich
Tel. (089)381709-0 Fax (089)381709-35

4 Bloomsbury Place London WC1A 2 QA
Tel. (0)20.73235004 Fax (0)20.76368004

175 Fifth Avenue, Suite 402 New York, NY 10010
Tel. (212)995-2720 Fax (212)995-2733
www.prestel.com

Redaktion / Edited by Regina Strassegger
Übersetzung des Beitrags von Arthur Miller Nikolaus G. Schneider
Übersetzung des Beitrags von Drago Jančar Klaus Detlef Olof

English texts translated from the German by Christopher Jenkin-Jones, Munich
Copyedited by Christopher Wynne

Design WIGEL, München
Lithography Repro Bayer, München
Druck / Printing sellier, Freising
Bindung / Binding Conzella, Pfarrkirchen

Printed in Germany on acid-free paper
ISBN 3-7913-2773-9

Die Photographien stammen von
INGE MORATH, ferner von folgenden
Photographen / All photographs are
by Inge Morath with the exception
of the following:

CHRISTIAN JANSCHOWETZ 174
(unten/bottom)

STOJAN KERBLER 10 (oben/top),
11 (unten/bottom), 12, 33 (rechts
oben/top right), 37, 40, 43 (rechts
unten/bottom right), 49 (oben/top),
106/107 (oben/top), 148 (oben/top),
153, 182 (links/left), 195, 198
(unten/bottom), 200 (links/left),
225, 226, 227, 230/231

BRANKO LENART 34 (links unten/
bottom left), 48, 49 (Bild/illus. 2–4),
51 (rechts/right), 134, 136, 137
(rechts unten/bottom right), 149
(oben/top), 198 (Mitte/center),
202, 203

IMO MOSZKOWICZ 169, 172, 173

ANDREAS PLOCHBERGER 51
(links/left)

REGINA STRASSEGGER 2/3, 15,
28/29, 34, 43 (rechts oben/top
right), 56 (links unten/bottom left),
57 (unten/bottom), 62 (links/left),
66 (unten/bottom), 73 (rechts/right),
74 (unten/bottom), 80, 86, 87
(unten/bottom), 90, 92 (links/left),
101 (rechts oben/top right), 103 (rechts
unten/bottom right), 111 (rechts/right),
122, 133, 147, 163, 167 (rechts/
right), 184 (links/left), 187 (rechts
oben/top right), 188, 189, 204/205,
206 (links/left), 209, 214 (unten/
bottom), 220 (links/left)

MATJAŽ WENZEL 210